D0480297

MARCHES PAST

To Christopher Oliver and
Anthony Barnett

PETER FULLER

Marches Past

———

A TIGERSTRIPE BOOK

Chatto *&* Windus
LONDON

By the same author

The Champions
Art and Psychoanalysis
Beyond the Crisis in Art
Seeing Berger
Robert Natkin
The Naked Artist
Aesthetics After Modernism
Images of God:
The Consolations of Lost Illusions

(with Jon Halliday)
The Psychology of Gambling

A TIGERSTRIPE BOOK

Published in 1986 by
Chatto & Windus
40 William IV Street
London WC2N 4DF

All rights reserved. No part of this publication may be
reproduced, stored in a retrieval system, or transmitted in
any form or by any means, electronic, mechanical, photocopying,
recording or otherwise, without the prior permission of
the publisher.

British Library Cataloguing in Publication Data

Fuller, Peter, *1947–*
Marches past.
1. Fuller, Peter, *1947—* 2. Art critics——
Great Britain——Biography
I. Title
700'.92'4 N7483.F8

ISBN 0-7011-3037-7

Copyright © Peter Fuller 1986

Photoset by Rowland Phototypesetting Ltd
Bury St Edmunds, Suffolk
Printed in Great Britain by
Redwood Burn Ltd
Trowbridge, Wiltshire

FOREWORD

I began to keep a journal on March 28th 1975. Although at first I made entries more or less every day, I also found that, in successive years, the anniversary of my first entry, March 28th, and of the three following days, March 29th, 30th and 31st, acquired an importance which was at once arbitrary and compelling. After a time – I can no longer remember exactly when this was – I conceived of the idea of ordering the material into four chapters, each of which would deal with a day across four successive years: 1975, 1976, 1977 and 1978. After many difficulties, I decided the material for March 30th and 31st presented too many problems, both personal and technical. For the moment, I have literally shelved it. *Marches Past* is comprised of two dates, March 28th and 29th, across the four years in question.

All this may sound confusing; it might, therefore, be helpful for the reader if I say something at the outset about the chronology of my life and about my circumstances at the time covered by *Marches Past*. I was born in Damascus, in 1947; at that time, my father worked for the Red Cross. My sister was born in Nazareth in 1945, and my brother in London in 1950. Most of my childhood was spent in Eastleigh, a Hampshire railway town where my father worked as a general medical practitioner. We lived in a large, semi-detached, three-storey house, The Elms, overlooking the recreation ground and the bandstand. The property had been built towards the end of the nineteenth century on what was once an orchard; originally, it had served as a railway works' manager's house. We attended the Union Baptist Church in Desborough Road on Sundays. I was baptised, as I describe in these pages, upon confession of faith, by complete immersion, in 1961, just before I went away to board at Epsom College, a minor public school which had close links with the medical profession. While I was there I drew some comfort from the fact that Graham Sutherland and John Piper, artists whom I have always respected, had been there before me and were as unhappy as I was. While I was at Epsom, I began to question

the values and religious beliefs with which I had been brought up. I was lost and confused. My teachers assumed that I would go either to Oxford or to Cambridge; in the event, I read English at Peterhouse, Cambridge, between 1965 and 1968, at a time when the influence of the great Dr F. R. Leavis was, sadly, beginning to wane. I wish I had had the chance of studying under him.

When I look back on my Cambridge days, I can see that I went through a period of personal crisis at a time of widespread intellectual and political ferment throughout the colleges. Inevitably, I found the faith in which I had been brought up inadequate; it had already been deeply shaken, if not destroyed, by my experiences at Epsom. But my problems at this time were not just spiritual and intellectual; they were also psychological, even psychiatric. In my last year at Cambridge I did in fact consult Dr Zeitling, a psychoanalyst who later died tragically in a cycling accident.

But throughout my three years at Cambridge, I searched in a confused and often compulsive way for solutions. At one time I was briefly under instruction from a Roman Catholic priest, a likeable fellow, whom I once observed placing a bet with a bookmaker on Newmarket Heath. As I remember, I backed the same horse – which lost. I was also interested in Peterhouse's lapsed Anglican, 'Higher Tory' traditions. My moral tutor, Maurice Cowling, probably had as much influence on me as anyone. He told me I lacked a political perspective and he advised me to read H. G. Wells' *The New Machiavelli*, which I did, but what sticks in my mind, to this day, is the sad scene in which the hero visits a prostitute. Towards the end of my time at university, I became interested in Marxism and the activities of the Far Left; indeed, it was difficult not to, since 'revolutionary' ideas and Marxist literature increasingly formed part of the cultural climate, indeed the historical expectations, of students in those troubled and yet optimistic days. While I was at Peterhouse, however, I was never a good Marxist; fortunately, perhaps, I carried far too much intractable baggage from other intellectual and cultural traditions. At this time, most levels of my life were a muddle. Nonetheless, I enjoyed Cambridge; I don't think I would have been as happy anywhere else as I was

there. During the Long Vac Term of 1967 I met Colette Dupont. She was a French student from Montpellier, who was working as an *au pair* for an astronomer. We fell in love.

After I left university, I worked for a time as a journalist on *City Press*, a local paper for the City of London whose motto was 'The Voice of Honest Capitalism', which it wasn't. The Lord Mayors, Livery Companies and financial institutions of the Square Mile made me more interested in Marxism than I had previously been, and I began contributing to the underground press which proliferated at that time. I also went to Argentina where I gained some first-hand insights into the nature of a National Liberation struggle. My feelings about this were ambivalent. Nonetheless, in the early 1970s, I certainly came close to believing that the editorial board of *The New Left Review* had access to 'The Truth', to which I too could be party if only I understood their texts correctly. I remember telling Colette, on a train to Winchester in 1968, that the virtue of the Royal Family was that it had 'saved' Britain from a violent revolution. Colette and I were married in July of 1971. By 1974, I was angrily informing her – poor thing! – that Marxism offered a 'scientific' analysis of the laws of historical development.

At this time, I was neither a happy, nor, in the jargon of the psychologists, an 'integrated' personality. Indeed, I was – as any reader of this journal will hardly fail to notice – still very troubled and confused. My intellectual dogmatism provided a thin disguise for a deep sense of fragmentation and I would also say, if the word were not so overworked, of 'alienation' from myself and others. Marxism enabled me to rationalise all this. Still, I had enough insight to realise that certain compulsive aspects of myself, like gambling and masochism, were not immediately determined by the prevailing mode of production, and so I entered into psychoanalysis with Dr Kenneth Wright, referred to in this journal – I'm not sure why – as W. My analysis began in November 1972 and ended in March 1977. For the first three years, I went five times a week with 'holidays' at Christmas, Easter and in the summer – like going back to school.

Throughout this time, I was struggling to establish myself as a writer on art. I contributed regularly to *Arts Review*, *The Connoisseur*, *Art*

and Artists and frequently to *New Society*, to whom I had been introduced by John Berger, the essayist, novelist and socialist art critic. From 1970 onwards, Berger was a major – perhaps *the* major – intellectual influence on me. He was generous with his time, friendship and encouragement when very few others believed in my work. (The others who did were Paul Barker of *New Society*; David Coombs of *The Connoisseur*; Richard Gainsborough of *Arts Review*; and my friend, Anthony Barnett.) John Berger was undoubtedly a 'good father' for me, and thoughts about him and his work played a large part in my psychoanalysis – and in this journal. I was not, however, a slavish disciple. About 1974, I began to become very interested in the work of the American abstract colourist, Robert Natkin – an artist whose work was not of a kind to interest Berger. Natkin and I got to know each other and became friends. I wrote catalogues and articles about his work from the mid 1970s onwards. He opened my eyes, and my heart, to dimensions of painting which were quite new to me. He, too, plays a central part in this journal. I am indebted to them both.

It must have been Colette who really suffered in the early 1970s. We were married from a rather unprepossessing flat which we sub-leased in Earls Court Square; then we moved to rented accommodation in Uxbridge Road, which was just above slum level. I was very preoccupied with establishing myself as a writer, and also with sorting myself out through the seemingly interminable processes of psychoanalysis. I believed, as one does, that I was doing these things, in part at least, for her. In 1974, we moved into the first home of our own: a dreadfully noisy half-a-house, on Graham Road in Dalston. I spent much of the day writing in my study there, while Colette taught in a local school – which was as rough and rowdy as they come. Graham Road was our home throughout the period covered by this journal – but we travelled quite a bit, mostly to France to visit Colette's parents, and sometimes to New York and Connecticut to stay with Robert Natkin.

I think it would be helpful if I now said a little about the context of each of the March 28th and 29th periods discussed below. When the journal opens on March 28th 1975, I was staying with Colette at her parents' apartment above the post office in Le Châtelet, near Bourges,

which is almost the navel of France. Colette's father worked as a village postmaster for the PTT, the French postal and telecommunications service. Monsieur and Madame Dupont moved around France a good deal, and, indeed, at this time they were preparing to uproot again to take over the post office in Vals-Les-Bains, a small spa town in the south. A few days after those described below Colette and I left Le Châtelet and went to visit John Berger and Beverly Hiro in Mieussy, a village in Haute Savoie, where they were then living. One reason for starting my journal on March 28th 1975 was that I wanted something on paper to show to John Berger who had supported my successful application to the Literature Panel of the Arts Council for a grant of £500 to write a 'novel'. The journal was to be my 'novel', and is sometimes referred to as such below. I am grateful to the Arts Council for their assistance, and am sorry that they have had to wait more than ten years for something which is not a novel anyway.

March 28th 1976 found Colette and me at home in Graham Road. This was a very difficult time indeed for me. I remember that in the spring of 1976 I had a crisis of confidence. I felt the victim of a resurgence of psychological and compulsive problems – and I was beginning to wonder if my analysis, in which I had invested so much hope and time, was not foundering. Our daughter, Sylvia, who was born in December 1976, must have been conceived just before these entries were made.

March 28th and 29th 1977 were altogether a much happier and more confident time. We were again at home in Graham Road; my analysis was coming to an end, by mutual agreement with W. My last session was in fact on Wednesday March 30th, the following day. My thoughts, at this time, were very much focused on 'life after analysis'. There is a lot of imagery about travelling to the front line of life again. But I was also very involved with Sylvia, who was then just three and a half months old, having been born in the circumstances I describe later on December 16th 1976.

On March 28th and 29th 1978 the three of us were in Redding, Connecticut, where we stayed in a barn on Robert Natkin's estate. I was researching the book about Natkin's life and work which was

eventually published by Abrams Books in 1981. Sylvia was acquiring her first words.

When I told W. about my intention to publish this journal, he expressed his apprehension in a letter. None of us, he said, likes our past selves. I am certainly not enamoured of the Peter Fuller depicted here. I am conscious of the fact that my views, and, I hope, my personality have changed a good deal since these *Marches Past*. It goes without saying that many of the discussions of politics and aesthetics are remote from, and in some cases the inverse of, positions I hold today. Analysis ended not with the long-sought-for sudden change in the analyst, but with a slow and gradual process of change in myself, which still continues – at least I think it does – today.

Some things in this journal make me wince every time I read them. Of course, the comments about art are all wrong: readers of my more recent books on art criticism and aesthetics should have no difficulty in spotting how I have changed. My position was every bit as 'idealist' as that of the 'formalists' whom I so freely criticised. But none of all that matters. Courage is easily come by in aesthetic arguments. What really grates, throughout this text, is my much reiterated belief that, as Victor Serge, a revolutionary and writer discussed at the beginning of the book, once put it, 'The only meaning of life is conscious participation in the making of history.'

This sort of talk indicates just how alienated, or 'cut off', I still was. Indeed, I feel more than a twinge of embarrassment when I recall those long hours spent assailing W. about the necessity of relating oneself to history, when I was barely able to relate to the things and animals, let alone the real, living people, in the world around me. Evidently, all this talk about 'history' was, at once, a denial of what was really wrong and, as is so often the case, a perverse attempt to right that wrong, to break through to 'real relations' somehow.

I must say, however, that Serge's view today seems to me to be highly dubious, perhaps even dangerous. I am convinced that the revolutionary intellectual position celebrated in *Marches Past* involves more than an element of psychological perversity. In the perversions, the subject attempts to compel and to manipulate an intimacy which

can, in fact, only be freely given; similarly, the revolutionary intellectual purports to believe, against all the evidence of history, that the utopian ideal of unalienated existence can only be realised through violent struggle.

I would now say that whereas Marxism can, and indeed often does, reveal hidden truths about social and economic life, as a 'method', it has no monopoly on 'The Truth'. Marxism is not only impotent and silent in the face of many of the most significant human needs, desires and aspirations. Marxism can, and in my case probably did, provide a dangerous patina of projections and rationalisations for what are often psychological conflicts masquerading as social and historical insights. This can be all the more pernicious precisely because it is shot through with strands and threads of objective insight, even truth. Exactly the same, of course, can be said of the dogmatic right-wing theories about economic and historical life which are fashionable today.

Many of the people described and quoted here would have been depicted differently if I was writing *Marches Past* today. My father is certainly one. For there is an important sense in which this book is the story of my relationship with him, and of my struggle – long after I had in fact left home – to shake off what I experienced as the hegemony of his beliefs, attitudes and world-view. Marxism was for me a staging-post on that difficult journey, but it was not to be my final destination. Like most clichés, the assertion that Marxism, especially *theoretical* Marxism, is a sort of secular mirror image of theology contains considerable truth.

As any student of the early Marx knows, Marxism begins as theology's hunter. Inevitably, in this journal, my father often appears, as it were, in my sights. I know that I have to track him down. As will become evident to the reader, in *Marches Past* I am still fighting to shake off an intellectual inheritance which, though I have outgrown it, lives on within me. Nonetheless, I would hope that this book does not betray any bitterness towards my father. Bitterness is the last thing I feel towards him today.

The argument with my father seems over now, within and without myself. It is really very simple: these days I no longer feel angry; rather,

when I look back, I am grateful to my parents for having provided a secure, stable and loving home in which my brother, sister and I spent our childhood. Perhaps it was only because this grounding was so secure that I felt I could argue back as strongly as I did.

I have already implied that my Marxism was a sort of secular mirror image of my father's theology. There is truth in that, but it is not the whole truth. My father recently complained to me that in one of my books, *Art and Psychoanalysis*, I had implied he was a Barthian, or follower of Karl Barth, the Protestant theologian. Although he respected Karl Barth, he was, he insisted, an eclectic thinker, rather than a disciple of any one man. This complaint was justified: my father has always been a genuinely 'Non-Conformist' thinker – and I like to think this is something I have inherited from him.

I am intrigued by the fact that in so much recent writing about Edmund Gosse's great book, *Father and Son*, critical interest has swung in the direction of the father. Philip Henry Gosse has been partially rehabilitated: even his *intellectual* positions no longer seem so foolish as they once did.

The shift probably began when Gregory Bateson, the anthropologist, pointed out that Philip Henry Gosse's book, *Creation (Omphalos): An Attempt to Untie the Geological Knot*, was not, as had previously been assumed, simply a piece of sectarian nonsense. The intention of Gosse *père* was to reconcile the abundant evidence of development and evolution with the scriptural account of an act of divine creation. He held it to be inconceivable that God could have created a world in which Adam had no navel, the trees in the Garden of Eden no rings of growth and the rocks no strata. He therefore argued that God must have fashioned his creation as though it had a past. As Bateson points out, through this perverse line of reasoning Gosse arrived at insights about the structure of animals and plants which are today scarcely mentioned in many courses of biology; notably, he saw that all animals and plants show a time structure, of which the rings of growth in trees are an elementary example, and the cycles of life history a more complex one. He thus recognised – as many subsequent biologists fixated on 'evolutionary' and 'developmental' models of

time have not been able to do – that every animal and plant is constructed upon the premise of its cyclic nature.

Now my father's way of thinking, as described in *Marches Past*, though very different from Philip Gosse's is surely as unfashionable in the second half of the twentieth century as Gosse's was in the second half of the nineteenth century. And if today I am no nearer than I was in the late 1960s, or throughout the 1970s, to sharing my father's beliefs, I am fully prepared to admit that my own quirkish, sceptical and idiosyncratic way of thinking owes rather more to him than to many of the intellectual traditions cited against him in this book.

At the time, I experienced his assaults upon Roman Catholicism, Sigmund Freud and Karl Marx as being as oppressive as Edmund Gosse found his father's assaults upon Darwinism – which, as the reader will discover, was not a closed issue in my own childhood. (This was all before 'Creationism' had become fashionable in Fundamentalist circles once again.) But, in retrospect, I can also see that my father was trying to defend those traditions of eclectic, Non-Conformist thinking and scholarship to whose secular tributaries, or equivalents, I still see myself as belonging. For example, today I would not wholly disagree with the view he expressed in a letter he sent to me, quoted in this journal, in which he wrote that modern culture was, perhaps, 'increasingly irrelevant to any serious approach, let alone Christian approach, to life.'

But perhaps that is not important: in the end, I am grateful to my father for having argued with me. Today, I can see that those arguments were his way of expressing interest and love. The same might be said of *Marches Past*: at least, I hope it could.

Stowlangtoft, August 1985

March 28th

———

1975 *Le Châtelet, France*

Victor Serge's *Memoirs* open with the words, 'Even before I emerged from childhood, I seem to have experienced, deeply at heart, that paradoxical feeling which was to dominate me all through the first part of my life: that of living in a world without any possible escape, in which there was nothing for it but to fight for an impossible escape.'

This morning, I have been reading another of his books, *Men in Prison*. Serge was an anarchist and a revolutionary: he would never have said, 'I am a writer.' He put his relationship to history before his relationship to literature. 'The only meaning of life,' he once wrote, 'is conscious participation in the making of history.' John Berger has written of him, 'He recognised the forces of history traversing his time and chose to inhabit them through both action and imagination.'

Men in Prison is a novel; but Serge says at the beginning of it, 'Everything in this book is fictional and everything is true.' Serge was put in prison in 1912 for his subversive activities against the French Government. Of his own term of imprisonment, on which this book is based, he wrote, 'It burdened me with an experience so heavy, so intolerable to endure, that long afterwards, when I resumed writing, my first book amounted to an effort to free myself from this inward nightmare, as well as the performance of a duty toward all those who will never so free themselves.' As a prisoner, Serge was forcefully prevented from 'conscious participation in the making of history'.

Serge's book says much about the concrete presence of the prison, about the cell as a remorseless, given fact. It clamps down round him like a clam. But he does not just accept its limitations, nor does he elaborate a private world in which fantasy substitutes for the historical reality which he feels he is denied. One passage describes how he studied the scraps of soiled newspaper in the guards' latrines hunting for hints of external events; another how he watched the movement of a ray of sunlight across a wall. It is as if, even when incarcerated, he

grasped at those clues which might put him in touch with the world, and with the forces of history, again . . .

1976 *Graham Road, London*

A year has passed. I have come back to this text on its anniversary. Mother's Day! It irritates me. I am editing some of it away with a blue biro. But that won't do either. I can scent an intolerable trail of slimy piety, of searching for the shell of a self-righteous position. Perhaps the fog of hopelessness is greater now than it seemed then. All this talk about books: other people's used and soiled words. It's too much!

I glance round my study. There are no rays of sunlight on the walls here. Just more books: floor to ceiling. Behind me, on a long wooden trestle table scattered with papers, piles of magazines and yet more books, stands a plastic aquarium, with slight scratches on all four exposed surfaces. Words. Within the aquarium is an axolotl. Words. I remember a letter telling me the angel fish had died soon after I went away to boarding school at Epsom. The axolotl is even older than the angel fish would have been if it had lived. The creature gulps for air at the surface.

On my thirteenth birthday, Alison Baker, daughter of another doctor who lived two doors away from us opposite the recreation ground in Eastleigh, in Hampshire, went with my brother and me to Winchester, on the train. We walked from the station to the prison gates, and then came down to the centre of town, in the shadow of the Cathedral. At Wingate's, a pet shop which I loved, Alison bought the axolotl for me as a present. The embryonic state of the Mexican salamander, the axolotl need never metamorphose and may even breed in its larval form. A year after acquiring this strange creature, I went away to school. My mother fed it, writing down what it had eaten in a notebook every day: 'March 28th – Two woodlice; one piece of meat; a meal worm.' In the school holidays, I tended it. Then I went to Peterhouse, Cambridge, and later began shifting from one rented room to another in London. Meanwhile, my mother, uncomplaining, cared for my axolotl, in the certain knowledge it would never grow up

unless she fed it thyroid extract and allowed its water slowly to evaporate.

Three weeks ago, she returned this sixteen-year-old living legend of the family bestiary to me. Throughout all these long years, the axolotl has never done anything except lie in a tank stripped of everything but two inches of water and a smooth, round, brown stone, eat, excrete, and occasionally gulp air from the surface.

The axolotl reminds me that recently I have been peering into Samuel Beckett, the murderer of the novel. Now that, surely, was an historical action? That gave meaning to a life! He insists on an image of a crippled, disintegrating man, moving repetitively between the bowl and the pot, eating and excreting, trapped in a room, pouring out words to which there is no point, and for which there is no ending. In they go through eyes, ears, nose and mouth: out they come from the hands and the anus.

And the traffic runs along outside, shuddering juggernauts, shaking the whole house, taxis, trucks, motorcycles, milk vans and family saloons. Up and down Graham Road. I am shut in here at my desk. It will take me more than a day to re-work these pages about this day, last year. There is no escape. I will go on.

1977 *Graham Road, London*

A year later. I am still here with the texts accreting like barnacles on the hulk of a prison ship. Beside my typewriter is a blue and white Pelican book, Ian D. Suttie's *The Origins of Love and Hate*, which I bought last Saturday in the Kingsland Road market known locally as 'The Waste'. I often go there on Saturday mornings before I buy our food in Ridley Road. For me, the attraction of The Waste is a second-hand bookstall. The shabby old man who runs it trades mostly in soft core pornography, girlie magazines and popular fiction arranged in heaps, piles, rows and bundles. But at the back of the stall he keeps three orange boxes brimming full with what he calls his 'culture titles', at very low prices.

Last Saturday, I bought several from him and wandered on down to

the end of the market, to the place where those drab and lonely men stand, each offering for sale a single watch, wireless, suit, or stack of long playing records. As I went past the second-hand book man on my way back, I noticed that he was pushing a new crop of Penguins and Pelicans into the orange boxes for intellectuals. Among them, I spotted Ian D. Suttie's *The Origins of Love and Hate*, priced at seven pence. I first heard of this book in Charles Rycroft's *A Critical Dictionary of Psychoanalysis*. Or was it in John Bowlby's *Attachment*? One of them wrote that Suttie did not think – as Freud had done – of the baby as a creature driven solely by the need to discharge instinctual impulses in a pleasurable way. Suttie, apparently, saw that babies, too, have to relate in order to survive.

I think of Sylvia's purple head pushing into this world last December, of her lips closing round Colette's nipple, of the strange, sweet smell of the two of them feeding. Sylvia must be sleeping now, downstairs.

Suttie's ideas interested me as soon as I heard of them, because he thought that life began in a loving relationship, rather than a solipsistic cell. But his book has been out of print for years. It is very hard to find. I pulled this rare fruit out of the orange box, and paid for it, at once.

1978 *Redding, Connecticut*

This must be the last year when this date will be loaded with all this arbitrary significance for me. March 28th. The day on which I began this continuous chronicle, three years ago. I am sitting in front of a painted, circular, white metal table, in a converted barn where we are presently living. It belongs to Robert Natkin, an American abstract painter, who lives and works here in Redding, Connecticut. I am researching a book about him. My writing things – notebooks, pens, pencils, scissors, paper, Sellotape and typewriter – are ranged in front of me. Natkin's paintings are hanging and leaning round the walls of the barn. I have my back to one of the best, 'Reveries of a Lapsed Narcissist'. It belongs to a series he calls his 'Intimate Lighting' pictures. When you first look at it you think you are seeing a shimmering uniform skin of light, like a raiment or a curtain, stretched out in

front of the canvas surface; but as you continue to gaze, this breaks up, and you are drawn *in* to an image of boundless, illusory space. You have been seduced by sheer prettiness into a momentarily terrifying situation. This painting is among the most successful of the series, all of which work in this sort of way. It has the sensual peach-pink colour of white human flesh. Four years ago, long before Sylvia, I first wrote that these paintings were explorations of the infant's relationship to the mother's breasts: affirmations, almost, of the perfected infant–mother relationship, as a possibility for the future, rather than a remembrance of the past.

But this morning, the paintings seem too sweet, too close to ice cream, confectionery and candy floss. The light entering the barn thins them down, and makes it impossible to enter into them, renders them literally superficial, pallid, almost sickly.

On my right, there is a light-box, the size of a large table, with a glass top. I use it for sorting the transparencies of Natkin's paintings to decide which will make the best illustrations for the book. Images of images. Each one kept in its own transparent plastic envelope. The transparencies are littered all around me, further than my arms can reach. But Colette is still in bed on the other side of the barn: the blue blanket rises and falls with her breath. Sylvia is sitting up on the pillow beside Colette's head playing with her plastic eggs, grunting, exclaiming. In front of the window, behind the bed, is a row of picture postcards from American art museums. Above and behind them, through the dirty glass, I can see the swollen slope of the hillside field which swoops right down to the barn from the woods. The green grass visible through the window is speckled with stained patches of once-white snow. If I were to stand up, turn round, and look out of the windows behind me on either side of 'Reveries of a Lapsed Narcissist', I would see a lake surrounded by weeping willows. Yesterday, after so much rain, the lake seemed to be turning into a sinister deluge. I had a fantasy that it might suck in the barn and spin it away, with all the transparencies and our possessions floating out behind like something from an underwater version of the opening sequence of *The Wizard of Oz*. So I warned Natkin of flood danger; but he knew the habits of the

lake better than I. Today, there is a bright sun and a definite promise of spring. I feel it in the way the light flickers and filters through the leaves of the trees bringing even these dull pages into a semblance of life.

1975 *Le Châtelet, France*

This morning, I was reading about Serge in his prison: and for lunch, we ate oysters. Life is filled with absurd conjunctures. I could ignore the oysters, but that would be to live another kind of lie, a lie in which books are more real than people and things. Or, worse still, a lie like the self-deceiving prurience of Puritan sectarians.

There is another danger in these creatures, too. The writer, if he is honest, if he is trying to prise open the truth, finds that he lives retrospectively within the present. In fact, he is always trying to eliminate that present. There is a persistent distance between himself and events, even events as simple as that of tasting a mollusc. He does not live through them, but stores the experience of them until he can find the language through which he may feel, know and record what he has already done. The analysand in an analysis interminable rather than terminable faces a similar problem. The analysis which should equip him for life becomes a substitute for it. He lives for the remembrance of events and feelings which can no longer be experienced as such, but only as potential material, or dematerialised ore, for analysis. A process which should make the individual capable of confronting history and acting upon it can thereby come to separate him from it. When all events are after the event, there is no present and therefore no possibility of a future.

These oysters are a Friday food. The fishmonger brings them to the village when people are abstaining from meat. We sit round the table: Colette, her father, her mother and I. Colette's mother gets up and fetches the dish from the kitchen. She puts two short, sharp-pointed, rigid knives on the table. The oysters, tightly clenching their grey shells, are alive. One by one, we murder them into our napkins. Fathers fuse with strong, tugging muscles, yielding in each little drama behind my jamming fingers; the salty, mucus sniff of sea-sex, molly-coddling, each

time bringing back the first time that the tongue tasted, there. Mothers mingle with that swallowing of a living, whole, bitter-sweet, soft dampness, cool down the throat, into the open belly.

I look round the table. Smiles and wrists twisting, snapping. The taut, specific, muscular struggler: the gelatinous, general, limp suffusion. The locked box: the swell of a wide, wide sea. And always the possibility of discovering a pearl. Everyone makes jokes about that. 'If I should find one, what should I do with it? Eat it?' Pleasure and nausea twist together as I skewer the knife tip into that all-signifying hole. Penetrate. Cleave. Separate. Incorporate. A calcareous crash: the indigestible shell smashes onto the plate. I take another. Close to the tang of briny jelly, a whiff, a hint, of oil or sewage. I remember Serge's latrines. I smile. What else can I do with a drop of crimson blood growing into a jewel on the ball of my thumb? I am still searching for an oyster which is an oyster which is an oyster.

1976 *Graham Road, London*

The oysters . . . I'll leave them untouched. They have the distant whiff of what is real about them. Sometimes, on going into a fishmonger's, or even a newsagent's shop, I pick up a tangy scent which brings back all the thrill and claustrophobia of family holidays when I was young. My father would drive us to the coast in a fawn Ford Prefect: I can even remember the registration number, MGO 570. Shells, sea-slugs, the gullible squawks of quarrelling siblings, buckets and spades, and clean white table-cloths in hotel dining-rooms. Those exciting sea-shore shops with piles of comics, 'Holiday Special' quiz books and dangling souvenirs. Lettered rock; dried sea urchins' tests; or tubes of layered, brightly coloured sands. As for the rest . . . Oh, look how they flood every space in this cloistered room. Scratch, scratch. Wave upon wave of wearily surging words.

I pick up the old, slightly yellowing Pelican in my hands. It is in good condition. The person who first bought it probably never read it. And this morning, in my own analysis, now so near to its end – am I really just thinking about my own deep need to keep clinging like a limpet to my analyst, as mother? – I talked to W. about how I found Suttie in the market. There was a relaxed mood, unusually amicable; it reminded me of the way we related to the teachers towards the end of the last term at school. They wanted us to accommodate the idea that their authority, indeed their very presence, was about to wither away from us, for ever.

A kind of parting is approaching. The separated future invades the present. 'Or ever the silver cord be loosed, or the golden bowl be broken.' We always read that at the end of term at Prep school. But with W., there is almost a tenderness now, after all that time, and work, so often hostile, together. And yes, he knew about Suttie . . . He said he had always thought his work was remarkable and in advance of its time. He told me that Suttie upset the analytic community by his 'too harsh critique of Freud'. The sub-title is spelled out on the front cover, above the Pelican's outstretched wings: 'A constructive and original criticism of Freudian psychology as it concerns infancy, sociability, love and sublimation.' W. evidently admired Suttie. Although I had still only flicked over the pages of the book, I felt I knew enough about him to share that admiration. Suttie must have influenced what happened between W. and me.

It's a 1960 edition of an original which was first published in 1935. Dr J. A. Hadfield, who was Director of Studies at the Tavistock Clinic when Ian Suttie was an Assistant Physician there, has written a short introduction. Dr Hadfield explains that Suttie was born in Glasgow, the son of a general practitioner. So am I. During the First World War, Suttie served with the Royal Army Medical Corps. I conjure an image of Stanley Spencer's painting, 'Travoys arriving at a dressing station', with the stately horses pulling the wounded on stretchers, like sledges. In the Second World War, my father served with the Red Cross. For a

time, Suttie was Superintendent at Perth Criminal Lunatic Asylum. The rock and castle of seclusion. Later, he moved to London and worked at the Tavistock Clinic. That is where my analysis with W. began. Suttie died suddenly on the day *The Origins of Love and Hate* first appeared.

I read on. Dr Hadfield explains that Suttie believed that the infant appeared in this world with 'a simple attachment to the mother', the sole source of his food and protection. A new version of the myth of the 'pelican in her piety'. Dr Hadfield agrees with him that the infant mind is not a bundle of 'co-operating and competing instincts'; he says that, rather, it is dominated from the beginning by 'the need to retain the mother – a need which, if thwarted, must produce the utmost extent of terror and rage, since the loss of the mother, under natural conditions, is but the precursor of death itself'.

I feel a strong compulsion to get up from my desk, and to go downstairs and make sure that Colette is still there and Sylvia is all right. But my eyes fall back to the page in front of me.

Dr Hadfield praises Suttie for basing social life on the relation of mother to infant, and he stresses that 'whereas Freud regards this as a sex relation, Suttie regards it . . . as a love relationship'. Dr Hadfield also points out that Suttie's views on religion differ sharply from those of Freud, who saw it as an illusion, *tout court*. But Suttie described religion as 'a therapeutic measure designed to deal with the problem of guilt and dependence by its offer of forgiveness and love'. I think of the wooden pews, the great, bare church, and the weekly epistles from my father which W. returned to me today. Dr Hadfield is saying that he came to very similar conclusions in his own book, *Psychology and Mental Health*. Apparently, he argued there that although religion could take perverse forms, there were 'modes of religion which accord with the fundamental longing for affection and find in the love of a "Heavenly Father", as in the Protestant Faith, the satisfaction of the need for tenderness and affection of which they felt themselves denied in infancy'.

I turn to the back of the book and look at the passport-sized photo of Suttie. Neatly combed hair. An open-necked shirt. The lapels of a sports jacket. The image makes me think of old photographs of my

father when he was a young man in the Boys Brigade. My father, merged with D. W. Winnicott, the great English psychoanalyst, perhaps. They don't look alike. But all English doctors have a presence in common. W. has that, too.

I turn over the pages, devouring the argument. Suttie tries to show that in the infant's relationship to the mother, it isn't the need to satisfy oral, anal, or phallic impulses, nor even the simple desire for food, which is primary. Before these things become possible, the infant needs to establish a social relationship, in effect to love and be loved.

I look up from the page. No wonder I heard about Suttie in John Bowlby or Charles Rycroft. These are the sorts of ideas which the English psychoanalysts 'discovered' in the 1940s and 1950s. They came to see that the infant needs to relate to another person – an 'object' in the psychoanalytic jargon – and not just to pursue instinctual gratification, as it were, in isolation. Since Sylvia's birth that has seemed obvious to me. The Left isn't interested in ideas like that. But it ought to be. I think this is where we can uncover the material basis for the belief, at the heart of the socialist enterprise, that men and women are fundamentally *social* sorts of creature: fully social relationships are part of our 'species-being', to use the phrase that the young Karl Marx borrowed from the German philosopher Ludwig Feuerbach. But modern life has alienated us from that 'species-being'.

Yesterday, I was sitting here at this desk listening to a programme about lambing coming over the radio. A woman reporter was interviewing a woman farmer as they watched the lambs being born. They could not approach too closely, in case they frightened the lamb immediately after it had emerged into the world, and ran away from the ewe before it had suckled. Human infants do not have that choice; they cannot opt even for a momentary flight. The human has to attach itself to the mother (or her substitute), relate to her, or die. Suttie was right when he said that love was not a 'sentiment', but rather a social necessity for the new-born human infant.

I close the book, and lay it down flat on the desk. And I begin to wonder. Suttie's face stares back up at me; his biography is laid out in three inches of type. His weakness is the same as the English

psychoanalysts who followed him. He is silent on the subject of history – the possibility of change in the social and material worlds. He has nothing to say about the ability of men and women to recapture – through the historical process itself – the lost, loving 'essence' of their 'species-being'. W. used to imply that it was just New Left rhetoric when I talked like that. Surging words. But I still think it is because the analysts can only see the individual in his or her present moment that so many of them still hanker after that old opiate, religion.

I think that Suttie, and the 'object relations' school of English analysts – W. R. D. Fairbairn, John Bowlby, Harry Guntrip, D. W. Winnicott, Marion Milner, Marjorie Brierley and Charles Rycroft, especially – have pointed towards the biological and psychological basis for a belief in the necessarily social nature of men and women. And that interests me, too. But I also need historical materialism to show the way in which this alienated social 'essence' can be reconstituted in the world. Marxists are right when they argue this can only come about through a radical transformation of existing *adult* social relations.

Is Sylvia still sleeping, down below?

Psychoanalysis – even the 'object relations' psychoanalysis which has had such an influence on me – is not enough in itself. It cannot touch the historical process. Now my own analysis is over, I feel I want to bring what I learned from it into contact with the making of history: I want to leap out of the shell of my residual narcissism into the full tide of realism.

1978 Redding, Connecticut

It is 11.30 a.m. I am still sitting at the white table in the barn. I have been working through a book by the writer, Michael Crichton, about Jasper Johns, the famous pioneer of American Pop Art. In a few days' time, I will be interviewing Johns for *Art Monthly*. I think that Johns is really a third generation abstract expressionist. By the end of the 1950s, abstract expressionist painting had drained itself of all content; in the early days, the days of the pioneer generation, and of the journal

27

Tiger's Eye, abstract expressionism was at least about the heroic exploration of subjectivity. But it degenerated into paintings about nothing but paintings. That was why Jasper Johns' obsession with given imagery — like maps, numbers and flags — seemed to be so culturally significant. Johns had found a way of re-introducing references to a world outside painting without seriously prejudicing the increasingly empty aesthetic of Tenth Street abstract expressionism. But, as I turn over the pages of the huge monographs about him, I feel that his painting involved no attempt to depict imaginatively his experience; nor do his images convey any convincing grasp over objects or the world . . . It looks to me as if Johns married the evacuated surfaces of thoroughly abstract painting with a repertoire of disconnected, faintly patriotic, but essentially arbitrary signs. Hilton Kramer, the art critic of the *New York Times*, was near enough the mark when he called Johns' painting 'De Kooning plus Duchamp'.

Johns is supposed to be the master of the ineffable paradox, but I am struck by how banal many of his concerns in fact are. His celebrated bronzes, 'The Critic Sees' and 'The Critic Smiles', are really just three-dimensional cartoons. Behind the spectacles, there are lips and mouths where most people have lids and eyes: instead of bristles, the toothbrush has a row of teeth. As drawings for *The New Yorker* or *Punch*, these works might, possibly, have earned a cartoonist a couple of hundred pounds, and have been lost within a week. But now, as High Art, these same weak ideas are treated as fetishes. They have accrued a voluminous, pretentious critical literature, and an astounding accretion of potential exchange-value. Johns' works are currently selling for up to $250,000 each. In what other area of human life could such feeble ideas be so over-priced?

I am determined, eventually, to leave the art world behind. I feel that we are living through the epilogue of the European professional Fine Art tradition — an epilogue in which the content and subject matter of most art is art itself. Art is draining down its own anus.

In Natkin's pictures there is, at least, a commitment to *experience* beyond the experience of art; he works with his materials to serve his imagination, and the area of experience which he explores, I think,

matters. Although some days, like today, I am more aware of his weaknesses than his strengths, of dabs of colour like showers of confetti, and the seductive scent of the boudoir.

Here, in America, many artists seem to talk about the signifier and its properties and qualities as if the signified were a thing of the past – something now eliminated from art altogether. They think that Art's 'legitimate' concern has been reduced to itself: the 'objectness' of the work, an obsession of Johns', is regarded as a sufficient reason for it to exist in the world. I believe that the 'objectness', or 'thingness' of a work of art is necessary; but what matters is the way in which these physical conditions of the work's existence reach out beyond the boundaries of art itself.

I remember seeing a piece a few years ago by an American 'Minimalist' artist, in an exhibition at the Tate Gallery called 'The Art of the Real'. This particular work was entitled 'There's No Reason Not To': it consisted of a coloured slab, leant against the wall. It was only because, after abstract expressionism, art was already set on walking the plank to this blankness that Johns' introduction of 'real' coathangers, beer cans, flags, and so on, could be seen as being of any interest. But the life of all such work is lived out within the narrow constraints of the art world: it just becomes a reflection of its own narcissism. I still have to write my way through, out of, and free from an art which I have *seen through*. I need to create my critical equivalent of Natkin's 'Reveries of a Lapsed Narcissist'.

As I look up from the litter of my reading and writing, I can see Colette through the windows. She is dressed in the brown fur coat which she bought for five pounds from a London junk shop. She walks round the outside of the barn carrying Sylvia in her arms. A small early painting of Natkin's is leaning against the window she is passing, now. It belongs to a series he calls 'Windows'. But the painted image is almost obliterated by the sunlight which is streaming through the real window, flooding the canvas from behind. Yesterday I asked Bob about his fascination for these 'Window' themes in which the centre of the canvas seems to be opened up so that a vista is revealed: he is also attracted to Matisse and Bonnard paintings which work in a similar

way. He replied by asking on what level I meant the question, adding, 'There's the Oedipal thing we've talked about, of course.' But that is not enough. A window which opens onto something else entails the promise of imaginative illusions. It spurns false Modernist notions about the 'necessity of flatness'.

Recently, I saw an exhibition of new paintings by Jules Olitski, one of the most celebrated of the American 'Post-Painterly' abstractionists, at André Emmerich's Gallery in the Fuller Building in Manhattan. I was shocked by the works. Colette could not believe they were serious, either. Their surfaces were like mud, solidified yoghurt, foam mousse, sludge, sprayed polystyrene, or fibre glass: they reminded me of the plastic madonnas you can buy on stalls in The Waste, our flea market in Hackney, for about twenty pence. The introduction to the catalogue began with these words: 'Whereas the nineteenth century artist took us to the window to look at the view, the twentieth century artist takes us to the window to look at the window.' No irony was intended.

I am not even interested in just looking at the view any more. I want to be able to walk through the landscape and to act upon it. As I write these words down, Colette must be standing behind me, with her back to the wall on the other side of which 'Reveries of a Lapsed Narcissist' is hanging. She is probably looking down at the lake. I am here, inside, in front of this circular table.

I have become efficient enough at spotting the contradictions of the art world, and at analysing the crisis affecting 'The Fine Art Tradition'. I know why, despite all this, I still feel it is necessary to defend painting – if only for its unrealised possibilities. Where else could the visual imagination find free expression? But where is that work I can simply affirm in the present? Natkin longs for my acclaim. But although, most days, I do get real pleasure from looking at his canvases, my respect for his project as a painter is pricked by qualifications, doubts and question marks.

I think I begin to see, as through a glass darkly, why John Berger went to live in the mountains of Haute Savoie, leaving this Hall of Mirrors behind. In America, the stench of the art world is even stronger than in England. Every picture here is packaged with the cling-film of

cash. The things which really seem to count for painters are remote from the reasons why I fondly imagine I am interested in art. John Berger used to say that in front of pictures he always asked the question, 'How do these works help men and women to know, and to claim, their social rights?' But what does it mean to ask this of a painting inside André Emmerich's gallery?

One quote from the book about Jasper Johns at least is true: 'The art world works on many levels. Most of them are not publicly acknowledged.' I believe that 'mainstream' museum art has subjected itself to a process theologians describe as 'kenosis' – or a self-willed emptying-out of creative powers. Fine Art has become tragically marginal, in relation to other media which threaten to swamp it. Now that only signifiers, signifying nothing, are left, some critics choose to spend their time shuffling them about in such a way that they can be read 'meaningfully' in terms of the historical development of art. That is what the critics who are called 'formalists' are doing. But I believe that criticism has to become a primary practice – to affirm values which are not present in the works themselves; or it risks becoming nothing at all. To be a critic, today, is rather like being a sports correspondent at a time when players talk incessantly about the games they might play, and display their tactics and strategies, without ever actually playing any. There is nothing to do but to take your standards from the future. I am in search of a concrete present.

1975 Le Châtelet, France

Siesta time. The oysters surge and swell in my stomach. I remember that at this time last year, here in Le Châtelet, I was reading, for review, Alessandra Comini's short monograph, *Schiele in Prison*. Egon Schiele, an Austrian painter born in 1890, was accused of the corruption of young girls, and put in prison in 1912 – the same time that Victor Serge was incarcerated. But they responded to captivity quite differently: Schiele immediately identified himself with his prison. Serge's hero felt that he carried within him 'a crystal sphere' of will, lucidity and freedom which could never be destroyed by the gaol or the gaolers; but

Schiele soon felt himself 'a part of the limy walls made leprous by the misery of mankind'.

I think of the latrines on the far side of the quad at school – not far from the art room. Sometimes, I would sit there, in the darkness, with my trousers round my ankles, thinking about the generations who had left their marks on the walls, and wondering how long my 'sentence' would last.

Schiele was held in prison for only 24 days, and there was a window in his cell, but he began to doubt whether the sun still rolled its 'sparkling giant gold disc in a high arc over the trembling earth'. Serge's hero often came close to despair, but he never submitted to it. He survived through a hope which was always on the point of slipping from him – but the ray of sunlight was enough for him to know that the sun was still rising and setting. Schiele endured imprisonment only by turning his cell into a metaphor, and himself into his fantasy of himself as a mutilated and castrated martyr. Over and over again, he sketched himself as Van Gogh. Schiele was totally imprisoned because, before entering his cell, he had accepted the illusion that he was absolutely free. 'How long have I been a prisoner,' he asks after a few days have passed, 'I, by nature, one of the freest, bound only to the law which is not that of the masses?' But, within his cell, Serge's hero is paradoxically never wholly a prisoner, because he knows himself to be bound by laws which are also those of the masses.

Even so, in their descriptions of personal time within prison, the two men come close to each other. Schiele writes, 'Much, much time – an eternity has gone by. Time is variable in length. Time can linger and time can hurry; it is a concept and varies according to circumstances.' How insensitive I was to put 'only 24 days'! Serge, too, writes,

'The unreality of time is palpable. Each second falls slowly. What a measureless gap from one hour to the next. When you tell yourself in advance that six months – or six years – are to pass like this, you feel the terror of facing an abyss. At the bottom, mists in the darkness . . . Not a single landmark is visible. Months have passed like so many days; entire days pass like minutes. Future time is terrifying. The present is heavy with torpor. Each minute may be

marvellously – or horribly – profound. That depends to a certain extent on yourself. There are swift hours and very long seconds. Past time is void. There is no chronology of events to mark it; external duration no longer exists.

'You know that the days are piling up. You can feel the creeping numbness, the memory of life growing weak. Burial. Each hour is like a shovelful of earth falling noiselessly, softly, on this grave.'

But Serge's imprisonment was never 'timeless'; he did not see it as unrelated to history, even though it separated him from the historical process. In 1911, Serge had been made editor of *Anarchie*, a Parisian publication which served the fragmented anarchist movement. At this time bitter and often violent disputes about theory and practice were constantly breaking out among the various individuals and factions involved in the movement. One day an Italian activist was murdered, and the finger pointed towards an anarchist comrade of a different tendency, one Joseph Bonnot, an 'Individualist'. The incident triggered a wave of desperate violence and suicide by those impatient for social change. Bonnot himself shot down the Chief of the French Sûreté before he was cornered and killed. Serge believed those involved in these acts were insane, and he repudiated them. But he was arrested, tried and eventually imprisoned, because he refused to inform on Bonnot's followers. And so Bonnot's confused attempt to take history into his own hands led to his elimination from it – and to the enforced exile of other militants. Serge's sentence began in 1912 and ended in 1917. One image running through the book is that of the way in which almost imperceptible traces of the convulsions that were sweeping Europe filtered through the walls and bars of the prison. Schiele, too, was put into gaol at the same time for a crime he did not commit. He was released after his hearing, at which the judge publicly burned one of his paintings. But he was humiliated. His father had done the same with one of his drawings when he was a child.

I remember locking myself into my attic bedroom, and refusing to come out until my father had apologised for having called my paintings 'childish daubings'. This, after his fashion, he did.

For Schiele, accusation, imprisonment and trial were externalisations of a conflict which already constituted the internal, psychological

'reality' of his mind. He did not look for ways in which parts of himself might escape. He seemed uninterested in hope.

But Serge's prisoner is like Roland Barthes' mythologist, 'excluded from this history in the name of which he professes to act'. Both these imprisonments are metaphors for me. I would like to follow Serge's example, but I know that it is Schiele's which I usually take after. I do not want to depict myself as a martyr within a shell: but how do you touch upon those events from which you are excluded?

In my bowels, I feel pangs from the oysters.

An image keeps coming back to me in which I see the revolutionary intellectual as a child with his nose pressed close to the window, watching with contempt the cocktail party within, as servants silently float trays from one guest to another. The child cannot affect events. He would not be listened to if he spoke. He may fantasise about throwing a brick through the window, but he knows what will happen if he does so. When I am in London, I live effectively as an exile. As a radical intellectual, I am always at the margins, on the outside, looking in. It is hard enough to bear that position when I can move freely. But to have done so in prison . . .

1976 Graham Road, London

A martyr within a shell. I did not yet know it, but molluscs, crustaceans, echinoderms, amphibians, sea and slimy creatures, quickly came to crunch, slip and slide through the mythology of my year. Since last June, I have circled round and round the urchin's test: time after time, I have tried to complete a story based on its imbedded, up-turned, five-pointed, familial star.

As I put that full stop at the end of the sentence, I can hear the axolotl stirring its water with its enormous tail. Sometimes, its underbelly gets covered with a swan's-down-textured white fungus, when it has to be dosed. Only this morning, Tom, the little boy who lives with his parents downstairs, was brought up here to visit the creature. All those who see it are fascinated and repelled. Some draw back in disgust from the sight of this inert, vertebrate turd, with legs

barely stronger than its external gills; others try to stroke the slippery sides of its primordial body with their stiffened forefingers. I do not make a note of the food it eats. Here, in Graham Road, the axolotl is no longer a pampered beast. Its life expectancy must have fallen.

1977 *Graham Road, London*

All my other writing is rubbed, worn, overworked. What is written down here seems raw and unsorted, dumped from a brain tip, not thought through. Often, it feels so far from the persons, objects, and events I am trying to reach through words that I feel I should cross them out, immediately. By the time this is read by others, I will, at least, have lightly polished it. Occasionally, I still have a strong compulsion to run a duster over the tips of my black leather shoes, although everything else I am wearing tends to be tatty and scruffy. I'll re-work all this in that sort of way.

I have been reading another old Penguin, Siegfried Sassoon's *Sherston's Progress*. Just before Sylvia was born, last year, I became interested in the literature of the First World War. All those public school boys, fresh from the playing fields, thrown immediately into the mud and blood of history. I took Robert Graves' *Goodbye to All That* into hospital with me when I went to have my wisdom teeth drawn. And Sassoon has been filling the idle moments of this week. I wonder if he and Suttie ever met.

Sassoon describes a journey he made from Egypt back towards the French front, as a 'reformed' pacifist returning to fight the war after a period of treatment by an analytically orientated army psychiatrist, called Dr W. H. Rivers. Despite where he is going, Sherston is affected by the feeling of a hopeful spring which pervades the whole landscape. Last night, lying next to Colette, in bed, I fell asleep, leaving Sassoon somewhere in the Holy Land, in March. This morning, on the bus on the way in to my analysis in Harley Street, I read:

'March 28. Late afternoon. Quiet and warm. Frogs croaking in the wet ground up the wadi . . . On my way home from a walk, a gazelle got up and fled uphill among the boulders; stood quite still about 500 yards away, watching me. Then trotted quietly away. A free creature . . . I look down on the dim olive-trees where the terraces wind and climb – wild labyrinth gardens. Huge headstones, slabs and crags glimmer anciently in the clouded moonlight, like the tombs of giants, heaved and tilted sideways. Some are like enormous well-heads; others are cleft and piled to form narrow caves. Ghosts might inhabit them. But they are older than men, older than wars. They are as man first found them. Now they are ramparts of rock tufted with flowers, tangled with clematis and honeysuckle and briar. Thus I describe my sense of peace and freedom. And as I finish writing, someone comes excitedly into the tent with the latest news from France.'

I have copied out this passage, here in my study, with Ian Suttie's face looking up at me. I can hear Colette moving in the kitchen downstairs. How would I have coped, if, with the mud still damp between the studs of my rugger boots, I had been dropped into Sassoon's position? I listen for a few seconds to the heavy traffic, blurring the London silence, and imagine a huge convoy of troops, rockets and tanks passing along the street outside.

Sassoon goes on:

'The bulletins are getting steadily worse. Names which mean nothing to the others make me aware that the Germans have recaptured all the ground gained in the Somme battles.'

Anyone reading all this is bound to think I picked out Sassoon's 'March 28th' piece as a contrivance. But it fell out that way. Chance. Fate. The ghosts of the Somme. I remember those endless rows of white crosses in France when we drove back with John two years ago, my head still full of Serge. There was a bright sun. He stopped the car. He told me his father had fought there. France. Real struggles, futility and mire. After all, Siegfried Sassoon chose consciously to participate in the making of history, as an officer and a gentleman. A fox-hunting man. I told W. this morning that I was impressed by Sassoon's sense of elation at leaving Dr Rivers, and returning, one March 28th, to the actual struggle. All this feels shot through with life and literature parallels from this journal, last year, and the year before. A free creature . . .?

36

Illuminating contingencies, like flashes, crackling connections or jumping-jacks, thrown into the crowd, sparking across the day, dancing like red-hot schwarf spun out by the uneven motion of the historical machine. I too have a sort of 'sense of peace' with the approach of the end of analysis, and the return to the front line of a life, pricked and penetrated by the brutality of external events.

I stay here seated at my desk and gaze through the window. A spring day, but a cold, sharp one. A deep frost this morning; a steely, bright sun. Sharp, uncoiled, suddenly. Now flakes of snow, spun round into a vortex. The cold sun goes on shining between the thick clouds, grey on their undersides, white on top: sky trout, swimming upside down. Patches of pure Brighton-beach summer blue show through between them. The great tree, over the road, behind and above the block of flats, is leafing. As I look down to write, the sun suddenly bursts through, forcefully, dazzling me and throwing dark shadows across my notebook, glancing off every reflective surface in this part of my room. It is so bright now I cannot raise my eyes to the clouds. The sun dims, flares, and dims again as the clouds heap up in front of it. The flickering spiral of snow stops. The interminable convoy is still thundering along the road outside, on its way to the Blackwall tunnel. And now the voices of the school-children, gathered round the bus stop, waiting to go home for their lunches, prick and squeak through the grind of tyres and the hiss of pistons and air-brakes. Am I, perhaps, projecting pathetic fallacies into those nimble, columbine clouds?

1978 Redding, Connecticut

I sit back, and push the Jasper Johns material away from me. In my mind there is a plastic memory, an image of Imogen: Imogen, naked, standing by the edge of the bed after intimacy, turned away from me, holding a garment or a towel. Like a Degas lithograph, or a Bonnard painting, perhaps ... I do not reject the image but focus it until memory sharpens into desire. I have conjured this moment, often. Now it exists again for me in the present, formed out of detached fragments

of appearances past, and all intermediate memories of memories of mirroring memories, embellished and completed by imagination's editing. Imogen: worthy to be looked at. Even though rolling oceans and tempestuous years divide and separate us. Only last night, Bob Natkin described his fascination with windows as *gazing*: he spoke of a leering monkey who stares at a naked woman in a Gauguin picture, and of a recurrent image of stone winged lions outside an illuminated city, their eyes fixed, their gaunt loins crumbling, crumbling . . .

Everything changes; some images remain, still. When Colette gave birth to Sylvia, I experienced a sinking back into the sensuous world. A taste of the real. Some time since that long, bloody day in St Bartholomew's Hospital, did I step back again? Has the glass screen descended? As a child, I kept pet mice. One day, the pane of glass at the front of the cage descended too fast – and decapitated one of them. I, too, was mortified. I buried the remains and tried, unsuccessfully, to forget the whole incident. Bob Natkin talks about sensual and hedonistic painters: Matisse, Bonnard, Klee, Vuillard. His own work belongs in there somewhere, too. But they are still only painters! Pigment is so cold, cooler, even, than Madame Bonnard. Painted light cannot dissolve the living darkness. At Sylvia's birth, body, blood, bones, being, entire unto itself. Whole. Intact. Alive. Not images, ideas, fantasies and paintings. I swore I would abandon art criticism. But now that moment, too, is a thin, elusive film of memory, head gossamer, and Colette and Sylvia are still somewhere else, just a few feet away, on the other side of the barn wall.

1975 Le Châtelet, France

The long French siesta draws on. Behind the closed shutters, the house is cool and still. Colette's father will soon get up, and go down to work in the post office again. Stretched out on the bed, I begin to forget about Serge. I remember a dream which I had last night. As I dreamed it, I experienced it completely and unquestioningly, although even now I do not understand it. Within the dream itself, of course, I did not feel there *was* anything to understand. Interpretation, analysis and record-

ing are separate from the dream-event; they take place outside the dream's own space. They must come after the event. Inside the dream, understanding, or analysis, cannot be used as a wedge to force a space between oneself and that which is being experienced.

I was in a gallery, an art gallery, with Colette. I noticed Clive Barker, one of the younger Pop sculptors, standing near the wall, talking about his new work. I was typing with the 'Brother Deluxe 900' portable machine, which I have brought with us to France and on which I have been writing up this journal. Colette walked over to him and he lifted a large lock of her hair which, in the dream, was black. I carried on ruminating about whether he wanted me to write an article about his work. Then the three of us were sitting round a table. Someone raised the question directly, and I was surprised, hurt, but also relieved to hear that he did not want his work criticised at all. He said this was because he was a 'Showman'. He had to repeat the word twice before I understood it, and it sounded quite different each time.

Outside the dream-time, Clive Barker is indeed a sculptor, whom I know. Not long ago, I wrote a short review of an exhibition of his and, after that, we saw each other again. That was the first meeting for several years. In 1969, he asked me to draft a catalogue statement for him and when, in return, he offered me one of his sculptures as a gift, I was naïve and foolish enough to accept. Worse still, I sold the piece soon after when I needed money to go abroad. Both my actions embarrass me whenever I remember them: accepting the work in the first place, selling it in the second. But they do not cancel each other out. They compound themselves. Once, in analysis, I told W. that this incident involved the only things I had ever done which I entirely regretted, which I quite simply would rather that I had not done.

Barker himself was generous about the whole business, and said he was not upset by what had happened. Indeed, recently he wanted me to go to his studio to see his new work, and he really did ask me if I would be interested in writing something about it again. But it has proved almost impossible for me to get to see what he is doing. First his mother was ill, and then he went away to Paris. When he got back, he rang one of the magazines for which I write, but I did not return the call. I knew

that whatever had interested me in his work was fading. Weeks later, I sent him a post card. He did not reply. And now I am in France.

He makes chrome-plated casts of everyday objects, transient things like Coca-Cola bottles, balls of string and false teeth which somehow seem to be catapulted outside time through his chromidas touch. They become fixed, bijou, *objets d'art*, whose polished, reflective surfaces seem to deny the fact that they are physical things, with solid insides. They become all shining surfaces, superficial through and through.

Once Barker made a whole series based on turning details from art images into these ambiguous things. Magritte's sandal feet and Van Gogh's chair, fully realised in gleaming metal. He even made a set of paint tubes and brushes, cast and gold-plated. Three-dimensional reflections of painted images of fantasies and things. Now his sculptures are more like works by the famous German photo-montage artist, John Heartfield; Barker solidifies images of the debris of war, and renders them permanent. But everything he makes remains isolated, precious, fetishised; his objects remind me of the lifeless and repeated obsessions of the neurotic. I know them well. I cannot interpret my dream. But I can recognise that like the prisoners, and the oysters, Barker's objects all relate to a particular distortion of the experience of time, to what happens when you get enclosed. Inside the prison, a tiny irritant or stimulus becomes a fixed image, like a chrome-plated thumb, or a pearl.

I also know that last night, just before I fell asleep, I was struggling with ideas about the difference between form and substance. Some critics assume that 'aesthetic' form is an actual, physical quality of material objects, real things. But this must be wrong. Form, in its 'aesthetic' sense, only comes into being at all when someone, with a conscious mind, starts to look at an object. Form really belongs to the image to which objects give rise in the mind of a viewer, and not to the objects themselves. A sculpture can have no 'aesthetic' form at all if there is no eye to perceive it – even though, of course, it would continue to possess weight, shape, matter and substance in a world from which all human beings had vanished. But since 'aesthetic' form can only be realised through the eyes, in perception, it is a very variable thing. The

self-same object will have a different 'aesthetic' form depending on who is looking at it, and when or where they are doing so. Anyway, I tried to write a poem about all this before I went to sleep. But it was a failure and I abandoned it, unfinished, before surrendering myself to my sculptural dreams:

> Come close! Touch this shattered marble torso
> With the soft pores at the tip of your tongue.
> Move smoothly over the cool, polished back.
> Lick the rough lumps where the head cracked away;
> Find the abrasions, the scratches and clefts
> Scattered by time through the belly's hard folds.
> Suck and know the fact of its being.
> Your taste tells you that these things are its own.
> History's traces dug in its substance.
> If form has such a palpable presence,
> Speak when your saliva drips upon it.

I know that when I woke up, I was thinking about a rather slight piece of sculpture by Rodin. I remembered that one critic had written of this white work, 'the smooth marble of the woman's body contrasts with the roughness of the unhewn rock.' When I first read this, it seemed such a simple, self-evident statement that I accepted it, almost without thinking. But later, when looking at a photographic reproduction of the sculpture, it occurred to me that really what that critic had written was only a manner of speaking, a shorthand, which, if taken literally, led inevitably to the great lie of all idealist criticism. Because, when you think about it, you realise that the smoothness of one piece of rough, inert stone, and the roughness of another, cannot really be linked together with a verb like 'contrasts'. The relationship between these two qualities, the 'aesthetic' contrast, only arises in the context of *sight* – of which *both* the smoothness and the roughness are objects. The eye perceives the formal contrast, and makes the relationship; in the absence, or blindness, of the eye that relationship does not exist, *as form*. There is a kind of criticism which tries to argue that such relationships really do exist in the materials of the sculpture: that

is what I mean by 'formalist' criticism, which always ends up as idealism. A 'formalist' critic will always say that he is examining the material qualities of art objects — but in fact he is just describing phenomena which only come into existence within his own very particular consciousness.

1976 Graham Road, London

I have been writing all day long. An orange sun is dropping, like a literary cliché, against a grey Hackney skyline. I begin to see why I started this day, today, a year ago, with images of imprisonment. I thought then that I was beginning to understand, or rather to reach beyond understanding, through yet more understanding, into sensuous being. I believed I was unravelling the cloying layers of meaning and association so that objects — things, people, and even slippery creatures — might reveal themselves to me in and for themselves. I sought for the reality behind the cocoon of appearances. But I found that it remained enmeshed, unreachable, ever more distant. A sea of drifting images: dolphin-torn, gong-tormented, always leading back again. Oceans of used signs and shifting symbols. The horror is that I am locked, like a prisoner, in *this* shell, *this* cell, *this* armoured circle of time, and no other. I can only ever see the world from a point somewhere behind *these* eyes; I can only ever know it filtered, mediated and distorted through the gills of this my claustrophobic, indestructible history.

1977 Graham Road, London

On the top of the bus, on the way back from analysis this morning, I found that I was thinking about a passage from a book by Otto Rank, one of Freud's first disciples. This made a great impression on me when I read it last autumn. Rank says that the end of analysis resembles — no, more than resembles, *reproduces* — the primal birth experience. As the bus passed the church in Euston, where all the caryatids hold up their stony load, I found I was remembering how sometimes, in a session with W., a thought would occur to me which I would refuse to put into

words more out of a sense of embarrassment than from any deep desire to repress or suppress it. Similarly, a part of myself wanted to forget or to obliterate this memory about Rank. The problem was that I came to the view that Rank was intellectually cranky – a sham, in fact. And yet, as I went by King's Cross, I ruminated on the fact that there was a kernel, a foetal coil of truth in what he said. It is as if, for the last ten days or so with W., I have been recuperating in hospital after a difficult birth (rebirth?) waiting to go out after the Second Stage struggle to re-join the world. As a mother to my new-born self? Is that what all these thoughts concerning Ian Suttie and Siegfried Sassoon are about? Born again. A new man. Half-free, at least.

One of the books I bought in the market last Saturday, along with *The Origins of Love and Hate*, was a soiled volume about the life of the unborn child which contained a page of drawings of strange births. I take it down from the shelf and turn the pages until I get there: a double cleft lip; a split palate combined with unilateral hare-lip; cyclopia – a foetus with a single, median eye, joined to a snout-like nose sprouting out from the centre of the forehead; failure of the ears to migrate up on the side of the head so that they hang like purses from the jawless chin in which the mouth is a sixpenny-sized hole.

All this reminds me of K., who fathered forth a monstrous birth. Why have I felt almost ashamed to contact him since then? Why did I burst into tears when I recounted this incident in analysis? These drawings are so crude, and yet they are chilling in their explicit and clinical directness. This would not be something to gaze upon in a pregnancy. Colette and I stared at this book together when I brought it back. But our labours now are over. Sylvia is here, and whole. It is a year or so since she was conceived: then I was more cynical. On Friday, we will fly out to do peaceful battle in France. This Easter, at least, we know that we did not produce monsters.

Analysis: W. and I did not fail. Those four years and five months were not wasted. The centre should hold, even if the clouds come over again. And they might. I could find myself inside the hermetic goldfish bowl again; worse still, the mirrored dome could shut tight round. But this

time, it could not be the same. I would know there was something else beyond: a material, concrete, sensuous, *reachable* world. And that, for me, is a rare knowledge. There are those who know this simply because they have never asked questions. I feel I have had to probe. I remember how after one year of analysis, with my symptoms dropping like dry scales, I wondered what we had left to do. But we were just beginning. Freud 'explained' nothing: all he did was to point towards a small door which led into an infinitely complex maze of illusions, at the far side of which was the world, peeled of its allusive and illusive meanings, revealed in its concrete, separate thatness. Analysis was just the curtain cord for a materialist perception of the world . . . and then comes the realisation that this perception, too, is an illusion, even if the best available, the closest to things as they are. My eye moves away from the monsters, back to the black-and-white image of Ian Suttie. It was a tragedy that he, and so many of the British analysts, lapsed back into sentimentality, or religion, again. About that, Freud was certainly right, and Suttie wrong.

1978 *Redding, Connecticut*

As I sit here in the barn, glancing through these window panes and thinking about Colette out there, I remember how, last week, tramping across New York's streets and down its long avenues, dazzled by the way in which, over and over again, intimate interiors seemed to have been thinned out and ironed flat to form a skin or gleaming surface, I reached Times Square. There, among the plastic glitter, neon sleaze, stained glamour, and peeling, high-rise, winking imagery, crawled tiny, lonely people, like myself, just vermin in this seething, electrical dream of gigantic paper limbs, torsos, faces and twinkling breasts.

Alone, I walked into a sex shop where appearances were sold. In the front stretched racks of books and magazines: images of glands, swollen like bulbs, straining behind cellophane. Each with its own price-tag. Labia opening like chrysanthemums in seed merchants' catalogues. Beyond these were two rows of fifteen tiny booths, each showing different pornographic movies. Stuck on the door of every one

were stills, and a description in words, of what could be seen inside. Most rotated around a surgically sadistic assault: anal rape, enemas, urination, necrophilia, multiple copulation, every orifice splayed, gleaming and gaping, buggery with pigs and ponies, grunting dogs. A haze of odorous disinfectant mingling with the scent of stale bodily excreta and dried semen hung in the air, insisting that those who gazed lived in fleshy bodies which violated the filmy, thin flatness, so clean, cold and dead, of their flickering, immaterial objects. Each booth seemed now like a confessional, now a lavatory. I chose one. A small projector threw a jerking, moving image onto the back of the door when I dropped a quarter into a slot in a machine on the wall.

A girl swinging a bag walks into a field, awkwardly conscious of the unseen camera, with a scruffy mongrel dog scampering beside her. Just like someone else's home movie about a day in the country. She spreads a blanket on the ground, takes off all her clothes, and lies down sun-bathing. The film fades: a quarter falls. The dog, agitated, probes between her closed legs with its nose and tongue. The camera focuses in on the woman's face: she is imitating sexual pleasure. The film fades: a quarter falls. The woman kneels on all fours, doggie fashion, and the dog licks her anus and vagina. The field fades: a quarter falls. The woman stoops over the panting dog, separates its black-and-white furry legs and masturbates its crimson penis.

Inside me, the Burger King I had eaten for lunch jumped from my stomach into my throat. I began to retch. The evil stench of the place seemed to fill my lungs. I was momentarily certain I was going to vomit onto the floor. What possible excuse did I have for being there? I had an image of myself at the end of a chain of exploitation and alienation: a man, alone in a box, watching a film of a woman 'making love' to a dog.

Outside the booth, other men with solemn faces, cripples, business executives, tourists, freaks, adolescents, hustlers, beggars, police, most with their hands in their pockets, all walking silently up and down, each avoiding the gaze of another, looking for images.

Beyond the booths, a man sat behind a desk, changing dollar bills into quarter coins. A microphone was poised in front of him. 'Live on

stage! Check it out! Check it out!' he shouted. 'She has the biggest ass you ever saw! Check it out! Check it out!' Beside him was a 'Peep Show'. This consisted of a room within a room, like a cage, to the outside of which cubicles were attached. Flashing red lights indicated whether or not a given cubicle was empty. I chose one, entered, and locked the door behind me. When I dropped a quarter into a slot, a blind automatically raised. I found myself staring into the cage. Inside, a naked girl moved from window to window, displaying now her genitals, now her breasts, now her buttocks. Above the level of the windows, a film of a couple copulating was projected. After two minutes, the blind snapped down mechanically.

Next to this 'Peep Show' stood another booth in which the customer could enter into a 'one-on-one' encounter with a girl who would undress for him for a dollar, on the other side of a large pane of glass, as he spoke to her through a telephone. A notice said this was, 'Something new in New York'. The door of the cubicle was open, and I could see the woman, probably a Puerto Rican, with crimson lips, standing behind the glass in flashy night-clothes, waiting to take them off when someone dropped the money into a slot and lifted the receiver.

Out here in the country, all that seems so absurd. I am disgusted by the very memory of the displays, and yet I cannot deny the urgent fascination they held for me. That woman behind her sheet of glass, appearing nude for unknown men at the drop of four coins. Imagine sexuality, the fumbling search for the other, becoming this sort of travesty in the life of any other species. Nothing could be *less* bestial. Only in New York, and other 'advanced' capitalist cities, could the social activity of sexual communion be transformed into this frozen, separated, sale and purchase of appearances, mediated by mechanical shutters.

But my intense curiosity related to my personal symbols, too. Sometimes, as a small boy, it seemed that everyone alive confronted the other from behind a stiff, transparent screen of rules, rituals and regulations. Only the eye could pass; I could not touch or feel. And even the eye was shut out by the cold, resistant surfaces of things.

46

Colette is still out there somewhere beyond those walls and windows.

My earliest memory is of being taken to a hospital to see my mother after the birth of my younger brother. I was about two years old, and I was not allowed to enter the room where she lay. A nurse lifted me up, and I looked in through a window in the door. The nurse kept smiling with kindly professionalism at me. She nudged me gently and pointed towards a cot where I glimpsed a well-wrapped red face, wrinkled and crying: my brother. But I quickly fixed my eyes on my mother and stared solemnly at her. She waved at me, and pointed towards the white bundle again. But I steadfastly gazed into her face. Then I was put down on the floor beside my elder sister and we were led out of the hospital to a car.

I know this memory charged many incidents and images for me later on. I remember myself on my fifth birthday, talking to my mother through the half-opened kitchen window as I sat on a tricycle in the back garden: it is the sort of 'impossible' screen memory which contains a distinct visual image of oneself, as if 'seen' by an independent observer. I also remember a whore sliding back a shutter in a door and opening her crimson, painted lips to tell me to go away. I have always sought out the appearance which can be separated and detached from the other through the blade of the eyes, and incorporated painlessly into the self: art criticism. I have an over-retentive memory, which stacks everything like a pile of plastic transparencies. Analysis was an attempt to shatter those sheets of glass, to break through the narcissistic veil, to find a way of touching and tasting and feeling *real*. Perhaps that is why art and its pleasures are paling. Memories of a lapsed narcissist. I don't even respond when a painter like Jasper Johns insists on the *objectness* of his images. Am I on the verge of journeying out over scattered, shattered, glinting fragments?

1975 Le Châtelet, France

After our siesta, Colette and I went on a walk, a walk we had made on each of our previous visits to Le Châtelet, up to a fine nineteenth-

century château outside the village. The road was full of signs which signalled layers of my past history. That notice, over there, declaring '*Propriété Privée*', do you remember how, just a year ago, I childishly defaced it, and how, when we were here again last summer, we looked to see if they had removed the added words, '*est le vol*'? And, of course, they had. That tree there was one which Colette's father freed of ivy two years ago; he chopped the creeping tendrils back at their roots. Now it is the only one rid of the clinging parasite. And here, where the gate opens on to a field of white cattle, here we sat, you and I, and talked about whether . . . Even the streams and rivers are full of shreds of our memories, and if we came again, they would be fuller. We would then remember this walk, too, and what we said, thought, felt, saw and did. We litter the landscape with ineradicable traces, all of us, and each one distinctly. We alone can read our signs: the teeming minutiae of events each has its little memorial. Time passes. At first, the château looks the same as it did last summer. But long and heavy months have clawed, rubbed and cut their graffiti into the fabric. Serge's and Schiele's walls. We are not imprisoned. Yet within, and without, time passes, scars and scratches, eating into ever more worn and worried surfaces. Inside, events must seem intransigent and indestructible. Our 'free' present grows ever more cluttered. Objects recede behind a veil of lived subjectivity. Perhaps only the child can find them: once.

1976 Graham Road, London

At that moment in his short life, poor Schiele was but a step away from Genet, who saw his cell as a hermetic capsule within which he could masturbate before images of Our Lady of the Flowers.

1977 Graham Road, London

My thoughts about analysis are broken by the sound of knocking at the front door, downstairs. I get up from my desk, but Colette has reached the hall before me. Dr G. has come over from St Bartholomew's Hospital, to take samples of her blood and breast milk for a survey he is

48

doing into the effects of contraceptive pills on lactation. Colette agreed to be one of his control sample. Dr G. sympathises with us about Barts' obstetric procedures. At one point, he was encouraging me to write something about what happened. I feel almost guilty that I haven't, so I don't go and greet him. I sit down again at my desk. I must do some *real* work today. I find my place in Eugen Weber's massive book, *Peasants into Frenchmen: the Modernisation of Rural France, 1870–1914*. John Berger bought the book when he was over here, and lent it to me. What will he think about the light pencil markings I have left littered through the text? They are hardly likely to be the passages he would have underlined. This is background study for the work we are doing together on Ferdinand Cheval, a French rural postman, who built a *Palais Idéal* from the stones he harvested in baskets on his daily rounds. Colette and I visited the *Palais* at Hauterives, in the Drôme, in the summer of 1975, and again to carry out my 'research', last year. Cheval laboured stubbornly for 33 years to make his monument. Now, covered with weeds and people, it looks more like living tissue, or a coral reef, than a space enclosed by walls. It seems as if it has just grown and accreted there. Cheval adorned the strange fabric with models of the world's great buildings and wonders which he had seen in illustrated magazines. He also made scores of little inscriptions proclaiming his stoic philosophy. Colette took a photograph of me lying on a wood-pile not far from the *Palais*, smoking my pipe. The Surrealists made a cult of Cheval, but the text which Berger and I are producing together will argue that Cheval was a peasant who nevertheless found a way of realising his image of the world, within the world. For Cheval, even buildings subscribed to the model of growth. I am drafting the first version of our text. It won't write easily. In analysis, W. and I have often talked about how I fear 'The Merger with Berger'. But this time, I must see my way through to a conclusion. I can't accrete a book in the way Cheval built his *Palais*.

Surely, I am nearly there. Our labours, now, are ended: almost. This is a good time for tying up, cutting cords, making two out of one. A jumble of clichés, jostling like fossil sponges in the basket of my head. Material, matter, mater. The comforting surround of the actual world.

D. W. Winnicott's facilitating environment. A fantastic, ideal space, where utopia grows at the ends of one's fingers and tongue. An open mystery. A tough and physical interior, contracting in spasms. Great quakes of the whole earth, and the contents of the womb, yielding, yielding. No wonder I have so often stumbled in my attempts to finish this draft. It is heavy ground: tough going, hard labour, stone-breaking. Those prisoners, again. On a sundial overlooking the most spectacular view of the *Palais*, Ferdinand Cheval inscribed the words, '*Ce n'est pas le temps qui passe, mais nous.*'

I can hear Colette showing Dr G. to the door. I think about the rows of little white and red samples in his case.

1978 *Redding, Connecticut*

It is now almost exactly a year since the end of my analysis. I have brought parts of my journal with me here to America. I pull them out, and quickly read through what I wrote on March 28th 1975, March 28th 1976, and March 28th 1977. Three years ago, I was flooded by that pious confidence that preceded the most violent phase of my analysis, the eruption from the deepest and most primitive layers of my personality of the furious energy of a 'high psychosis'. Two years ago, I was pricked by a kind of self-cynicism as my internal calendar repeated itself. But this was also before Colette and I conceived of Sylvia and before I discovered, however transiently, through Imogen, that another could be actual, palpable, for me. A year ago, I felt good: the landscape was becoming not just a view, something worthy to be looked at, but a glove that fitted closely. Today, I can say that a year better than any other I can remember has passed. But I still feel this window pane between myself and the world, between myself and others. It seems to be made of a regenerative glass which repairs any chinks in itself immediately. How far has it been made by forces quite outside myself? How far does it just fill the distorting frame of my own psychology? Or is it, perhaps, just part of the legacy of being human, of the biology of our species? I cannot accept we are necessarily doomed each to the smooth, reflective dome of an individual consciousness which we can

never shatter and transcend. I have noticed how sometimes I feel the transparent barrier is flat, like a sheet, and at others round, like a breast or a cranium. Panes and globes.

I was right to opt for *realism* in art, and materialism in my thinking, but there is an irony that these choices led me to love Natkin's paintings, and to refuse the distorted fictions of 'Socialist Realism'. I find myself thinking of Derek Hirst, a British painter of beautiful, abstract arches, who has survived a near-fatal cancer. Recently, he wrote to me, 'Before, I used to say that painting was a matter of life and death to me. Perhaps I had to say that to continue working, but *it was not true*. Life is more important than pictures. Even so, I have come to see that the appearance of reality, from which we drew our pictures, is itself just another illusion. Sometimes, I despair.'

I am haunted by images of caged animals, great bears prowling at the base of some imaginary Mappin Terrace, tiny creatures scratching on the glass in some darkened, twilight world. For a long time the lemur imagines that the painted landscape on the side of his cage is the jungle: he accepts his inability to enter it as part of his experience of it. One day, a crack appears in the coloured cement, daylight glints in the night, and he *sees through* the sham. Gradually, the crack widens, and eventually he squeezes through and breaks out, not into the jungle, but into the Small Mammal House.

Probably it is worse here in America. Almost everyone seems to exist at the centre of a sealed and impervious globe of individualism; the only taboo is any sort of belief in social or collective action. The artist sees his task solely as the discovery of forms for his particular, specific, and subjective experiences. Among intellectuals, the literature of existentialism is far better known than the traditions and theories of socialism. I get so angry with Natkin because, in the end, his vision of socialism does not extend beyond a nostalgic yearning for a perfected relationship with his late mother.

It is strange: I do not look upon my writing about art as 'real' writing any more than I can conceive of my reading about art as 'real' reading, or my experience of pictures as 'real' experiences. Where are the winged beasts and angelic choirs in Hackney or downtown Manhattan?

And yet my involvement with art, and its images, constitutes what I do in terms of my work — my productive and social life. A lot of my writing is just a secondary practice, an adjunct to the image-making of others. Here, in this barn, I almost despair: the problem now is almost exactly the same as it was three years ago — to find a way of writing about people, objects, things, and the social and material worlds, *directly*.

1975 *Le Châtelet, France*

Consciousness is like a miner's helmet lamp: I turn it on to different people, events, objects, books, memories and dreams. So much in the course of a day, from the pain shooting under my shoulder blades, to Serge and Schiele in their prisons. I must try to make sense — a whole, a totality — out of all these fragments, these scraps which are partially revealed by the beam. And all the time, I have a feeling of the round world turning, remorselessly, of events taking place outside of myself: that is, of history. The lamp does not seem to be enough.

The papers are full of stories about Saudi Arabia following the assassination of King Faisal. Not much has been discovered about the killer himself. He has been described as being 'sane' enough to be condemned to death through public execution and yet, at lunchtime, as Colette's mother put the grey oysters down on the table, the newscaster said that the attack had been 'an isolated act of madness' and that no foreign power appeared to have been involved. The assassin was described as a cousin of the king, a student at an American university known to have experimented with LSD. In the newspaper photographs, he has afro hair and startled, blank, gazing eyes.

I find I am fantasising that through this act, this sudden chopping down of the feudal king, he was seeking a desperate way of reuniting himself with history, of leaping, even at the cost of his own life, across that gulf which, for him, must be even greater than it is for us. Of course, it was futile: a rhetorical gesture. Even through the brief news reports, I can see the regime folding in on itself, closing its ranks, and sprouting a new absolute monarch to carry on, literally, from the point

at which the old king fell dead. But I feel I can still understand the assassin's action; for, in a single instant, an act of self-destruction as much as of attack, his life becomes welded and fused with the forces of history. In that disintegrative flash which is everything, and yet nothing, the whole self stands exposed without reservation, all qualifications torn away: its definitive position is revealed and made clear. The beam of light issuing from the head isolates a moment within the foaming historical torrent, and acts upon it; the self thereby realises and shatters itself simultaneously. The wheels of oppression will run on in Saudi Arabia in almost the same way: but, for all that, they will no longer be exactly the same.

1976 Graham Road, London

I did not realise that mind-forged manacles can clamp even tighter. The escape from them: that is truly *impossible*.

1977 Graham Road, London

After lunch: I didn't get very far with my reading of Eugen Weber. I am feeling restless, pricked by inexplicable urgencies; I jump from one thing to another. The sun flashes in bright sheets of light, skating off grey Hackney roofs. It is only half an hour or so since that miniature snowstorm which came down out of the sky like a spinning-top. The weather seems as changeable as the moods inside my head. But the landscape knows that winter is over. The sombre clouds and last late flurries of snow-flakes realise that they must soon lose out to the still cold sun, whose rays will soon coax and tickle the earth and the trees into intimate, seasonal life. Pathetic fallacies!

I pick up the notes I made on March 28th 1975 and March 28th 1976. One and two years ago. It is evident, reading all this through, that one of the meanings Victor Serge's text had for me was psychological, though I could hardly say it was unconscious. I too have fought for an 'impossible' escape and, perhaps, having come within sight of the end

of the tunnel beneath at least the innermost prison wall, I can now begin to make a run towards history. I use that word much too loosely. I should say, perhaps I can now begin to recognise the forces of history traversing my time, and to occupy them more accurately, more exactly. Two years ago, even if I thought I was free, I was only at the beginning of the tunnel. As a matter of fact, it was more like a rebirth canal rather than an escape passage to history.

I am not in a real prison: the 'crystal sphere' is, for me, not so much a matter of self-protection as of narcissism. You could say that, in real prisons, those behind the spheres are 'realists' – that's the difference. Serge was in a cell. History roared outside. In the same chronological moment, Sassoon was a company commander moving back with his battalion towards the front after he had made a conscious decision to repudiate pacifism. Two different positions: the anarchic revolutionary, and 'an officer and a gentleman' – in each of their particular circumstances, two realisms.

Perhaps I have freed myself from my internal prison. I am standing more surely on the terrain itself, looking for history in the making of which I can consciously participate, even if my form of participation is just bearing witness. But here we have our prisons too: they are not just psychological. The walls are outside as well as inside. It is realistic to feel impotent and hopeless in the face of those forces I cannot affect at all. Monopoly capitalism has good reasons for feeling itself triumphant over man and nature. Human potential everywhere remains unrealised: it belongs to an unwon future. Can any of us, then, hope to be individually 'free'? No, but in this situation, one still has to dare to hope. That is the 'impossible escape', for which there is nothing for it but to fight.

1978 Redding, Connecticut

Direct experience. My father believed in the possibility of direct experience of the Historical Jesus: the letters which W. returned to me last year when my analysis was ending show that. Perhaps they were the reason why, last November, I found I was immersing myself in study

of the difference between the Jesus of History and the Christ of Faith, again. In the nineteenth century, Liberal Protestant theologians, like Adolf Harnack, believed they could cut away the veils of dogma and tradition and gaze directly into the eyes of Jesus – like a child seeing its mother's face for the first time. But Father George Tyrell, a Catholic Modernist, was surely right when he wrote, 'The Christ that Harnack sees looking back through nineteen centuries of Catholic darkness is only the reflection of a Liberal Protestant face seen at the bottom of a deep well.' Paul Tillich, the Protestant theologian, acknowledged that the attempt of historical criticism to find the empirical truth about Jesus of Nazareth was a failure; with the advance of such criticism, the Historical Jesus, as Tillich put it, 'not only did not appear but receded farther and farther with every new step'. Those who declared they had had direct experience of the Historical Jesus were each gazing into a mirror, on which was painted a halo.

Last autumn, I tried to write an analysis of the way in which ideas about 'The Christ' had developed and changed; it started as a review of the book *The Myth of God Incarnate* for *Socialist Challenge*'s Christmas issue. When it was published last summer, this collection of essays, edited by John Hick, unleashed a storm of controversy because several prominent theologians revealed through their contributions that they did not believe that Jesus had been the Son of God – at least not in any specifically Christian sense of the term. But my review got out of hand. It began to turn into a long article . . . possibly a book. Even now, the text will not finish. Another minotaur's box of loose threads, leading nowhere, losing themselves in chimeras and myths. Here in America, when I can tear myself away from Natkin's shimmering hazes of colour, I have been studying D. M. Baillie's *God was in Christ*, and Rudolf Augstein's *Jesus Son of Man*, searching for further clues. Baillie is a critical theologian, who believes that Christianity depends upon the affirmation of both the humanity and the divinity of Jesus. Augstein takes a secular approach, and tangles effectively with the contortions of German theologians, who are always trying to deny the evidence their own researches have brought to light. Even the smell of the pages of Baillie's book brings back the aroma of half-forgotten arguments,

long straining sermons in Sunday chapel. Today, I would like to be free to pursue my meandering journey of discovery and rediscovery. I would like to be a cerebral *flâneur*, not chained by the obligation to produce a book on Natkin, or an aggressive interview with Jasper Johns. I would like it if, for a time at least, this journal could become all the writing I had to do.

But I push Baillie's and Augstein's books away from me, across the round, white table, and pick up Michael Crichton's book about Jasper Johns again. I have got to finish this research because soon I will be going to interview Johns. Crichton writes:

'The pictures suggest less and less some relationship to the outside world, the world of the spectator, and more and more some set of relationships within their own boundaries. Barbara Rose put it nicely: "Their meanings, if decipherable, are entirely within the world created on canvas or paper. Within this world, not the identity of the objects, but the nature of the relationships, counts."'

But what is a relationship in abstract? My eyes stray across the table to the theological books. Baillie has a lot to say about docetism – that was the heretical belief that the body of Jesus was only *apparently* human, but in essence had no relationship to anything in the material and physical worlds. Such beliefs, Baillie argues, have no currency today. But critics like Barbara Rose perpetuate them in the aesthetic domain. I long for a demystified, secular and sensual vision – a post-Christian version of those humanist traditions which thrived in ancient Antioch. Art cannot help. I sink back into Johns.

1975 *Le Châtelet, France*

Deeper and deeper into Serge.

'I think of the mystery of time's passage. There are minutes and hours which have no end: the eternity of the instant. There are many empty hours: the vacuity of time. There are endless days; and weeks which pass without leaving the least memory behind them, as if they had never been. I cannot distinguish the years that are behind me. Time passes within us. Our actions fill it. It is a river: steep banks, a straight path, colourless waves. The void is its source, and

it flows into the void. We, who build our cities on its banks, are the ones who raise dikes against it, who colour its waves with beacons upraised in our hands, or with blood.'

I think of the staring eyes of that young Saudi whose neck awaits the executioner's sword. In my mind's eye, I see him being led to the block by an armed guard in white swirling robes. His hands are tied behind his back. The fantasy merges into a memory of a senior prefect raising a cane in a sweaty box-room in Holman House, Epsom College. A cut. A scream. And then silence. The daydream is over.

Serge goes on:

'Time could not exist outside of my thought. It is whatever I make it. The instant which I fill with light is priceless, like a ray from a star which shines for eternity through the space it illuminates. The empty hours and days which I yield to dead things have no more existence than shadows . . . My very dream is the surest reality.'

A year ago, I was here, in this village, in this house, in this room, at this very desk. As always, I can remember the books I was reading at that time. Life is one long sentence. Not just *Schiele in Prison*, but John Berger's first novel, *A Painter of Our Time* and Jean-Paul Sartre's *Nausea*. I was struck by the fact, as I sat here, that they all contained passages about time, which sunk into me, as these lines from Serge are sinking into me now.

Some of those passages formed part of the content of a letter which I sent to Berger: I wrote it here, just as I am writing now. I quoted from Sartre's *Nausea*:

'All of a sudden you feel time is passing, that each moment leads to another moment, this one to yet another and so on; that each moment destroys itself and that it's no use trying to hold back, etc., etc., and then you attribute this property to the events which appear to you *in* the moments; you extend to the contents what appertains to the form. In point of fact, people talk a lot about this famous passing of time, but you scarcely see it.'

I put these lines beside some from Berger's own book, *A Painter of Our Time*. He wrote there:

'As one grows older, every moment passes to one between the twin sentinels of gratitude and fear. Strictly speaking, the fear it may not arrive precedes the gratitude that it has. But the process is so fast that they seem simultaneous, whilst the moments follow one another so quickly that normally we acknowledge neither the gratitude nor the fear.'

I was using Serge and Berger to try to explain, to Berger, experiences of my own. I had visited him in London in a terrible state just before we came out to France. I had felt then that everything inside me was exploding; but, in my letter, I remember writing that only once had that terror of disorientation touched me here in France. I told him about a day when we went to stay in a chalet belonging to an uncle of Colette's in the hills of the Cévennes. I woke up in the night – I think because the wood fire was still smouldering in the grate and the smoke disturbed me. Outside, I could hear the silence of the night: not a sound. No wind, no night-birds, and, of course, no rumble of traffic. The only noise was in the room itself, a grandfather clock, ticking, marking the passing of each second. For a while, my mind seemed quite empty, neither harassed by remnants of dreams, nor fabricating busy waking thoughts. All I was aware of was the noise of the clock, ticking. It happened when I realised each tick was a moment, dropping away, empty . . . it was not that I wanted to fill them, it was the starkness of the confrontation, as if, it seemed, I had touched on pure time itself. It was only when I had reassured myself that it was not time I was listening to, but the unwinding of the spring, or the swinging of the pendulum in a machine, that the fear passed.

You extend to the contents what appertains to the form.

We came here to Le Châtelet, Colette and I, in the summer of 1973, in the spring of 1974, in the summer of 1974, and now again in this spring of 1975. I can still distinguish the years that are behind me. Each time, I thought about time, read about time, wrote about time. The heavy wooden desk stands by the window: this room, above the post office, overlooks the small village square. Each time, the same view, always changing. In the summer of 1973, that shop, which now sells newspapers, notebooks and a few paperback books, was the ground floor of a shuttered house. A place of sequestration and seclusion. A

year ago, Bernard Goldman and Imogen drove with us here from England: they were on their way to the South of France. Together, we all watched the contents of the house being put up for public auction, out there in the village square. Everything had been cocooned inside within frozen time ever since the owners had died – no one we spoke to seemed quite sure when.

1976 Graham Road, London

Tonight, we are going to have supper with Bernard Goldman in the big house where he lives alone with his carpets, antiquities and fantasies. Imogen has gone.

1977 Graham Road, London

It is no use. I am not going to advance Cheval, or anything else, today. Ian Suttie died on the day *The Origins of Love and Hate* was published. Did I mention that? I am not even sure why I think of it, now. Perhaps I am afraid that all infant–mother, analysand–analyst relationships must end in a fatal separation. Am I unconsciously linking maturity and death? What will life after W. be like? I visited him for longer than the time I spent at Epsom College or Peterhouse, Cambridge. What is the point of learning to stand on your own two feet if all you then do is to put your head through a noose? Posthumous publication: I find I am thinking about Christopher Caudwell, a writer about art, and much else besides, who was killed at the age of 29, fighting against Fascism in Spain. Caudwell had already published five text books on aeronautics and eight novels before he died: but the great books, like *Illusion and Reality*, came later. I remember how excited I was when I read Caudwell's argument that in making external reality glow with our expression, art tells us about ourselves. 'No man can look directly at himself,' he wrote, 'but art makes of the Universe a mirror in which we catch glimpses of ourselves, not as we are, but as we are in active potentiality of becoming.' All these rifle-men, journeying to the front just before analysis ends: I catch glimpses of myself in them.

I turn over the typed pages of this journal for last year, and read the passage about the axolotl. One day, last July, it died, conveniently, just a week or two before we left for America. Too conveniently, perhaps. I came to hate that axolotl. The sight of the creature, and the sounds it made, filled me with nauseous loathing. I resented having to hunt for flies and woodlice for it to eat; it rejected most of the food I gave it, often spitting it out as soon as I turned my back. It infuriated me because it refused to grow up, or to metamorphose itself and come out on dry land. A pampered turd! It was inevitable that after all those luxurious years in that tank of plenty the unfortunate beast would only survive a few weeks with me. I came to despise the futility of its imprisoned life. One day, I noticed it had developed fungus which had spread from its underbelly right up to its gills and throat, and, in the opposite direction, down to its anus. This had happened before, and I knew what I had to do. I dosed it with Liquitox, a preparation intended for the cure of fungoid and fin-rot infections in pet fish. As a child, I had even contributed an item on the treatment of axolotls with Liquitox to *The Aquarist and Pondkeeper*; I did not reveal there that I had named the axolotl Ernest after a character in Oscar Wilde's play, *The Importance of Being Earnest*. Wilde's Ernest was found abandoned in a handbag. I thought of this as a modern version of the myth of Moses, who was discovered floating in a basket among the bulrushes. But this time, when I placed the axolotl in the solution I had prepared for it inside its tank, I noticed that it started gulping for breath more often than usual at the surface of the water. It was clearly suffering. The fungus infection looked peculiarly severe. Large patches of its protective mucus seemed to have been quite eaten away. When we returned on Sunday night, it was lying, immobile, on the floor of its tank. I did not realise at once that it was dead; sometimes, for hours on end, it had rested like that. Even when I prodded it with a pencil, I was not absolutely sure: it still had the limpness that characterised it when living. But, later, its mucus began to float away from it like a piece of clothing. I lifted its slippery, now stiffening corpse with a sense of disgust, and not even momentary sorrow. Shivering at the texture and odour of the beast, I wrapped it in newspaper and dropped

the whole thing in a polythene bag which I sealed with a wire tie – exactly as we treat Sylvia's soiled nappies today. As I put it in the rubbish bin outside the house, I wondered what had been the point of its fatuous longevity.

All this reminds me of a recent article of John Berger's which impressed me. I rummage through a pile of back numbers of *New Society* until I find it. Berger says that the practice of keeping pets is a modern innovation, and 'part of that universal but personal withdrawal into the private, small, family, unit, decorated or furnished with mementoes from the outside world, which is such a distinguishing feature of consumer societies'.

He goes on to argue that the small family living unit lacks space, earth, other animals, seasons, natural temperatures, and so on. The pet, he maintains, is either sterilised or sexually isolated, extremely limited in its exercise, deprived of almost all other animal contact, and fed with artificial foods. (The flies and woodlice at least didn't come in tins!) This, he claims, is the material process which lies behind the truism that pets come to resemble their masters or mistresses. 'They are creatures of their owner's way of life,' he writes. 'Equally important is the way the average owner regards his pet . . . The pet *completes* him, offering responses to aspects of his character which would otherwise remain unconfirmed.' Berger explains that he can be to his pet what he is not to anybody or anything else: the pet can be conditioned to react as though it, too, recognises this. Berger says:

'The pet offers to its owner a mirror to a part that is otherwise never reflected. But since in this relationship the autonomy of both parties has been lost (the owner has become the special-man-he-is-only-to-his-pet, and the animal has become dependent on its owner for every physical need) the parallelism of their separate lives has been destroyed.'

In another, related article on the way that zoos are 'monuments to the marginality' of the animals they house, Berger also writes that everything that had been central to the interest of the animals in the wild was replaced in cages and paddocks by a passive waiting for a series of arbitrary outside interventions. 'The events they perceive occurring

around them,' he says, 'have become as illusory in terms of their natural responses as the painted prairies.' But he points out that this very isolation usually 'guarantees their longevity as specimens and facilitates their taxonomic arrangement'.

Narcissus saw his reflection in the waters of a pool: loving and hating. The cool, still tug of mortifying self-love, running deep. In analysis, I sometimes admitted to a feeling of enclosure at the centre of a hermetic globe, which was myself. More often, I denied this feeling. These sentiments could represent themselves in my conscious mind through nothing more than a vivid and intensely visual image of an aquarium. Thus, lying alone on the couch, staring at the wall, I would suddenly 'see', in apparent isolation from everything I had been thinking or saying, a vision almost of some aquatic fragment: a clump of the waterplants, *cryptocoryne* or *sagittaria* growing in the corner of a tank, or a flashing cloud of blue and red cardinal tetras, darting and changing direction within my field of sight. As a child, I filled my attic bedroom in the big house in Eastleigh with creatures in tanks, especially fishes – Egyptian Mouthbreeders, Blind Cave Fish, Black Widows, Swordtails and Bristol Shubunkins. On the back of some of the aquaria, I painted false underwater vistas in household enamel paints.

Later, as an adolescent, a brown Windmill Library edition of Edmund Gosse's *Father and Son* became one of my favourite books. Gosse was sequestered within the space of a difficult father, a Plymouth Brother who did not believe in evolution, but was the inventor of the modern public aquarium: he set up the first 'fish-house' at London Zoo. As a small child, Gosse derived endless pleasure from the tanks of sea-water with glass sides 'inside which all sorts of creatures crawled and swam' which his father kept in his study. Gosse wrote:

'Before I went to Clifton my mental life was all interior, a rack of baseless dream upon dream. But now I was eager to look out of the window, to go out in the streets; I was taken with a curiosity about human life. Even from my vantage of the window-pane, I watched boys and girls go by with an interest which began to be almost wistful.'

Today, I feel I have gone beyond even Gosse: I have not only escaped from the aquaria; I have reached the other side of the window-pane. I am glad the axolotl died! My assassination of it was an act of self-realisation, a symbol of that process I have completed through analysis.

After our last visit to the house in Eastleigh where my parents have lived now for more than quarter of a century, Colette and I talked about the longevity of Honey, their brindled house-cat. Honey came to the house as a kitten about the time I was first sent away to school. I loved Honey, of course; we all did. A jelly in a fur coat. Pounds of sleek and sexless neutered eunuch flesh. Seventeen years of whiskered inertia . . . And the axolotl, too, lived on, and on, in a capsule within a capsule, in this world but not of it, outside the vicissitudes of the river of history, for sixteen interminable years. Sometimes, as a boy, shut in my bedroom, surrounded by my tanks, I pulled out art books, and admired Modigliani when I read he had said he desired *une vie brève mais intense*. About 30, I imagined, would be more than enough to accomplish all I had to do. I did not want to extend myself indefinitely, indeterminately, on and on, in glutinously petted life.

Once, John came into this room here . . . That must have been two years ago, after they had driven us back from France. It was before the axolotl had arrived from Eastleigh, but there were fishes in aquaria on the trestle table behind me, just as there are now. I think he asked me if they got bored. Perhaps it was no more than the way he looked at them. In that instant, however, I read in the expression on his face the article about caged animals which he was later to write. He revealed their bleak, sealed existence and, ever after, seeing myself in the metallic sheen of their scales, I was touched by disgust when I sprinkled their food.

Somehow, too, I associated buying fish with sad visits to painted women: an intractably alien beauty, absurdly, absolutely separate. Only last week, a flesh-pink goldfish died here in this room: one of an almost identical pair, purchased in June 1975, a sad memento of Kiki's two cold, distant, white breasts, untouchable except by tactless fingers, at a price. Mere skin and appearance in the palm of my hand: unfeeling. A calico character, her personality like mine, flawed Venetian

glass. I purchased the fish impulsively in Ridley Road market the following day, as both symbol and living act of reparation. A veiled tale. Gliding, harmlessly, cold blood, iced heart, glinting, plated, flesh-tint flanks, flashing scales, unreachable, the other side of the tank frame: yet wholly, indisputably mine. Owned by me. Separated in their otherness, they hang and spiral there, swallowing Tastey Pet Fish Flakes at the surface, while I digest sprinklings of over-determined projection: flying up like the rising penis, floating like the hallucinated breast, sinking, satiated, bottom-feeding, mouth-blowing amidst the excrement, turd-day, polymorphously perverse.

The other pink one is still left. It lives in a separate tank beside the last remaining Telescopic-Eyed Black Moor, with its bulging, globular eyes: each in its own medium, its distinct container, cut off from the other and all the world. They are marginal now, even within my world, of which they form a wholly dependent part. I stop writing and drop a little food into each of the tanks. It has been some time since I last fed them. Colette has commented on how I have lost interest in them recently: pale reflections of the past, without promise of a future. Even if I still feel uneasy about survival in the post-psychoanalytic element, I think I have moved outside the fish-tank. A fish out of water. Ernest, again. An axolotl is only an embryo; it is to the salamander what the tadpole is to the frog. Except that for the axolotl, metamorphosis is of a more voluntary kind. The axolotl can choose, or be compelled by changes in the environment, to change, to mature, more or less, and to venture out, re-born, into a new element, as a creature which lives on the dry land. In myths, and fables, or perhaps just in my overworked imagination, can't the salamander evolve still further to live, like the phoenix, as an elemental spirit in fire? No matter. Ernest just lay sluggishly there.

Last time we visited France, John gave me *Turtle Diary*, a novel by Russell Hoban, to read. 'I think it has something,' he said. 'I don't know. There's a lot about aquaria in it. It may just interest you.' I borrowed it from him, and read it through. Neaera H., who keeps a water-beetle in a tank and illustrates children's books, and William G., an obsessional who works in a bookshop, meet by chance in London

Zoo's aquarium and plot to set the turtles free. This they manage to do. Meanwhile, unknown to William G., one of the other inmates in the lodging house where he lives is driven to such despair that she hangs herself. When he lent me the book, did John want to tell me to set my fish-self free, to break the glass, wipe away the veils of gossamer, and find the forces of history traversing my time, to recognise them, and to inhabit them, through both action and imagination?

Russell Hoban's book moves formally from two disparate monologues towards a sort of dialogue. Neaera H. and William G. come together to carry out a concerted action: setting the turtles free. By the end of the story, they share the same tank, at least. Last night, before I read a few pages of Siegfried Sassoon's *Sherston's Progress*, Colette and I lay in bed, side by side, watching Melvin Bragg's programme, *Read All About It*, on the television screen. It comes on, every week, to the tune of the Beatles' song, 'Paperback Writer'. Last week, *Turtle Diary* was re-issued as a paperback, so it was reviewed. For me, Hoban's symbolism has a quaint transparency; but the Duke of Devonshire found the book 'too introspective'. I wonder what he would think of this journal? Marghanita Laski, ageing throttle of the right, didn't like it either. She also said that William Feaver's book, *When We Were Young*, an anthology of images from children's books, expressed why she could never be a revolutionary.

Books again! I pick up the dusty, calcareous sea-urchin's shell, or echinoderm test, which sits on the desk as I write. A memento from the outside world! I found the urchin when we went on a family holiday to Robin Hood's Bay. (I remember I wanted to go back home because I had been told I would be given an aquarium for my birthday.) I cut away the urchin's beak and cleaned out the flesh from inside; later, I scraped off all the external spines. I have kept the dried test ever since. Its globe nestles neatly in my hand. I often spoke about it to W. Sometimes, it seemed like a breast, sometimes an armoured cranium; but always, a test, is a test, is a test. An analysis. I told him about the five-pronged starfish, the Holy Family, which seemed to be imbedded within it, as the family ingrains itself in the armour-plating of every head.

One path out of narcissism into realism is to smash the glass, poison the axolotl, flush the pink-fleshed fish down the vortex of the lavatory, crush the five-pronged echinoderm test, leave analysis. Free the turtles in the zoo. I would loudly defend *Turtle Diary* against those familiar cathode ghosts in *that* glass-fronted box. This March 28th, I recognise it as a much closer parallel to my own veiled tale than Serge's *Men in Prison*, or even Schiele's gaol. I have been gazing out at the painted terrain pasted on the other side of the glass, and mistaking it for the landscape itself; I have followed every kind of false realism.

I stop writing these words and pick up the local newspaper, the *Hackney Gazette*, which is lying on the trestle table near the tanks. There are two photo stories on the front page, both about missing pet dogs.

'Moira Anderson gives "King" a welcome hug after he had been missing for three weeks. And she thanked the *Gazette* for helping find the eight-month-old pedigree Sheltie.'

And:

'SHE FEARS SHANDY MAY HAVE BEEN STOLEN: A lonely 76-year-old pensioner this week pleaded for her only companion, a pedigree Yorkshire terrier, to be returned to her. She believes her little dog Shandy may have been stolen for breeding purposes or medical experiments. She has unsuccessfully walked the streets looking for him since he disappeared . . . Sitting alone in her Finsbury Park flat, Ada Pearce said, "Shandy was more than a pet to me. He was my sole companion. He means the world to me."'

1978 Redding, Connecticut

Natkin rings down on the telephone which connects the house and studio to the barn. He is excited. He has finally decided to pay for the publication of a set of eleven prints on which he is working himself. The businessman who put up the money to produce them had very different sorts of values from Natkin, and, inevitably, they have clashed over costs. Natkin does not criticise his erstwhile backer. 'I got into this through greed,' he says. 'In the past, I have only dealt with

people who really loved my art. But he regards art as money. I don't blame him for that. I blame myself.'

Yesterday, I told Natkin that a limitation of his work was his inability to produce a picture which referred to human suffering. He races on to tell me that, this morning, he has been trying to make a painting which does just that. 'But,' he says, 'it is going to take a long time.' I agree to go up to the studio so we can carry on our work together.

I put the phone down. While thinking I need to gather together my notebook, tape-recorder, and 'Natkin File', I turn the pages of a Johns book, detachedly. A chance reference to Rudolf Virchow, a nineteenth-century German medical pathologist, anthropologist and liberal politician. He noted that medical students in his classes could not observe even gross pathological disorders in organs because they saw the 'normal' prototypes of their anatomical text books. 'We see,' he wrote, 'what we know.'

I am in the studio. Natkin is talking quickly into the telephone by the racks of paintings. Bright light floods in from the sloping landscape, outside, through the great sliding windows, which take up the whole wall looking out onto a field, and the woods, beyond which lies the barn. The pictures here look much richer and stronger than those in the barn earlier this morning. I remember why I enjoy them so much. Huge canvases are stapled flat, against the wall. In front of me is a table on wheels, crammed with paint pots, cloths, sponges and brushes. Assistants come and go, bringing canvases and tools from the stores downstairs.

The 'suffering' painting is hanging on the end wall of the studio. It is in Natkin's familiar 'masculine' Apollo format: erect, vertical bands ambiguously hold off the viewer in front of an unseen picture space. An xylophone of colour. A carnival parade of painted, cardboard characters. Or is that a window? A glimpse through into the unspeakable unknown? Light and fire: the great god's penis, burning, rising. Just rolls of unravelling, coloured rayon, quivering above a void.

The difference, today, is that one of the bands is being painted black.

A dark and sombre strip in all this resplendence. Its darkness is scuffled with fleck-white highlights: a murky impressionism. I am reminded of Rothko, of those black, floating rectangles sunk into or ballooning out of blood red, draining grounds. Of Rothko's bleeding arms; rusting pools on the studio floor. Where life has gone. But Natkin's solution, his marriage of suffering and pigment, does not convince me. It seems too mechanical, opportunistic and derivative.

It reminds me of how I told him about what happened when I went into the Emmerich Gallery, in the Fuller Building in Manhattan. André Emmerich sat on his sofa in a selling room, like an inflated madam, and explained, through oblique innuendos, why, unlike Natkin, Jules Olitski was a 'Great Artist'. Olitski sprays on sweet and sour hazes of colour; he has been championed by the critic Clement Greenberg. But Emmerich told me that Olitski has been 'brave' enough to produce black works, even though he knew that black would not sell well. Emmerich explained that he could not live with a black painting himself, 'The associations would be too painful.' As he spoke, I remembered an Olitski muddy sludge surface, like a section from the bottom of the Thames, which had been hanging in the gallery when I passed through it on my way to this interview. 'What, you mean there are no black Natkins?' I asked. 'There are no black Natkins,' Emmerich replied. Then he explained in his pompous, insinuating way that the black Olitskis had come about because someone had delivered a consignment of black paint to the artist by mistake.

Natkin's suffering Apollo does not worry me as much as it might otherwise have done when I remember that he said only half an hour or so ago, 'it is going to take a long time.' He is ringing off.

'To me,' he says, 'Iago suffers more than anyone: more than Othello. But why give a shit about them? When I think about real suffering, I think about people made homeless in Vietnam. That is real suffering: and I don't know how I can ever depict it through art.'

The phone rings again. 'Shit! Just a second!' He answers it, and talks for several minutes. When he returns, he asks me if I remember 47th Street, in Chicago, where he lived as a child. We went there together

recently. He tells me that not long ago, he took a walk round there, 'Now it is an all-black neighbourhood – and I felt unbelievable suffering, just walking the streets, looking at people.' He says that few artists have been able to depict this kind of suffering. 'Picasso did it,' he adds. 'Not just in Guernica, but later on, too, in those really great pictures he did about Korea. Did you ever see Leon Golub's paintings? The early ones he made in Chicago were filled with such suffering. And they were very moving as art, too. I didn't feel anything in front of his later ones about Vietnam, though.'

The phone rings again. 'Oh fuck!' he shouts. But he takes the call. While he is talking, I find myself straining to remember what John Berger wrote about Picasso's *Massacre in Korea*. I think he said that the effect of the painting was almost the opposite of what Picasso intended. Although the soldiers carry sten-guns, Berger saw them as heraldic and archaic in a way which destroyed the sense of a contemporary massacre, and turned them into symbols of eternal evil. And so, he said, our indignation, which the painting was meant to provoke, is blunted.

But Natkin is surely right about Leon Golub. I visited him in New York recently. I liked him immediately. He was once the most talented painter of the so-called 'Chicago Monster Roster'. He pulled out some of the pictures from the 1950s, which had impressed Natkin. They were implacable images of damaged men, sphinxes and colossal heads, often alluding to Roman sculpture, but painted in an abstract expressionist, 'all-over' way. The more recent works, however, were enormous, wall-sized compositions of raw figures on rawer cut or torn canvas: mutilated men, shot through, directly, with napalm and Vietnam. He was also working on a series of stylised portraits, based on photographs, of world political figures.

Golub has a huge, bald, dome-shaped head: he looks, and talks, like an oracle. Nancy Spero, his wife, who is also an artist, is thin, like a strange bird. They resemble the monsters in their own paintings. I listened to Golub. I understood why he had moved from the general towards the depiction of the specific, and I approved his intention. And yet when I looked back at the new paintings, I felt that he had failed. There seemed to be something mechanical about the way in which he

had attempted to heal the artist's separation from history; although I wanted to applaud the works, they left me cold.

Natkin is off the phone again. 'I'm such a competitive person,' he says, 'that as soon as I heard you tell that little anecdote about Jules Olitski and black, I wanted to start a whole black painting. I still might. Now you might say, "Oh, come on now! You can't be as blatant as that . . ."'

My eyes are already turning towards the black band in the 'suffering' Apollo. He follows them.

'That has nothing to do with Jules Olitski!' he shouts in mock self-criticism. 'That has to do with suffering! Anyway, the Olitski business is just the sort of thing that turns me on. A challenge. Any kind of challenge. I don't think there is necessarily anything wrong with external motivations of that kind. It is like when someone makes a demand on me to do a painting of a certain size for a certain living-room, or architectural environment. During the war, all kinds of propaganda movies were made. The craft of art can even be used in the territory of propaganda – and some of it still succeeds as art. But the temperament of the particular work of art has to be just the right timbre, psychologically and narratively, for the subject matter which is being expressed. That's what bothered me about Leon Golub's Vietnam paintings; it bothers me about this Apollo painting, too. The timbre isn't right. It makes me feel nervous and embarrassed. I'm not saying it won't succeed when it's finished. But the actor, in this case myself, must make an *allusion* and an *illusion* of an experience so that it is realised. Real, realised. I am using the word "real", and I am using the word "realised". Otherwise it remains in the area of sentimentality. And you know what James Joyce said about sentimentality? He said it was "unearned emotion".'

His words continue to pour out at me, without an edge. He reminds me of the tortured monster paintings he made in the 1950s. 'They were hooked into sentimentality,' he says. 'That's why I turned to what some people call "abstraction". I hate that word! I honestly believe I can "realise" my experience better this way. If I didn't, I would move away from "abstraction", too. I'd even stop painting altogether if

necessary, and go on the stage, or whatever. You know those purple and black paintings, by Mark Rothko, in the Tate Gallery. Well, they really frighten me. You see, I've used painting to bolster myself up. My sanity, my manhood, my stability, rest on painting, on the mythology that is in my work. I worry about monkeying around with that.'

He looks back at the 'suffering' Apollo. His voice slows down. He seems less agitated.

'These things make me very sad. I didn't want to talk about them with you. When I first met Judy, before we married, she used to tell me, "You have a right to privacy inside your own head. You always think that everyone, like your mother, knows what's going on inside your head. You have to tell them everything, because you feel they know anyway. But you don't have to tell them. You don't even have to tell your doctor, or me. You've got rights, too." It was hard for me to learn that. One reason I have integrity is because I believe people will always see through me. I think that if I lie, or cheat, they will be able to read the words "Liar", or "Cheat", in my face. But, in my own privacy, I am no longer that vague as to why I am suffering.

'The feeling has been growing stronger, probably because of my age. I try to compensate for it with tennis, and running for an hour every day. You see, I got upset talking to you yesterday because I have been thinking about all this, too. But one doesn't have to go looking for it . . . For death, I mean.'

Then, in self-parody, he shouts out, ' "I want to experience everything, even death!" ' He answers his own voice, ' "Don't worry, kid! You'll have your chance." ' He starts to tell me about a painting called *The Poet* which he bought recently. 'It's by a German artist. A lot of his work didn't interest me at all. But the imagery of this picture really got to me. There are busts of Voltaire, Aristotle and someone else, I can't remember who, in the background. But it's all about this guy with a bald head going like *that*.' He grimaces, tightening all the muscles in his face. 'He is straining, almost as if he was trying to shit, but maybe he's just straining because he's a poet. In the background is the figure of a sleeping boy. When I saw the painting, I began to think, "My God I

wish I could work with such overt imagery." And I bought the painting, just because of the imagery.'

He begins to punctuate the words with great, uncontrollable sobs, like a child.

'It was a very expensive picture. I worried a lot about it. I saw it in a gallery in Germany. I lay awake thinking, "Am I really going to buy that painting?" I tried to make psychiatric sessions out of it – to imagine I was talking to my doctor. I asked myself whether I was responding to the art, or just to the sentimentality of the imagery. I went through a sort of wrestling with myself. It would have been so much easier if it had been an abstract painting. I would have been confident about my motives. I don't think I will ever use such direct imagery myself. But then again, I don't want to say that *definitely* I won't . . .'

He then tells me about how he went into a gallery in Hanover, where the assistant told him that one of the gallery's well-known artists had stopped making paintings after the death of his son. 'Suddenly I had a terrible image of one of my own children, Josh or Leda, lying horizontally still, so still, and dead. I was looking on. And I just could not bear it. Then I thought, "My God! What would I do? What could I possibly do?" My first reaction was that I would hope to die first. I just don't want to experience that. But then I thought that, if I did, I would have to do something about it in my art. And I thought, "Would I be able to do it any other way than by using subject matter?" You were here though when my assistant Francis, whose mother died recently, told us that his sister had leukaemia, and she was dying, too. And all I could say to comfort him was, "Think about colour and light! Think about colour and light!"'

Natkin is now sobbing heavily, convulsively.

'People are always saying to me, "Gee! Isn't your work happy?" I can't turn round and say, "You stupid fucker, what do you know?" I mean when I look at a painting like that little Apollo on paper, over there, it really is *gorgeous*. If it were the right scale, it would grace any living-room in one of those fancy magazines. And I wouldn't mind that at all. But when I look at it, I almost see the shrieking and the

screaming. Yesterday, when you said to me, "Your work cannot deal with suffering", two things happened. You've got to remember, I was brought up by a family who said, "You don't have any feelings." They didn't actually *say* that. But when the tears began to come in my eyes, I would get slapped. "Stop doing that!" Smack, smack, smack. I'd get slapped. They'd say, "Don't cry, or you'll get nervous!" I think that in me there is an incredible suppression of feelings, and yet I have another internal way of expressing them, deeply.

'My grandmother was one of the few people in my childhood whom I respected and who liked me. But she used to say, "Use your art to help mankind realise the social inequalities that are to be found in the world." Now, in one sense, that is *very* important to me. Even when you are not here, part of me can always hear my grandmother saying that. And when you say, "Your work is wonderful, but limited. You can't express suffering", part of me immediately says, "Yes, you are right." But I also become *enraged*. Another part of me wants to scream, "How can you say a thing like that!" '

He is sobbing so much that he has to gasp for breath. I want to reach out to him in his suffering, but I cannot.

'*You* don't see it! You just see what everyone else sees! But I get confused. You have written about how devious my work is, how devious *I* am when I talk about certain things. And it's true, I am. I worry about putting anything out on my sleeve. But even so, I am furious when *you* don't see it. It just makes me feel even more alone.'

Huge, sentimental, crocodile sobs, pear-shaped, tumbling, and splashing, children's picture-book tear drops, splat, splat, splat, on the studio floor. A green frog face; inside, a fairy prince of an artist: touching, absurd, moving, preposterous, all at once. I want to put my hand on his shoulder, and tell him it's all right. Instead, I keep the tape recorder running. I watch and wait.

'Look, I just can't help it that I do this. I'm sorry. I'm always living a dual expression: one side of it is affirmation, joy, splendid happiness and pleasure. But the other side is the reverse. The reason that doesn't appear overtly in my paintings is because I don't want to have to gaze at

the skull. I see it more and more every day when I look in the mirror.'
Ce n'est pas le temps qui passe. C'est nous.

1975 Le Châtelet, France

Throughout the day, I have been reminded of a dream which I had the
night before last. I was walking with Anthony Barnett, in a sandy place,
and we were talking about the weekly newspaper, *7 Days*, on which we
both used to work. I mentioned the names of some people who might
work on a new revolutionary weekly, but he became angry and asked
me if I did not realise they were the very people who had sabotaged the
last one. We walked on and he told me that if ever a new paper started
he would insist that everyone burned the books they possessed by
Stalin.

I was cynical and I said he would not persuade me to burn every one
of Stalin's books.

'What is worth keeping?' he asked.

'*An Outline of Language,*' I replied.

Anthony said at once that this was an interesting choice but added
that he had just been testing me. Didn't I realise it was the stuff of
Stalinism to make people burn their books? I climbed a bank where I
found a small, white rodent in a hole. An albino desert rat. At first it did
not seem afraid and made no attempt to run away. I watched it closely.
Then I called down to Anthony and told him to come up and have a
look. But he was busy with something down at the bottom of the slope.
I knew he did not want the rat brought to his attention but I thought he
might still come and have a look at it. Before I had managed to
persuade him to do so, the rat had run away.

1976 Graham Road, London

I am so agitated and fragmented today. I feel madness pushing up like
toadstools through the tarmac. I pick up a catalogue of an exhibition
called 'Bottoms', which arrived recently from the Nicholas Treadwell
Gallery.

74

Inside, there is a picture which has been obsessing me As a painting, it has no merit, but I cannot keep the imagery out of my mind. The artist, Ludmil Siskov, was born in Sofia and educated at the Fine Art Academy in Budapest. He has depicted a girl in a maid's costume crouching on all fours, with a child in a policeman's hat sitting on her back, gazing at her buttocks and screaming. Siskov must have copied the woman from a pin-up photograph published in *Penthouse* magazine. I know, because I remember it. Inside, I hear that long scream: from the child within me who wears a policeman's hat.

1977 *Graham Road, London*

Colette comes into the room. She has to go to hospital again today. The birth tore something inside her and left her with a 'fistula': a long, pipe-like ulcer with a narrow mouth. She hates these appointments and I hate myself for being able to do nothing more than sympathise, dumbly. Sylvia's birth took place outside of me. The hospital she is now attending specialises in the rectal and anal.

She has gone. I find myself trying to imagine what manner of man, or woman, would choose to work in such a place. But then I should know. 'You feel as if the breasts belong to your brother,' W. once said, 'and all you can do is mess around with arse-holes.'

I have a memory of lying on my side in the school sanatorium, where I have been admitted with stomach ache. The usual dose of kaolin has not worked. The doctor has shrouded his finger in a surgical glove and he is raping me with it. I am yelping, not because of pain or tenderness, but because of the violence of this intrusion deep into my bowels. As he pulls his finger away, I am sure that all my intestines and excrement are flooding behind it onto matron's sheets. I cry out again.

That night, I was taken in an ambulance to Sutton and Cheam Hospital and a surgeon, who had known my father as a student at King's College Hospital, cut my appendix out. I have often wondered whether this was really necessary, or whether I somehow seduced them into this violation by my reaction to that impinging finger. I remember that, as soon as I awoke from the anaesthetic, I asked the nurse if my

75

appendix really had been swollen. She said, 'It was almost bursting!', in a way which made me feel they had found nothing wrong with it at all. I kept this severed part of myself in a jar of formalin, among my preserved fishes and specimens, in what I called my museum. It looked perfectly all right to me.

Years later, I discussed this incident with Dr P., when I saw him to talk about whether I was a suitable case for psychoanalysis. In his gentle way, faintly smiling, he said, 'It is so much easier for the doctor, of course, if the patient can relax.' Soon after I left Epsom College, I went to teach in a preparatory school. I took the place of a master who had left under a cloud. A cupboard in my room contained eight or nine glass jars in each of which there was a human foetus at a different stage of development. When I told the headmistress about this she said she would get someone to clear them away. After a few weeks in this school, I sprouted an ischio-rectal abscess, the size of a prize tomato.

I went home to Eastleigh on my way to hospital in Winchester. In the gleaming drawing-room, surrounded by all that patterned wallpaper, with the porcelain figures looking on, my father asked me to let my trousers down so he could examine my putrefying fruit. 'It's right down *there*,' I protested feebly.

Within me, a chained and enraged child screams and screams in silent terror.

Something of all this was in my mind quite recently, when we went to Eastleigh. My father showed Colette and me the large, round silver medallions engraved with designs 'after' Leonardo da Vinci's drawings, which he collects. Before he picked them up, he pulled a surgical glove over his fingers: the plastic material turned shiny and opaque over his knuckles. 'Look, look at them,' he said. 'They are beautifully done!'

Colette left for that hospital with Sylvia strapped onto her front in a baby carrier. I decide to go out for a walk. I will need to buy a new notebook before the end of the day.

I am back at my desk, writing, as always, in a present permeated by an immediate and a distant past. When I left the house for my walk, the

sun was so bright, so beautiful, it cut out the surfaces and silhouettes with crisp clarity. Pure shadow; pure light; blue skies above us. A freshness that made me want to empty the dust and crumpled fragments from my pockets, buy a new shirt and shoes, and start writing on a fresh, clean page of an unencumbered notebook. Even the shabby warehouses, the drab salmon curer's shop, and the wasteland at the top end of Ridley Road, where a sodden sofa is abandonedly uncoiling, all these things were dancing in this light.

In a recent article in the art magazine *Studio International*, Andrew Brighton compared Constable unfavourably to Millet on the grounds that, 'unlike Constable the materiality of the world (in Millet's landscapes) is never dissolved in the momentary effects of light and weather.' This must be wrong! In the streets this afternoon, I felt that the changes in the light and weather, from moment to moment, revealed the material facts of the world to me, and reminded me that material things can only exist *through time*. Physical being is not something which is inertly given, for ever. Constable saw that, but Andrew Brighton can't! Underneath the immediate, impermanent landscape – which reveals itself through momentary changes of weather, and through longer monthly and seasonal shifts – there is something stubborn, resilient and enduring. Last year, when Sylvia was still in Colette's womb, we went on holiday to the Stour Valley. I had never been there before, but I could recognise the landscape from Constable's paintings, though not a drop of water nor a blade of grass, not a horse nor a person, not a branch nor a pebble, are the same as those he saw. This 'materiality' Andrew Brighton talks about *includes* change and becoming. That's why I would say that the vision Millet expresses through his densely *given* landscapes is less 'materialist' than Constable's, with all his 'momentary effects'. Perhaps Andrew Brighton is just the most perceptive of a new generation of false 'realists'.

When I saw the buildings in the sun today, I found I was thinking again about the issues raised by Sebastiano Timpanaro's book *On Materialism*. Timpanaro is an Italian Marxist who has been stressing the fact that a 'materialist' perspective must include understanding of physical and biological levels, as well as social and economic. The

buildings were there as undeniable physical things as I walked along the pavement, but I saw them as no more than a flaky crust, the uppermost, superficial, dispensable surface of the earth, the shallowest layer of disposable epidermis, or the outer chitinous integument of a shell. The play of the sun upon them shifted the way I usually saw them; their appearance seemed quite different from what it had been yesterday. And this reminded me that these things come and go: that second-hand shop was not there only a matter of weeks ago; whole edifices have been flattened and wiped out since we arrived in Hackney just over two years ago. And so personal monuments are effaced from the world of the given to survive only in memory as ghosts of a material world which once was but is no more. Some such landmarks may live on through the words in this journal, though they have disappeared from the real world: that butcher's shop, perhaps, where one assistant has a lascivious smile behind his blooded front, or the eel-and-pie shop, with its writhing boxes and bloody execution slab, white marble-topped tables and 'historic' photographs on the walls. It is already a relic, a museum piece. But today most of the market was shut down: painted store-front roller blinds, drawn right down and padlocked to the ground. There is too little trade for many of them to stay open on Mondays.

When I left the house, I was intending to visit a stall called 'Lester for Stationery', where a middle-aged man and his daughters sell piles of remaindered notebooks at cheap prices. But Lester's, too, was shut up for the day. I should have known! I walked round the corner to Woolworth's. I am obsessively particular about the notebooks I use. There was just nothing there. Only a silver jubilee souvenir notebook, decorated with the face of the Queen, or a five-year diary, without the dates of any specific years, but arranged so that all the March 28ths or March 29ths, for 19—, five times, were stacked one above the other. But finally I found the sort of hardbacked notebook I wanted in the newsagent opposite the station at Dalston Junction. And I walked back home. In Graham Road, I experienced a feeling of openness, of a new beginning, of green things unfurling and pushing up through drab expanses of black macadam. I felt it was good to be finishing analysis, to be in the world, without glass.

Soon after I got back and sat down here, at this desk, another flurrying snowstorm began, as quickly as if an unseen woman had suddenly begun to whisk cream in a jug. Now gusts of large, white flakes are spinning everywhere: torn paper, confetti, snowdrops, blossom, feathers, bridal down. The children playing in the street, waiting to go home after school, are gathered around the bus stop outside the house. Screaming and laughing, they run for cover.

1978 Redding, Connecticut

In the late afternoon, I walk back from the house to the barn. The rain has washed away the snow to shrinking patches, draining into the earth like memories vanishing somewhere in the grey matter of the brain. I remember, only two weeks ago, the soft womb whiteness, silent thudding of cotton wool and shrouds, a gentle coldness of the thick, frozen, watery velvet, clinging deeply to every branch and twig: that was probably the last snowstorm of the year. Today the mud sticks to the soles of my shoes like mucus: the trees, fields and hedges seem strangely undressed and vulnerable, like shorn sheep. Even the half-built tennis court is exposed. A deer crashes out of the woods and leaps across the path, just a few yards in front of me. I can sense its muscular yet tank-like strength, balanced on its fragile, hoof-pointed legs. I imagine what it would have been like if it had knocked me down and danced its cloven daggers through my rib cage.

I kick a pebble with my shoe. Sometimes in front of Natkin's paintings, or, more often, away from them, when I attempt to recall an image of them, I find myself feeling there is nothing there: mere tinted and perfumed breath. A tart aroma! But after a time, I become aware, again, of the pleasure they are giving me – of the sheer strength which informs them. Something similar happens in my encounters with Natkin, the man. This morning, he made some shrewd and perceptive self-criticisms; what he said about Leon Golub's burned and damaged Vietnam figures seemed right to me. I see Natkin and Golub as the opposite poles between which the skin of my own problems with narcissism and realism is stretched out. Is Natkin's a kind of narcissism

which transcends itself and becomes a new kind of realism? Is Golub's just a self-centred realism which lapses back into narcissism?

Somewhere around here I always begin to ruminate on Courbet: that deer leaping across the vanishing snow was certain to remind me of him, anyway. When Natkin looks at a painting by Courbet, he seems not to notice its insistence on thingness, thatness, material gravity and opaque otherness. I find the fruits, buttocks and rocks so heavy that they seem to drag down the canvas surface. But Natkin complains that Courbet is incapable of getting beyond himself. 'Haven't you noticed,' he asks, 'how even when he paints a little dog, the dog looks like him?' And it's true. Perhaps Natkin is saying the *thatness* of Courbet's rocks is a kind of lie: they point back to a subjectivity which, because it is denied, seeps out at every point; whereas, because Natkin sets out by admitting that his vision is solipsistic, he is able to reach beyond himself.

Last night, I was talking with Natkin in his studio, and he said, 'Sometimes I do start wondering, what do my paintings *mean*?' Then he pointed to a small Bath picture of his own. 'I think this picture of mine has a lot of that in it,' he said. He gestured towards a reproduction of Piero della Francesca's *Nativity* pinned up among the postcards and stained colour-plates above the sink: cool, cool blues, musicians, like actors, a braying donkey, a mother and child. I could see at once what he meant. The emotional feel of the pictures was similar; both had the same subject matter: the mother–child relationship. A gentle blueness: a tracery of veins, filled with warm blood, running under the comforting skin. I think that once religion provided an iconography through which such experiences could be expressed and shared. Perhaps Natkin has invented his own symbolic order. The mother–child group of the Madonna with the Holy Infant has been melted down to re-emerge in his painting as the coloured suffusion of his Bath and Intimate Lighting canvases. The father–son conflict, expressed in Christian art through the imagery of the crucifixion, is replaced in Natkin by all the ambiguities of the grid-like Apollos. Is he painting a secular, sensuous and immediately accessible version of the subject matter once expressed through religious symbols?

I reach the driveway which leads up to the barn. There is a smell of conifers everywhere. Inside, I look again at those typed notes for this day last year, the year before, and the year before that: an anniversary of self-examination, of the exploration of the past within the present. I put the worn pages back in the wallet file, make some tea, and carry on preparing for my interview with Jasper Johns.

1975 Le Châtelet, France

These dreams about Clive Barker, Anthony Barnett and the rat in a sandy place. Not long ago, I would have wanted to analyse them. Is the fact that I can leave them alone – almost – a sign of progress? Dreams constitute their own reality.

1976 Graham Road, London

This image of the child, screaming, wearing a policeman's hat: it is so close to the central nexus of my analysis. Recently, I lay on the couch and stared at the pane of glass above the door, which opens out onto the hall; I began to say, 'There is a passage . . .' I was intending to speak about John Berger's description of circular self-time, which has been in my mind because I wrote something about it at this time last year . . . but, at that point, a cat began to whine plaintively and insistently immediately outside the consulting-room door. Like a child. It silenced me. After a few minutes, I had a fantasy which involved asking W. to get up, go outside and strangle it. The cat reminded me of Honey, who can wail in the silent house like an abandoned child. Through all this, W. remained silent, immobile behind me, out of sight. After a few more minutes, which brought me to the rare brink in analysis of committing an action – namely, of getting up, going through the door, picking up the cat and putting it outside – W. said, 'We can, of course, do something about the cat, but since it is causing you such anxiety, perhaps we should look at that first.'

But I had already thought of the meanings the whining cat had for me. Many times in analysis I had associated the glass pane above the

door with the window through which I had seen my mother just after my brother was born. My screaming brother. Even today, I feel cross about the care my mother lavishes on Honey. Of course, it went without saying that I had asked my analyst (as mother) to strangle the cat (as brother) so that his (her) undivided attention might rest on me. I said it, nonetheless.

W. made the point that, in all this, I had not given a moment's consideration to the fact that there was a cat outside the door, and, by the sound of it, that cat was suffering.

'A cat,' I said scornfully. 'You want me to be concerned about a cat? A person . . . I could understand what you were saying. But a cat?' And I knew, at once, how selfish I must have sounded, reshuffling my ancient symbols while the living creature cried and cried.

1977 Graham Road, London

As I look through the window, I find I am still thinking about the painted prairie: the walls of this room divide me from the world. They will do even after analysis finishes on Wednesday. I remember how for Christmas, in 1975, Colette and I went to Tunisia to stay with her friends from university days, Arlette and Christian. They took us out to a small town by the sea where there was an ancient castle, and stone battlements, where Zeffirelli was working on a movie about the life of Christ. Parts of the towering walls had been 'extended' by the addition of false segments made out of paint, plaster and canvas. From the front, it was almost impossible to tell which were the real and which the fake walls. I had to go right up close before I could decide which was which. I had to look behind to see how the sham walls were supported by an enormous structure of wooden scaffolds. Here, at my desk, I have an image of shattering the imprisoning walls with an axe and of finding that they collapse at the very first blow. The rock of ages turns out to be just wattle! Beyond the rubble is real prairie . . . no uniformed keeper, no routine meals. But that is just fantasy, and I am here in the real world of self-reflecting illusions.

I gaze on. I imagine that I see a rough track in the Hackney sky, above

the tops of the buildings; it runs towards a thundering river. Is that 'History' again, perhaps? Yet this River History is not crowded with ceremonial barges, burnished with rhetorical gold and pomp; it consists of nothing but a great tide of men and women surging forward, together, their flow disrupted here and there by eddies, counter-currents and whirlpools. Once I enter this river, in my fantasy, I realise there is nothing above it, behind it, or outside of it, which is not a lie of some sort. I have been within it all the time.

I must have fallen asleep among the books, papers and manuscripts. March 28th. There is no reason why *this* date should have any importance rather than any other. Little clusters of transitory gossamer snatched from the flux, and preserved. Like stuffed humming birds, or dead coral, under a glass dome of words. Where life has gone. Taxonomy. Old men with beards; mahogany cabinets; dusty volumes embossed with Roman numerals. Museums. I prefer the vanishing snowflakes. I find myself wondering, 'Is this journal nearly finished, at last?' Perhaps it has not been so arbitrary after all. I am using the given, formal calendar as a helter-skelter spiralling back into the actual spring, twisting myself into consciousness of the seasons. But inside, too, there is another calendar, etched with the acid of a private life, a personal history: birthdays and death-days, each uneasy anniversary stored, active like a poisonous bulb in the soil of memory, at its appropriate time of year, stirring, stabbing, shooting and probing, without being seen or understood. Psychoanalysis scraped away the soil to reveal how, every year, before my brother's birthday on May 11th, my mother's belly swells menacingly inside my head, and I find that I am overtaken with a sense of panic, an annual premonition of dethronement – which is *never* done when 'tis done.

Last year, on this day, I worked over the material for the year before: I did not change much, nor did I add so much for March 28th 1976. Not as much as I am adding today, anyway. The crab-like terror was already clawing at the bottom of my throat, and I could not set it down on paper. That is when I escape into the problems of aesthetic 'formalism'. Don't worry! It's only an image! Not the thing itself:

there's nothing to be afraid of! I am surprised how clear I was about all this two years ago when I wrote a poem about a shattered marble torso, and glossed what the critic had said about that sculpture by Rodin. Without the evidence of this journal, I would have said that I had not fully grasped the difference between image and object until March 1976, when I wrote a long essay on William Rubin's (formalist) book about Anthony Caro's sculpture: this has only just been published in *Studio International*. At the end of every March, I am haunted by ghosts and imagos, by the conjured orbs and globes of the past and I retreat from it all into the demystification of sculpture.

It is now nearly five o'clock. The clock on my desk is 35 minutes slow. It is a travelling clock. My mother and father first gave it to me eleven or twelve years ago, about the time I went up to Cambridge. The little cogs through which you adjust the hands at the back of the clock got lost; and I never replaced them. I left it at my parents' house in Eastleigh. They returned it to me with the axolotl, last year, but I have only just started using it again. I wound it up, one day, at the time shown on the clock face; but the mechanism is very slow, and I have no way of adjusting it. Through the window, I can see the sky has turned as grey as steel wool. Snow is brilloing in every direction again. I worry about Colette and Sylvia out there on their way home from the hospital, but as I set this sentence down I can hear them coming in through the door downstairs. I reach forward and switch on the radio. It is halfway through the signal for the five o'clock news.

1978 *Redding, Connecticut*

In Michael Crichton's book about Jasper Johns, I come across another quotation from a physicist. 'Nothing,' he writes, 'is more important about the quantum principle than this, that it destroys the concept of the world as "sitting out there", with the observer safely separated from it by a 20 centimeter slab of plate glass. Even to observe so minuscule an object as an electron, he must shatter the glass. He must reach in ... Moreover, the measurement changes the state of the

84

electron. The universe will never afterwards be the same. To describe what has happened, one has to cross out that old word "observer" and put in its place the new word "participator". In some strange sense the universe is a participatory universe.'

I wonder, do I then really ever 'observe' anything at all?

1975 Le Châtelet, France

I think of the quotation I read this morning in Victor Serge. 'My very dream is the surest reality.'

1976 Graham Road, London

In the end, the cat must have just walked away. In any event, it stopped whining. No action was necessary. But if it had stayed there, none of the endless unravelling and elaboration of the meaning its wailing had for me would have suppressed my desire to do something about the cat's intrusion into my analytic space. For the rest of that session, I talked about my difficulties in getting through to other people. At least, I said, despite the fact that I lived in a sealed prison of self-time, I was aware of the veils, of the incessant mediation of experience through the self. I did not allow myself the illusion I had broken through when I had not.

At one moment, he interpreted my 'struggle towards the other', as I called it, as a wish to break the glass window in the hospital door and seize hold of my mother's breast for myself, again. And so, it seemed to me, even that which I regarded as a healthy impulse in me – the desire to grasp hold of real objects, beyond the chimeras of the self – was being thrown back, by W., into the closed circle of my regressive pathology – and so I became furious with him.

1977 Graham Road, London

I can hear Colette and Sylvia coming up the stairs. The main news story is the largest crash in aviation's history. I have often been shocked at

the way I can almost fail to register a flood, human error, 'Act of God', disaster, avalanche, accident, earthquake or whirlwind story even when it covers the front page of a newspaper. But I don't think I am being callous. Such things happen. They bring terror and mayhem if one suffers them: suffering ripples out in circular waves from them. But they enter history, and wreak havoc within it, without themselves being subject to it. Sebastiano Timpanaro, the Italian Marxist thinker, whose writing is saturated with the pessimism of the poet Giacomo Leopardi, intrigues me because, unlike so many left-wing thinkers, he stresses we are not the masters of nature, nor even wholly of our own nature, nor yet of the technology we produce. And we never will be. Through nature, we have our being: ultimately, we depend upon it. 'Accidents will happen!' What more can be said? The truth is that people enjoy disasters at a distance. Everyone has an active eschatology rooted in their heads. My mother has a terror of planes – like my dread of heights. They are flying back from Majorca today. I find myself worrying about my mother's worry, hoping she has not heard the news, or read the newspapers.

Sylvia and Colette come into the study. Sylvia cries for her dummy. *Naught for Thy Comfort*. Isn't that the name of a book about South Africa which my mother admires? Colette sits in the armchair, with Sylvia on her knees, and reads through the typescript pages of March 28th 1975 and March 28th 1976. 'And now for your letters . . .' The radio is still running. ' . . . the Heath Government took endless pains to avoid union confrontation before being forced . . .' Sylvia, here is more to cry for! ' . . . the Labour Government have put our children through the mangle of a comprehensive school system, and turned them out onto the streets with heads as empty as their own electoral promises . . .' Colette passes Sylvia to me. She is still in her zip-up yellow suit: she falls asleep on my knee with my arm around her, supporting her. She was conceived just a year ago; a fleck, a fusing egg cell and sperm: one that was not spat out into a shattered sherry glass.

All this makes me think about Ada Pearce, the old woman on the front page of the *Hackney Gazette* with her fears and her vanished world-dog. Shandy was the living, furry token of her isolation; Shandy

embodied, for her, what Karl Marx was on about when he wrote of our estrangement from the 'human essence' of social being. But her pet was also the creature through which she transcended the lonely depths of her isolation, a mythical beast which had stopped her from being swallowed up by the spiralling vortex of estrangement. 'He means the world to me.' The loss of that dog must be the eschatological nightmare realised for her, the annihilation of her world, the global catastrophe. Around the time Sylvia was born, I used to make a joke, 'Our world is a little fuller.' And so it was. Outside, in the streets, a dog barks loudly, as if on cue. All these incidents pour in, through the window, from the outside, punctuating thought with showers of enticing contingencies . . . That dog barks again.

Now analysis is finishing, the ground becomes clearer. I have been heaping up my own associations today, trying to relax by letting them flow with the ink through my ball-point pen, watching the level in the plastic tube drop. I can't look on this sort of writing as work. There is still so much of the puritan left in me that unless I am producing a batch of tiresome reviews, under pressure, I don't feel that it 'counts'. I am having a day off.

Sally and her sister Irene come up from the basement flat below us. They bring the mail which was put through their door. They ask if they can use the telephone. It is hand-outs from art galleries; there's one about an exhibition of Valerio Adami's work at the Thumb Gallery. Thick lines. Bland expanses of pure colour. Red surfaces. Unmistakably Sigmund Freud's face. Round white glasses. I know the photograph Adami used as a source: it is in so many of the books. Freud, glimpsed through the window of a railway carriage, going into exile in the last months of his life with the roof of his mouth eaten away. Adami's signature in white. The dead, packaged language of publicity men.

'Adami's highly individual approach in which cultural and political issues often of some complexity find expression in bold, graphic outlines framing areas of pure colour – has roots in both the Futurists and Pop Art as well as the work of Matta and Bacon. His work dwells on the isolation of contemporary man:

Adami portrays him as literally fragmented against a background of industrial trivia; frozen in transit in hotel lobbies, cafés, massage parlours. In the portraits of celebrated figures in intellectual life there is the same transitional feeling, often charged with violence, as in Walter Benjamin dying on the Spanish frontier or Sigmund Freud travelling to exile in London. The exhibition includes the ten original pencil drawings for the *livre d'artiste*, 'Ten lessons on the Reich', in which Adami collaborated with the avant-garde poet Helmut Heissenbuttel in an exploration of German history from Bismarck to Hitler.'

But I don't like this image of Freud. Adami: behind the mirror; it appears as disingenuous as the writing. I imagine Adami screwing his panes of plate glass over passages of past history and watching them flatten out for him. Waving the Freud flag. That must be what interests me today. Analysis and exile. Sigmund Freud's steam-rollered face and flattened hat, paper-thin, empty and artificial, behind the glass of a train window, riding to London, Swiss Cottage, chows, Ernest Jones, Maresfield Gardens and death. Exile. Freud ended his life just yards away from where my analysis with W. began. Travelling to and from the front of life.

Touched by the reference to Walter Benjamin, I pull down my copy of his collection of essays, *Illuminations*, from the shelf. Benjamin once said that he would have liked to have written a whole book which consisted of nothing but quotations.

'On September 26, 1940, Walter Benjamin, who was about to emigrate to America, took his life at the Franco-Spanish border. There were various reasons for this. The Gestapo had confiscated his Paris apartment, which contained his library (he had been able to get 'the more important half' out of Germany) and many of his manuscripts, and he had reason to be concerned about the others which, through the good offices of George Bataille, had been placed in the Bibliothèque Nationale prior to his flight from Paris to Lourdes, in unoccupied France. How was he to live without a library, how could he earn a living without the extensive collection of quotations and excerpts among his manuscripts?'

How to live without a library? Without quotations? Seven years ago, when I was in Buenos Aires with Katherine Eliot, a friend and journalist, we visited Jorge Luis Borges, the famous Argentinian

author, in the National Library there. In the time of Juan Domingo Perón, the Argentinian dictator, Borges was demoted to the role of a chicken inspector, but he had been re-habilitated. We walked through this vast building, past shelf after shelf after shelf of books. We came to the office where Borges worked. He sat behind a desk, on which there was a globe. He is blind. Behind him, and around him, were more books. Books everywhere. I do not remember much of what was said, only his statement, as he handled a heavy volume, 'Sometimes I think books are more real than people.'

Even though I dislike Valerio Adami's opportunism I pin up the reproduction that came with his gallery's hand-out. Freud's head floats on the wall immediately in front of my desk and I look out again at the world through my window.

The radio babbles on. Marghanita Laski is back again. The pitch of her voice sends prickles of irritation throughout me. She is now saying that the employment of women is, 'in some respects an act of charity'.

About seven o'clock, I go downstairs. Heather has come to visit Colette and she has brought her baby, Leo, who is now about nine weeks old: six weeks or so younger than Sylvia. The babies are fascinated by each other. Colette says this as I am thinking it. Leo looks so tiny beside an elephantine Sylvia, and yet within just a few months, they will effectively be 'the same age'.

Although baby books, and no doubt reality itself, show an infant's head-to-body ratio constantly diminishes as he or she gets older, the impression you get is of the head growing faster than anything else, of its dramatic transformations in size and shape. And the personality seems to root itself into the growing skull and face. No wonder phrenologists fumbled there! The personalities of Sylvia and Leo are quite different already. Leo always wears a hat: Heather says she is ashamed that he has so little hair. But they both make a similar 'er-wer' noise when they want to communicate pleasure.

They are much more interested in each other than they would be in a new adult. Is this because only another baby can provide a credible reflection of self? Now there are babies in the house I can see, without

the books, that Ian Suttie was right and Sigmund Freud wrong. When I look at Sylvia, frenetically sucking at a rubber dummy, I cannot deny her frantic search for what Freud called 'auto-erotic' oral satisfaction. But she only does this in the absence of the actual breast; the dummy, to her, is what the pin-up is to the masturbator. And even her relationship to the real breast can only be satisfying as part of her whole, complex, loving and loved relationship not with a thing, nor part of a body, but a complete person – Colette. I think her pleasure is oral only in the sense that the pleasure in making *love* can be said to be located in the penis or clitoris of the love-maker. Sylvia clasps, clings, shows flashes of a smile and hints of recognition, indeed *relates* to everyone she meets (and not just to Colette) in ways of which Freud seems unaware.

Heather has sad, wide eyes; she always feigns surprise at everything that is going on around her. She says that Julian, her husband, a company lawyer, felt his world to be shattered by roaring Leo's arrival. Leo looks so small and innocent there on her knees. 'Julian likes collecting stamps; going to football matches. Quiet sorts of things,' Heather says. 'He doesn't know what has happened to him now we have this screaming creature in the house.' I am lucky. I have never felt that, even though W. often seemed to be warning me that I would react to Sylvia's birth at some level as I had done to my brother's. An imposition and an impingement. But I am conscious only of having enjoyed Sylvia being with us in the world. I even like to think that her sensuously noisy presence, crying, feeding and crapping, has had positive effects on my own productivity.

Liam and Sally, who live in the bottom half of the house, may be going to live apart. Sally tells Colette and me that Liam told her, on the telephone, that he wanted to do his degree, and felt he could not do it as a married man. Apparently, he said he wanted some weeks to think everything out. He even spoke about selling up downstairs. The other day, Liam came and had a talk with me. He said he did not regret his decision to abandon the degree at all. We talked about the way in which he was taking on too much; he works as a laboratory technician, part-time window-cleaner, bar-tender, and he goes on evening courses.

He is six years younger than me. I put on a mock-patronising tone. 'You're young,' I said. 'You have your whole life in front of you.' Sally cannot understand why he wants to study when he has a 'good job' already. The growing fissure in their relationship makes me feel sad.

'They all wear gloves in that hospital,' Colette says, 'and they go around with their rubber gloves on all the time.' I am sitting at the table in the kitchen, and Colette is telling me about her day. 'It's only an arse hospital there, I think. But there were some people in it in pretty bad shape. A teddy boy there really looked terrible. People who've had accidents and things come there if they have done something to their arse. When I was in that terrible position, one of the nurses said, "There's a baby out there." I said it was mine. Then they started asking me, "Is it a boy or a girl?" But you really feel awkward stuck up there in that position. You don't feel like talking as if nothing was happening.'

While we are having supper, Tom, who is about three and a half, comes up from downstairs. Although Liam has left the house, Tom does not understand what is happening. He kneels on a chair at the other end of the table and draws. I watch him sketch a rough rectangle and place a circle somewhere near its centre; this he zig-zags with bold lines. As I write this down, I find I am thinking of the lines in some Munch prints, and also of that rare Matisse etching of pain – a single line, like a scream, across the page. I think it comes from his illustrations to James Joyce's *Ulysses*. I am seeing Tom's drawing as a diagram of his suffering. 'Daddy has been a bad boy, and gone away,' he tells us. 'Mummy is downstairs banging her head on the table.' Tom has a short, pudding-basin haircut. He puts on an impassive, round, self-consciously doltish expression. Sometimes, he seems to me like someone living within a polythene bag. I can feel him protecting himself against a world which he fears may injure him, lie to him, or delude him.

Sylvia is sitting in her baby-chair, which has been put on the table. She is reaching out and tugging at my hair. She wants me to stop writing and to attend to her. For a long time, after supper, through

news of the air crash and a million-pound sale of a piece of porcelain, Sylvia and I watched, looked, and played together. She isn't the only one who gets pleasure out of these exchanges! In his famous paper 'On Narcissism', Sigmund Freud wrote, 'Parental love, which is so moving and at bottom so childish, is nothing but the parents' narcissism born again, which, transformed into object-love, unmistakably reveals its former nature.'

Freud says somewhere else that, for adults, the charm of a child lies in its narcissism, self-contentment and inaccessibility. If he had been really close to children, I don't think he would have felt this. I suspect something much cruder in parental love than 'narcissism born again'. All this makes me think about the long period of dependence of the human infant on the mother, which must have been crucial in establishing the difference between man and the other higher primates. The unique nature of the mother–child relationship in our species surely holds at least some of the clues concerning mankind's evolution as a social species, capable of symbol-formation, culture, civilisation and possibly even socialism. It can't just be a matter of mirroring narcissisms. As Ian Suttie realised, the infant has to play its part in establishing a *relationship* with the parents: without parental love, the infant cannot survive at all. Does this explain that whisper of a smile I see in Sylvia, even in Leo? There's no equivalent for this in other species. It is one of the ways the tiniest infant draws you into a protective relationship, and 'rewards' its parents. The infant's experience of this necessary and reciprocal love forms, ideally at least, the basis of even the most complex of adult intimate and social relations. As I think these thoughts, I see, as a vivid and very plastic image in my mind, a male stickleback with a chest as red as a robin's, building its nest, spines a-quiver, driving a ripe female in to drop her eggs, fertilising them, fanning and tending them for twelve days, chasing away all predators, shoaling the fry, and then calmly eating them on the sixteenth day. In the stickleback, the nest-building instincts are programmed in a way which is unrelated to those whom the nest is designed to protect and nurture.

I telephone my parents. They arrived home safely, of course, at about eight p.m. Their friends, the Smiths, went on holiday with them. Frances Smith had been even more upset by news of the air crash than my mother, and this appears to have given her confidence. She seems to have been more concerned about comforting Frances than with her own fears.

'The food wasn't bad,' my mother says. 'It was the best hotel we have been to for food, abroad I mean. At first we didn't think it was much, but it wasn't bad.'

'We saw four species we hadn't seen before,' he says, with birds in mind. 'Although the total number of species was very few, very few indeed. We couldn't get out of town enough to see a great many. Still, we saw the four we hadn't seen before, in the scrubland, and that wasn't bad.' I imagine my father is ticking off the 8,798 bird species of the world. 'A very pleasant holiday,' he adds. 'Very pleasant indeed.'

1978 Redding, Connecticut

We have all come up from the barn to Natkin's house, for supper. No one is talking about suffering Apollos. Bob is making a soup. I am looking through a catalogue from Delaware Art Museum which includes a reproduction of Edward Hopper's painting, *Summertime*, of 1943. Four years before I was born. A lonesome, sensuous woman, wearing a hat, stands in front of a house. She is framed by pillars. In the background is an open window the curtains of which have been blown outwards by a fan. An architectural façade shuts out the unseen inside, behind the window. The woman's dress clings to her body, but she is isolated and unreachable in the airless light. Hopper has painted the overhead noon-day sun as cool as the woman's unseen sex, which I imagine to be cold and clammy, like a whelk.

'To me,' Edward Hopper once said, 'form, colour and design are merely a means to an end, the tools I work with, and they do not interest me greatly for their own sake. I am interested primarily in the vast field of experience and sensation.' I like to place this quotation

beside a statement by Mark Rothko, who did not want his great colour field pictures to be taken for abstracts: 'It is not their intention either to create or to emphasise a formal colour–space arrangement,' he said. 'They depart from natural representation only to intensify the expression of the subject ... not to dilute or efface it.' He added, 'My paintings are sometimes described as façades, and, indeed, they are façades.'

1975 Le Châtelet, France

Colette comes into the room where I am writing, and dreaming, and writing about dreams, to tell me that it is time for supper.

1976 Graham Road, London

I must stop working on these days, and get ready to go out to Bernard Goldman's house, off the Roman Way. I think of the bright colours of his kilims.

1977 Graham Road, London

I telephone Rosie van der Beek. Tomorrow, I will go into New Left Books, where she works, to buy a copy of Jean-Paul Sartre's *Critique of Dialectical Reason* as a leaving present for W. I ask Rosie if she will have time for a coffee then. She says, 'How's your analysis? Have you given up yet?' She asks that every time we talk. She makes analysis sound a bit like smoking which she stopped through a course of hypnosis. She was just as surprised as Ruth, my sister, yesterday, when I announced that my analysis was ending on Wednesday. Then Rosie said she had been thinking about having either analysis, or a baby. Ruth, too, responded by saying she was either going to *become* an analyst, or have a baby. They are just like me in that they seem to associate analysis, particularly *ending* analysis, with the mother–child relationship. I say to Rosie, 'I'm glad I went through with it.' 'Yes,' she replies. 'You're a walking advertisement for analysis.'

When I put the phone down, I think that was a strange comment. But I know that the work W. and I have done – whatever its limits – has been sound. Four and a half years ago, I was really in chains. I often played down the strangling tightness of those compulsions: like a sphincter ruffed so tartly round the neck that no escape was possible. Now at least I feel relaxed enough to know where I want to engage myself, to choose how and when to invest my energy.

Through analysis, I think I can accept what cannot be changed and realise, to the full, the chance of changing what can. Analysis has made me aware of the extent and limits of my capacity to choose and to act effectively upon myself and the world. I hope I can now be like an Engels-Man, making myself by acting on those elements of my history which are given, or a Later-Sartre-Man, making something of that which has been made of me. I am glad I went into and am coming out of analysis, pushing it through the choking throttle into some kind of resolution.

Perhaps I have only broken through into a bigger enclosure which is surrounded by another, yet-to-be-discovered, painted façade. But even that is worth something: the walls are further away. I feel much better than I did last year, when I sat here in a state of cynical turbulence, at home with Beckett, just before those snatched moments with Imogen; better even than the year before that, punctuated with pious 'moments of becoming', with so much still to be done, or the year before that when I sent John a letter from Le Châtelet. At that time, I was almost in despair: a black March madness. Pushing on, deeper, into Marches past. Images of writing and confessing a year before that. Of 7 *Days*, the weekly magazine, failing, a memory, it must have been March, of embracing A . . . A life develops in spirals. It passes again and again at the same points at different levels of integration and complexity. But I am clearer and surer than before. I feel this is a new beginning.

1978 *Redding, Connecticut*

Bob says the soup will be a couple more minutes. As I watch him, stirring, I think of story book characters again: of good witches from

his favourite *Wizard of Oz*, and of what he said earlier about when he looked in the mirror. Among the ingredients Rothko listed in a 'recipe' he once drew up for his art were 'a clear preoccupation with death'. 'All art,' he wrote, 'deals with intimations of mortality and sensuality, the basis for being concrete about the world.' I consider telling Bob about this, but think better of it.

Instead, I look back at the reproduction of Edward Hopper's painting. I am sure I am right about how close the sensibilities of these two artists were. *Summertime* too is a sensuous painting, a façade painting, shot through with 'intimations of mortality'. Edward Hopper just found another way of realising his sense of alienation, as an image. And that is what Natkin was saying he has done, too. The feelings I have in front of a good Rothko, Hopper or Natkin painting are very much the same. See how in this Hopper, in all that brightness, the woman is stifled with cold.

1975 Le Châtelet, France

Tonight, on television, there was an epic film about Pontius Pilate. We watched it, Colette, her parents, and I, in silence. I was reminded of Roland Barthes' essay 'The Romans in Films', which I read earlier this week. Needless to say, Pilate had a perfect Roman forelock. The film touched upon all those religious debates and battles of my past. I did not spring into this world as a ready-made materialist: my eyes were cleared on the road from Damascus, my birth-town. Partially cleared. It is hard for me, too, to kick against the pricks. Stigmata bleed in my mind. In Holy Week, they tend to sting.

1976 Graham Road, London

Good Friday is still weeks away, and already I feel as pierced as St Sebastian.

1977 *Graham Road, London*

It was Passion Sunday yesterday: no tears, and hardly a drop of blood. A mythology has been crushed: its living matter dried out. The stigmata are no more than withered cracks in the oil paint of ancient images. The icons have ceased to weep and excrete.

1978 *Redding, Connecticut*

Easter is over, unnoticed.

March 29th

1975 *Le Châtelet, France*

I lived yesterday believing it was a Thursday: time twists strangely when I am on holiday. Perhaps I wanted to avoid *that* Friday, Good Friday, in particular. In France, shops stay open: you can bank on a crucifixion if not on a resurrection. My determination to erase that black day from my consciousness must have been strong. I realised the oysters were a Friday food; we watched a Good Friday film on television. Even so, in the evening, before we went to bed, when I asked Colette which day it was, I would not believe her when she said it was Friday.

Earlier this week, I wrote a short story with Easter in mind. A man goes to a prostitute and asks her to crucify him. She refuses, but he insists she should let him talk. He produces a chain of associations describing the 'mind-forg'd manacles' which trap him within the mail armour of repetitive, personal time. He ends by worshipping the cross formed by the great divide of her buttocks and thighs. She tells him she will not be there the following week because she is going away for Easter. The reader then realises the man comes every week, repeats his request, and all his associations, and she replies with the refusal he has scripted for her, each time the same. He has devised a brothel drama through which he can repeat rather than remember. The only means of escape would be a crucifixion itself, a crucifixion which, of course, he will never enact. As I remember the story, I become aware of all manner of links between it and the thoughts I had yesterday about Faisal and his assassin, and two different kinds of imprisonment.

1976 *Graham Road, London*

This year, Easter has slid down the calendar again. There are still almost two weeks before Passion Sunday. I said that I *wrote* that story in Holy Week last year. In fact, I did not finish it until May. If I had not made the entry, here, on March 29th, I would have been convinced that

the form and plot had grown slowly with the work; but now I see it was there, intact, at the very beginning. It was not finding the story that caused all my difficulties with that piece. In writing, the loops, the boundless curved spaces and twists of personal time reveal themselves. The linear chronology we retrospectively impose on experience disintegrates. Writing burrows forwards, backwards and sideways all at once. The rest is a matter of making excuses for working, as if for the first time, towards points in fact passed several times, long ago.

Derek Hirst, a painter friend, once told me another crucifixion story: a true one. Sometime late in the last century, the Royal Academicians began to argue about what Christ's crucified body 'really' looked like. The main hindrance to empirical research was the fact that a crucified cadaver tended to be in a state of advanced *rigor mortis*, but Jesus was alive when he was nailed up. The Academicians therefore arranged with Chelsea barracks that the body of a soldier condemned to death by hanging, for treason, should be rushed to Burlington House as soon as sentence had been carried out. The Academicians received the soldier's corpse, and immediately it was laid out on a wooden cross, flayed, nailed up, and a plaster cast taken from it while the flesh was still warm. The cast loiters in the Academy, among the dust, copies from the antique, nameless canvases, cracking pigment, and stretchers: but this plaster soldier has no chance of rising again. It is long after the third day. In the late 1960s, apparently, a surgeon examined the terrible relic and declared that, at the moment of his impalement, the soldier had still been alive. Realism is rarely more than the repetition of a lie.

1977 *Graham Road, London*

This morning, when I get up and go to wait for the bus, I notice a strange translucence in the sky. The last three days have been bitter cold, with sharp night frosts: a living death. But the light has been crisp and bright. Today, Graham Road seems strangely unfamiliar, unreal, impalpably transfigured; it is peculiarly empty. There are fewer cars and lorries rolling into the city than usual for the time of day. The

silent, agitated crowd at the bus stop, shuffling over newspapers and lunging with cigarettes, waiting to get to work, is smaller than it ought to be: there are fewer people walking the streets too. 'Is today a bank holiday I have forgotten?' I find myself wondering. Can all this be projection? My eye smells a tree newly snowed with spring blossom. Another year! The 'end of analysis' coincides with a new beginning: a season of births and flowerings. Perhaps it isn't the end in an absolute sense: rather that one mode of analysis is superseding another.

I arrive for our penultimate hour. Four years and five months, I have been coming. Beside the chair where, recently, I have been sitting since I refused to take any more of it lying down, there is a brown envelope. I know at once that it contains those yellowing, typed letters my father sent me – Epistles to Peter – when I was away at public school. I lent them to W. more than two years ago, just before we went on holiday to France to visit Colette's parents, and then to stay with John Berger. I wanted W. to understand. I often asked for them back: or, at least, I mentioned the fact he had failed to return them. I had my own theories about why this was – and, of course, I did not hesitate to elaborate them.

This morning, W. tells me I may find things harder than I think, later on. I say that I realise the difficulties. I have an image of a dug-out, an aerial view of military earthworks, followed by a muddy trench, wattle, camouflage, barbed wire, netting with twigs and khaki caught in it, dying trees, stripped naked and torn apart by bullets, a man from the cover of a book about Flanders, holding his part of the front line with a raised rifle, heavy boots and a heavier heart . . . images from Sassoon, and the smell of the dubbin we used on Thursday afternoons when getting ready for the Officer Cadets Training Corps session the following day. I try to put the feelings this arouses in me into words, but I cannot. I know we no longer have the time to track down all the associations. Once the date for an ending has been fixed, the process is effectively over: the story written. The rest is adjustment to the idea of not being in analysis while in fact one is.

Pulled along a narrow canal towards the light. Mechanical metal forceps locked around the head. An imminent freedom. Like not having to go to school any more. Birth and discharge. But it threatens

another and more negative kind of freedom, too. I say psychoanalysis becomes almost an institutionalised, external superego, a day-to-day way of watching over oneself in the presence of a critical other. How will knowing that I will not have to talk about what I do, and what I think – becoming, in fact, answerable only to myself again – how will that affect what I think, and *do*? In all the material I produce today, there are hints and traces of such fears.

But I am enjoying the lack of tensions in these final sessions. I have the feeling of something finished on its own terms. I say to W. that it is like a book which could have been written differently, but, in fact, has been written the way it was, and in that sense has reached its definitive end. Again, he questions my feelings of confidence, but I admit to doubts, grey shadings, traces of apprehension. But today, my overall dominant feeling seems to be what matters. And it is good. I welcome the coming break. From this point, here, I look forward, leap forward, towards 'Life Without Analysis', just as in November 1972, I leaped forward to 'Life With Analysis'. The possibility of decisive, positive *change* in both these situations excites. A war is finished!

1978 Redding, Connecticut

We wake late, but still tired. Sylvia was teething through long slices and rough chunks of the night, kicking, crying and feeding, again and again, from Colette. Outside, spring unlocks and uncoils, each day stabbing more sharply through the soil of the New England country-side. I turn away from the window, walk across the bare concrete floor of the barn, and plug in the kettle to make some tea, as I do so remembering that last night, before Sylvia woke, we made love, warmly and well, and with Colette there, so tenderly, I felt myself slipping into the world's glove, working the joints and knuckles of the hand: no space for vacuous imagery.

According to Michael Crichton, Jasper Johns wrote on one of his notebooks:

<div align="center">

'Time does not pass,

Words pass.'

</div>

Postman Ferdinand Cheval's, '*Ce n'est pas le temps qui passe, mais nous*', is much better. The Johns book goes on to quote – it would – Dogen, 'A Zen Master':

'It is believed by most that time passes; in actual fact, it stays where it is. The idea of passing may be called time, but it is an incorrect idea, for since one sees it only as passing, one cannot understand that it stays just where it is.

1975 *Le Châtelet, France*

Le Châtelet is a kind of citadel, too. Here, right in the centre of France. I have an image of Herod's palace, Feisal's prisons, and the great cathedral not far away in Bourges. Easter impending in the fabric of French life. About five years ago I became so excited when I first read Marx's statement that the critique of religion was over. I wanted to believe it was true so that I could relinquish my own past. Sometimes, I feel as if I lived the first parts of my life in an insulated capsule, a bathyscaphe, which had been lowered into the previous century. If I had chosen to ignore my own history, I would be doomed endlessly to repeat it. I was born in Damascus, and my sister in Nazareth. Children of the Holy Land. I have always felt that in the first twenty years of my life, my biography became indelibly bound up with His: He permeated my being. Only slowly could I pluck His thorns out of my flesh. Even quite recently, I have woken up in the night, with a white sheet pressed against my lips like a grave cloth, shivering with the thought that tyrannous Faith might return. The road from Damascus.

Even before I went away to public school at the age of fourteen, I was juggling with contradictions. I had scores of fossils – corals, urchins, ammonites, belemnites and Saint Cuthbert's beads – arranged roughly and none too systematically in rows on the shelves of a glass-fronted cabinet; among all the living creatures that shared my bedroom was a tank of Blind Cave Fish, eyeless pink creatures from the pot-holes of Mexico, which shoaled and twisted, endlessly restless, round and round their aquarium. These fossils and living things had already taught the less pious half of me that the principal of the Sunday School

was probably trying to lie when he repeatedly showed film strips about the Piltdown Man. 'You see,' he wanted us to think by showing us the forged missing link, 'you see, all the evidence about evolution has been similarly rigged.' But I knew that the Winchester fish dealer, Mr Wingate, whose shop stood in the shadow of the grey Cathedral, had not gouged out the eyes of his cave-dwelling creatures. And I did not believe God had made them that way, either.

My father did not pronounce on evolution himself. He wrote a letter to the Sunday School principal, the successful manager of a Southampton-based chain of hardware shops, in which he advised him to avoid the subject because it was 'too controversial'. I am not sure that I ever came to understand what my father himself really thought about all this; but it seemed to me, at the time, that he believed simultaneously that God created the world in seven days and that evolution was scientific fact.

He was a prodigious reader. So many of my childhood memories are of him armed with a pile of books and journals; even at breakfast, he used to place them beside him on the morning-room table. But he appeared to be an opponent of most contemporary ideas. The business over the Sunday School film-strip was the first intimation that I might be going to have intellectual differences with him; later, we were to struggle fearfully over Marx and Freud. But my father was not so harsh on Darwin: had he not kept his faith, after his fashion, to the end? Was he not a professional man, a scientist and a doctor? Instead of criticising him, he raised the spectre of the primacy of Faith and the necessity of letting it override our petty doubts, contradictions and lacunae of ignorance. Later I discovered he admired Père Teilhard de Chardin, even though he did not agree with him about everything, or perhaps about anything very much. But Teilhard had achieved the kind of uncompromising synthesis of science and spirituality which appealed to him.

Slowly, I turned my bedroom into a museum and filled it with books, drawings, specimens and small living creatures in tanks. And so, one day, I found myself lying on the floor, in the middle of all this, studying the gospels, worried because those words which I knew so well, almost

by rote after years of daily readings, left me cold, with less feeling than when I handled a piece of dead coral: a calcareous residue from which all life had fled. But that same day, I was to be baptised by complete immersion, and on confession of a faith which was quietly slipping away from me. Thus would I be received into the community of the brethren and become part of 'the priesthood of all believers'.

In those days, Eastleigh, where we lived, was a railway manufacturing town. There were two main factories, one for locomotives and the other for carriages. Sometimes, on 'open days', we would go into those places which were full of the smell of oil, cataracts of sparks and spirals of metal twirling out of the giant lathes. We were allowed to pick up a few twists and coils of discarded metal shavings, so long as we did not cut our fingers on them or get grease on our clothes. That was the closest I ever got to industrial production. There was also a huge cable workshop complex, behind a high brick wall, run by Pirelli's in the town: every morning, we timed our preparations to set off for private day schools by the sound of the works' hooter. Sometimes, during holidays, we would walk up Leigh Road to the great gates of Pirelli's, to watch the muddy stream of cloth-capped grey and brown figures, some on foot, some on their bicycles, pouring out, on their way home.

Most of those who went to the Union Baptist Church were working class. Many came from these three factories. But there were also shopkeepers, carpenters, postmen and bakers among them. My father was – as he said himself – 'a professional man', a general medical practitioner. The Town Clerk was also a member of the congregation; there were a couple of school-teachers; but otherwise few professional men. My father had – or so I imagined – pulled himself out of a milieu of tailors and aproned tradesmen by bending the soles of his own boots upwards. He did not often speak about his own childhood in North London. His father had died before I was born: he was a retail shop manager for a tailoring firm whose strength was its weaver-to-wearer policy which eliminated distributors and middlemen. Apart from that, I managed to gather only a handful of facts about him. He smoked a pipe – something my own father would never do – read Thomas Carlyle's *French Revolution*, and was, or so my father's cousin George

told me, mean about the amount of meat he served from the Sunday joint. His wife, my grandmother, had once been an assistant in a greetings card shop. Until the end of her life, she enjoyed card rhymes and would read out what she took to be good ones at Christmas. Once she arrived at the house in Eastleigh, saw a gleaming new hat-stand rising erect in the hall and said, 'The poor can live.' Another time, she brought back a tea-maker my parents had given her three years previously, unused. She said she preferred to brew herself. I could see my father was hurt by these incidents. He hoped she would recognise he had 'bettered himself'. She did, and she was proud of him. But she also felt threatened by his success. She would often say things like, 'We lived the whole week on half-a-crown and was happy on it.'

My father was always conscious of where he had come from. He was never fully accepted into the middle class because he never fully accepted it. What he once called his lack of 'social poise', and his modified temperance ideology – I could not imagine him actually signing a pledge – separated him from his 'professional colleagues'. He still spoke about 'respectability' and 'conformity' as virtues to which one ought to aspire.

Perhaps it was in those well-packaged, white-table-clothed, middle-class motoring hotels when I saw his anxiety as he struggled in vain to 'catch the waiter's eye', something I, too, have never been able to do with any grace, that I began to realise how he was also on his own. He referred to working-class people as 'simple bodies', if they were deferential, or as 'uncultured individuals', if they were not. But he could never become absorbed into the class of his aspirations. For all his 'craving to conform', he remained a courageous and unyielding Non-Conformist.

Culture, or, as he called them, 'The Great Things in Life', were part of his salvation: they formed the heady terrain onto which he believed he could raise himself above the philistines of all classes. He did not think that the modern world nurtured many of these 'Great Things'. The more I became interested in modern painting and writing, the more it seemed to me that he tried to construct a shell, or capsule, which insulated him from his own time. On the front of the large house

was a stone on which the date 1886 had been decoratively carved. The advances of science and technology he acknowledged – if not taken too far – as a sign of progress. But apart from an interest in the unused and the brand-new, the ideas, art, philosophy, literature and ideologies of the twentieth century largely passed him by. The exceptions, perhaps, were the major theological thinkers – Karl Barth, Dietrich Bonhoeffer, Reinhold Niebuhr, and Paul Tillich among them – who had held fast to the faith in such difficult times. Much twentieth-century culture, he would argue, would be seen, in the fullness of time, to have been a transient phenomenon. He wanted to put his finger on that which was eternal. His shelves were piled with texts on theology, art, literature, archaeology, topography, natural history, medicine, music, astronomy and ornithology, but the ambience of most of these books was that of a world which stopped short somewhere before the First World War.

He was a collector of facts which filled the small white cards he filed in bundles, suitcases and boxes. Dates and page references; lists of names. I sometimes used to imagine that he believed that one day, when he had gathered enough of them, he would possess The Truth. I thought that he saw knowledge like a beach of pebbles: each hard-core 'scientific' fact could be autonomously stored in a world where even the slow erosion of the ocean had ceased. But perhaps I never fully understood his way of thinking.

Once he was given a great Victorian brass microscope and boxes of slides. We were thrilled when he showed us the Lord's Prayer written on a dot the size of a pin-head, a beetle's wing, stained segments of leaves and stalks and a miniature photograph of the grave of Spurgeon, the preacher man. Later he turned briefly to gazing at the stars from his waiting-room through a mounted telescope. Then he equipped himself with binoculars, a telephoto lens and camera and special recording gear, and he began to gather images and tapes of the birds of the world and their songs. All this sounds Victorian, but that is not fair. For nothing tarnished a patina of brand-new freshness: most of his books, with the exception of the theological tomes and a select section of antiquarian medical books, came in recent editions. I think it was I who introduced him to the Folio Society: he liked the old rendered new. His

world seemed to be covered with a cling-film skin of modernity.

And Faith, of course, plugged the gaps in his system. Faith was the source and spine of his rectitude, the pillar which, as an adolescent, I felt had rendered him as rigid as Lot's wife. Anything which threatened Faith, or called it into question, or even corroded it at the edges, had to be evaded, ignored or denied. If none of these was possible then the offending irritant – whether from the fossil evidence, findings of the physicists or the depths of human suffering – was smothered with a pearly excretion, so that it could hang, suspended, as a token of the feebleness of man's understanding of God's world.

An outsider might have assumed that, in the communion of the faithful, he would have found companionship and a retreat from the threats of an impending and impinging world. But this was not really so. Although he was inside that brotherhood, he was not of it. A doctor in this community of shopkeepers, working men and tradespeople, his fellowship was that of an intractably insoluble chip dropped into an even solution. Outwardly, he expressed admiration for their 'simple faith'; inwardly, he knew he was set apart from them. His beliefs were more complex and so, perhaps, more precarious than theirs. Despite his Faith, he prided himself upon his scientific outlook on life; thus he was contemptuous of the 'poppy-cock' of unproven arguments and irrational speculation. A rigorous teetotaller, he was merciless in his criticism of vegetarians, Pentecostalists, herbal medicines, Jehovah's Witnesses, osteopathy and, of course, psychoanalysis. He never served wine, beer or any alcoholic drink to anyone who entered the house but, wherever he went, he expected soft drinks to be provided for him. People, he said, respected his principles.

Where Science and Faith were palpably at odds, he went to great lengths to keep them apart, to ensure that they never clashed in his mind. But it was not just his scientism which set him apart in his chosen congregation. There were also 'The Great Things in Life': those of 'the simple faith' did not pass their leisure listening to classical music, learning new languages, subscribing to quarterly magazines on the archaeology of Palestine, or visiting stately homes and the opera at Sadlers Wells. Indeed, they rarely came to the house at all and when

they did they sat stiffly, on their best behaviour, embarrassed by the tall ceilings, lavendery smells of polish and sprinkled linen, the heaps of crisp new books, *The Lancet* and the floral-patterned bone-china tea-set.

But with whom was he to share his interests? His middle-class 'colleagues' were as ignorant of The Great Things as those circles he had so painfully and so partially left behind. At best, they were Church of England Sunday Christians who drank and smoked. Music, art and literature were little more to them than by-products of their social lives. He never developed any interest in boating, cocktail parties, local politics, Tory fund-raising, horse-racing, parish functions, adultery, the Rotary Club, Local History, golf, motor rallies or any of the other Ungreat Things which were the consuming passions of local doctors, most of whom read nothing at all. Not even *The Lancet*.

On Saturday afternoons, my mother and the three of us happily accompanied him on his restless visits to theatres, opera houses, nature reserves and the stately homes of England. But once, during the interval at a repertory performance, she said to me, 'Shakespeare's not really one of my favourites.' I felt, perhaps wrongly, she tolerated 'The Great Things in Life' out of love for him. In the house, she had her own bookshelf, with novels by Nevil Shute and Morris West, reference books about flower arrangement, gardening, cats and patchwork quilting. I never heard my father discuss his reading with her: she acknowledged it was a world of his own.

My baptism was the symbol of my acceptance of this incongruous castle of contradictions as being synonymous with 'reality'. The Minister said to me, jokingly, 'We want to make sure of you before they try to get you.' He was referring to the Anglican public school to which I was about to be sent. No other candidates from his flock would be exposed to such influences. The water in which I was to be immersed represented my decision to become drowned within my father's contradictions, for the sake of my identificatory love for him. I was, for the time being, agreeing to accept his cross, to live my life outside of history, without a class identity, nailed through one hand by Faith and through the other by Science, with my head raised above the things of this

world, lost in the mists and sonorous clouds of 'The Great Things in Life' as defined by the experts. But I already had my doubts.

1976 Graham Road, London

Throughout last week I did not go to analysis. W. telephoned to say he had a crisis and was therefore cancelling all his appointments. This week, we have begun again. But as I lie on the couch and stare at the top of the door, I find the intrusion of reality impossible. Of course, I have not been told what his 'crisis' is: I suspect a birth, or a sudden death. But, for me, it had all the violence of a brick crashing through the window during a session. I am reluctant to associate to my swarming suspicions, because I am aware that they are rooted in my perceptions and intuitions about his *real* life, as separate from those projections originating in my own life which, during the usual course of analysis, I heap upon him. His phone call, at least temporarily, seemed to tear a gaping hole in the protective screen of the transference. Behind what he calls the 'necessary fictions' of the analytic procedure, I felt the actuality of events which he was suffering. This outweighed any fantasies I might have had about them. Is this a sign of how far we have progressed over these three years?

1977 Graham Road, London

I walk from Harley Street over to Soho savouring the thought of life without analysis. In the New Left Review Editions office at 7 Carlisle Street, Rosie tells me she has been arguing with Ronnie. As she talks, I am thinking about how, for four years, Ronnie held his microphone in front of the gored peasants who survived the Spanish Civil War. Excluded, like the rest of us, from 'conscious participation in the making of history', he tapped the wounds of those who were not, and the old, bad blood of Spain flowed into his cassettes. Once, when Rosie went out there with him, I missed her very much: Rosie and I confide in each other. She sent me a postcard of a blonde woman on the beach:

when I twisted it in the light, the woman winked. The face on the postcard reminded me of her.

Back in England, Rosie helped Ronnie to transcribe his tapes and to transfuse his material into a book, but now she is saying that she feels their whole lives are draining into his text. She wants a separate identity. A flat of her own in Tufnell Park. She repeats what she told me on the phone last night: she is wondering about what to do next in her life, whether to go into analysis, or to have a baby. Whether to mother, or to be mothered: that is the question.

Rosie and I met on *7 Days*. *7 Days* that shook the world. A short-lived 'revolutionary' photo-news weekly of the early 1970s. Rosie kept the ledgers; I ran the home news desk. Now Rosie manages the New Left Review Editions Book Club. Rosie is always easing other people's words out into the world. She has been midwife to too much left-wing intellectual matter. Talking about babies has reminded her of a time when, after we had been winding down the tangled affairs of a collapsed *7 Days*, she, Fred Halliday and I went to a grubby café near Piccadilly Circus, and I said that I did not want children because I did not want to produce someone who, even in imagination, would be plotting to murder me. 'Well, psychoanalysis has changed all that, hasn't it?' she says laughing. Psychoanalysis and Sylvia.

I buy a copy of *The Critique of Dialectical Reason* from her, for W., and she gives me Terry Eagleton's *Criticism and Ideology* and the hundredth issue of *New Left Review*. She thinks she wants a baby more than analysis. As I leave, bearing my texts, I wonder how many times I have trodden these stairs. *Black Dwarf* once had offices here below *New Left Review*, and I used to bring in articles by-lined 'Percy Ingrams' for a 'City Dwarf' column, which I compiled from material I gathered while working on *City Press*, 'The Voice of Honest Capitalism'. When I went into the office, having rushed over from Moorgate, Tariq Ali would greet me with, 'Hallo Comrade!' And this made me feel proud, and confused, all at once. I also discovered from my reading of Victorian esoterica that 7 Carlisle Street had once been the home of a notorious nineteenth-century flogging whore, who specialised in whipping gentlemen. *Plus ça change . . .*

I walk across Soho Square. Every time I do so, I think of Colette, of the first time we had to part, in 1967, after we had fallen in love, and I sat here, and wrote a poem for her.

It is hard to understand
Soho Square on Sunday.
Here it is quiet:
Memories of you,
Hands, lips, eyes and hair,
Make the whole scene sad.

I have said
I don't understand
What you have left behind.
But something there is of you,
Still, here in this place.

I have come, like a supplicant,
To find it.
But absolve me, my love;
Because it hovers and haunts me,
And changes to rank despair.

I must go now and leave you.
I think you will find
The faceless ignorance of
Pigeon feeders
Is kinder company.

Two minutes later:
Black ants pitching battles on the paving stones;
Ringed pigeons everywhere;
Still the royal statue,
Watching through its stiff, macabre mask
In grimy majesty,
Still the crowded emptiness,
Still the air.

In the Charing Cross Road, I pick up a 38 bus; upstairs, I start to turn over the pages of *New Left Review*. One hundred issues. A time for celebration, taking stock, eyeing the past and the future. Once, NLR writers seemed like gods to me. The bus is passing the Ministry of Defence buildings in Holborn as I find myself reading the words, 'In 1960, Marxism was only just beginning to emerge from the long night of the Stalin era.' And I was about to be incarcerated for more than three years in a minor public school.

> Grey-suited we stand by the kissing grid gates,
> 'Please Sir, it's time for the bell.'
> Grey-suited we Bosch through the slippery air,
> 'Please Sir, I think this is Hell.'
>
> Grey-suited we hear the pot-bellied priest,
> 'Please Sir, he's holding a fork.'
> Grey-suited we clamour for food everyday,
> 'Please Sir, it's unclean; it's pork.'

The school magazine rejected it. 'The Young Marx was having his first impact on an English-speaking readership – the *Economic and Philosophical Manuscripts* had appeared in translation in 1959 – but the *Grundrisse* and *Theories of Surplus Value* could still only be read in the original . . .' I have read only parts of the *Grundrisse*, and none of the *Theories of Surplus Value*, but the early Marx had a profound effect on me. At one point, I more or less told W. there was no point in trying to proceed with my analysis unless he had read the 1844 Manuscripts.

The article continues,

'Lenin was available only in a heavily censored edition; there was little in English by Luxemburg, Gramsci or Lukacs. Isaac Deutscher and Raymond Williams, of course, wrote in English; but their books – the second volume of [Deutscher's] Trotsky trilogy appeared in 1959, [Williams's] *Culture and Society* in 1958 – had only begun to gain a mass public. The diffusion of Marxist works by tens of thousands in paperback editions was not to occur until the late sixties.'

For several minutes, I gaze out of the bus window. The diffusion of Marxist works by tens of thousands in paperback editions. All lined up behind Rosie's head in that office. Words. Yet more of them, multiplying. We are passing Mount Pleasant now where a cluster of postmen are standing on the street, talking. The only money I earned for anything other than writing was when, one Christmas, I worked for a fortnight as an auxiliary postman. Delivering letters. More words. Holy birthdays.

'When the Review was founded, it was true to say that Marxism had never taken hold in the English-speaking countries. Now, though it still has only the weakest implantation in the working classes, a basic Marxist culture is at least available, and has to a degree established itself in their general intellectual life.'

Intellectual life. A long way from Serge. But it was inevitable, I suppose, that as I lifted my dripping head out of my father's pool, I would find this current.

As the bus loses itself in the Angel, I find myself thinking about the fact that many of us who came to Marxism after that 'long night of the Stalinist era' was over never felt the *necessity* of historical action. Of course, my generation looked upon 1968 as a moment of historical *hope*; however confused and contradictory my political perspectives at that time, I marched, protested, evaded the police horses in Grosvenor Square, and believed in an imminent, and benign, transformation of the existing structures of power. It was the spark of that moment of hope which ignited the demand for Marxist books 'by tens of thousands'. But the hope was quickly extinguished. A capitalism which, in the *New Left Review* terminology, was 'torporic' (where do they find these words?) and culturally stagnant, nonetheless revealed itself as intransigently imbedded.

The Marxist tradition – already fragmented by the prism of Stalinism – shattered into another myriad of splinters. Out of the window, I can now see the old Odeon Cinema building (it must date from the 1930s) with its magnificently decorative tiled façade. Certainly, I soon discovered that I could not communicate with many former student friends – the ones, as it were, who still believed the meaning of life could only be realised through immediate action. Some of those with

whom I had marched in London and Cambridge, who nurtured notions of *Urbs Militans*, the city, like a sea-urchin, bristling with arms, drifted towards the fringes of the Angry Brigade, Anarchism, and a now forgotten cult of the late 1960s and early 1970s, 'Situationism'. They thought random letter bombs could revitalise a sluggish historical process.

I went back to the books which continued to appear, unabated. Words and more words. In the 1930s, it made sense for a left-wing intellectual like Christopher Caudwell to pick up his rifle and to go to fight in Spain. Today, Ronnie Fraser, a former member of the *New Left Review* editorial board, picks up his portable tape recorder and a pile of history books, and goes out there. And most of us don't even do what Ronnie did. Here at home, the jostling for rarefied, nuanced, over-tuned theoretical 'positions' heats up. As one might expect of 7 Carlisle Street, historically speaking, everyone vies with each other for the most perverse and punishing 'correctness'.

The bus turns right into Balls Pond Road. Further on in *New Left Review*, Raymond Williams is writing on Marxism in Britain since 1945.

'. . . through the conflicts of legitimating theory, and in the very amplitude of academic theory (in its establishment of several clear and alternative Marxist traditions, and its critique of particular selective traditions), it becomes more and more difficult to use "Marxism" as the crucial definition of alignment which, in the late forties, it ordinarily was. It becomes, that is to say, less and less an adherence to any significant kind of operative theory – a theory carrying practice – to announce, flatly, that one is a Marxist and (which follows in polemic as night follows day) that someone else is not, or is not yet, or might be or could well be if he tried. Is or is not what, any serious inquirer is bound to ask, as he sees the significant and important variations of operative Marxist theory (leaving aside the even wider variations of legitimating and academic theories) on such central questions as class, culture, the democratic process, the capitalist state, productive forces, the division of labour, industrial growth and political organisation.'

He criticises 'the polemical habit of measuring everything against a pure (and therefore often undefined) essence called Marxism'.

That, in a way, is what I tried to do in analysis . . . That is what analysis helped me to *see through*: the rain of words that obscures the world. But, even when I deployed my 'pure Marxism' as a defence, a flight from the self into the autonomous reality of theory, I clung to my idea of Marxism as the redemption, through historical, economic, and political means, of The Whole Man. And, as my analysis progressed, I realised how uncomfortable I was, even among the theoretical Marxists, as I watched them dissolving this sensuous, living, loving, potentially fully human being, into a desert of decentred, linguistic constructs. All that was exactly what I had been trying to escape from.

At Dalston Junction, I start leafing through Eagleton's book, *Criticism and Ideology*. I appreciate his search for a materialist aesthetics; but, for me, that can never be a matter of words alone. The proliferation of this sort of Marxism in visual criticism is obscuring the senses, the self and the world from view. The thin, formalist skein of *Screen*'s, or *Studio International*'s, diluted Marxist structuralism, abstracted, self-referential, effete, pursuing itself tendentiously within a vacuum outside – or perhaps hermetically sealed off within – lived experience, words, streaming in a continuous loop from mouth to anus and back again . . . None of this has much to do with what I believe myself to be pursuing. I cannot recognise the insoluble jigsaw of, say, *Art Language*, the fashionable 'avant garde' art-world group, as even a component within that tradition to which I feel myself as belonging. As the bus runs along Graham Road, I think that in such systems, too, the internal relations, or syntax, are held to be everything. The world is left hanging, for ever, in brackets. I get off at the bus stop outside the house, and immediately go upstairs to my study.

1978 *Redding, Connecticut*

In the morning, I finish studying the Jasper Johns material and Colette, Sylvia and I go up to the house for lunch. Bob has gone into New York City for the day. His assistants, David, Tony, Dean and Francis, are seated round the circular white table in the kitchen with food spread out in front of them. The faces round the table could have been painted

by Caravaggio. The scene feels like some strange, eucharistic rite for a departed god-man, whose absent presence permeates and binds all who are there.

Dean is bolt upright, nervous and silent behind his moustache. He smiles sometimes, but it is usually no more than a half-hearted attempt to collude with others in their amiable mockery of his stupidity. He rarely looks to the right, or the left, even when someone is speaking to or about him: when he does, he only moves his head and his neck. But he manages to eat great hunks of Natkin bread in nibbles.

He always greets me with, 'How you doin' then?' and reminds me of someone from one of those 1950s films on American youth culture: he rarely talks, but when he does it is about cars, diners, drive-in-movies and 'dial-a-dates', bars where there are telephone receivers on every table and the boys can ring up the girls they fancy. Before he came to work for Bob about three years ago, he had never even seen New York City. Bob met him because one day, in a sale, he saw a fine piece of Amerindian work offered exceptionally cheaply. The stall-holder told him he was handling the piece for a collector who had been forced to sell up very quickly. Bob bought the work, asked who the collector was, and went round to see him. Thus he met Dean, who was living in the desert of lower Lower Middle-Class American Suburban Life. Dean had managed to learn a great deal about American Indians and their culture. His room was full of books, posters and mementoes. But circumstances had forced him to send one of his prized original pieces for sale. Bob pressed him to accept the difference between the price he had paid and the work's real market value, but Dean refused on principle. Bob immediately identified with him. He often says, 'I have no background, only a foreground', and he likes to describe his own childhood as 'early nothing'. In those days, he was redeemed by his fantasies too: not Red Indians, but movie houses and tinsel lines of chorus girls. So Dean was invited to the studio, pressed to choose a painting as a gift, and very soon employed as an assistant. Part of Bob's fantasy was that Dean, too, would flower into a great painter: but this did not happen. He produced a few wooden Wild West scenes. Indeed, even within his new milieu, he remains somehow locked within his

former culture, and gazes out on all that is going on around him, unable to comprehend, let alone to join it.

Tony is different. A former sailor, now about 25, with a lot of what is usually taken to be experience of life and the world, Tony exudes shrewdness: he is cunning, likeable, determined and ambitious. He is heir apparent to David, as Bob's senior assistant, and has already been told by Bob that when he gets this job, he will succeed in it by growing out of it. Tony watches; behind his smile, he is assessing. He is careful to follow the *double entendres* and exchanges bartered between David and myself. Although he has only been here a few days, he has clearly established himself *above* Dean and Francis. He has also identified Bob's vulnerable points, the wounds in his side. Colette wondered if, in the future, he took over from David, he might be tempted to exploit them.

Francis is a gentle person, who lives now in a sore cocoon of suffering. His mother died recently of breast cancer: his sister is beginning to die of leukaemia. He wears an unconvincing smile, but it is for the outside world. One feels that inside he is weeping and bleeding all the time. Once, he brought in a picture he had painted of an imaginary mine, where half-naked, hermaphroditic figures strutted in brightly coloured protective helmets.

This is David's team, but he himself is the only one of the assistants who is completely relaxed in the Natkin household. David has a prickly orange beard, smokes a pipe, looks like a ship's captain and shouts like a Sergeant-Major. When we talk about painting, and the need for it to relate to experience and the world beyond the world of art, then I find we agree. His own pictures are monochromatic – often with a central division. Their surfaces are such that they refer to the history of their own making, and sometimes open up muffled illusions of emotionally symbolic space. There is an over-worked quality about some of them: the opposite of Bob's light, expansive, generosity, but Bob declares David to be one of the great innovators in American painting.

David has been with Bob as an assistant for ten years now: for eight of them, he has lived within the Natkin family almost as the third child,

the eldest, adopted son. He has shared in Bob's growing prosperity. Although he often fights Bob about the best way of doing things, he is a meticulous, thorough, imaginative and well-organised worker. In the Natkin household, he enjoys food, drink, materials in abundance . . . a way of life he could not hope for as an artist working out of some shabby New York loft. If he left, the wrench would be intolerable and shot through with all sorts of psychological resonances. If he stays, his art remains unpricked by necessity.

He has a seamlessly indulgent anal humour: once Colette and I told him about the French music hall star, *Le Pétomane*, who 'sang' and played the trumpet through his ass-hole. *Le Pétomane* could 'drink' a bowl of water in the same way, too. David sent us a photo of himself 'emptying' the Natkin swimming pool in like manner.

David and I have built up a complicated pattern of in-jokes and allusions with which we amuse each other and infuriate everyone else. We will burst into laughter at some obscure reference to one of the Great Moments in 'The Life' of Natkin – say about the way in which he has mythologised his brief encounter with the famous critic, Clement Greenberg. But this banter also includes the life and works of *Le Pétomane*, and the subject of 'shower curtains'. Neither David nor I could explain precisely why such a wet and transparent image is amusing to us. The point is largely that the curtains are maddeningly opaque to everyone else – especially to Bob, who hates not to be able to see what is happening. David and I can amuse each other and exclude him by talking about 'shower curtains', or the short-comings of structuralism and semiotics, about which he knows nothing.

At lunch, the other assistants, for their different reasons, tend to keep their silences, like schoolboys when the headmaster is present. But David likes to puncture their conventional behaviour. He shouts at them in feigned but paralysing anger, comments freely on their appearance, mores and appetites, and dumps food in front of them, or heaps it up on their plates. I imagine that this is how members of the Pre-Raphaelite Brotherhood, in its Oxford jape days, treated their assistants.

Meanwhile, over in the shadows by the dresser sits Jackie Harris, all

twenty-two stone of her. She comes in every day to keep house. She won't eat at the table because, she says, she starves herself all day. She lives on her own with innumerable dogs, and a house full of dolls, one of which she has given to Sylvia. When she does the washing, she will often walk into the room, hold up a pair of pants between the finger and thumb of either hand, and ask, 'And whose are these?' She is a devout Catholic and has recently struck up an improbable friendship with Dean. They are even talking of going on holiday to the South together.

1975 *Le Châtelet, France*

Throughout the day, these plastic memories persist. Almost like a film thrown up against the inside of the skull dome. The flickering traces of an activated past. Whitsun, 1961: the Eastleigh Union Baptist Church is crowded. The ground floor pews are filled with the faithful; the gallery and choir stalls are packed. The naked table on which the brass cross usually stands beneath the pulpit has been removed: beneath it is a swimming bath, filled with warmed water. Marble steps lead down into it from either side. I come out of the vestry and a surge of singing voices sends shudders of feeling through my arms and legs, into my head.

I try to imagine this is the laying-on of the hands of Faith, or the fiery tongues of the Holy Ghost descending, but I am not convinced. I know I feel something similar when I am sad and step into a hot bath, or when I listen to the works' band parading down Leigh Road. I am wearing white: cricket trousers my mother has neatly pressed, and laced plimsolls.

As I go down into the water, I am surprised at how deep it is. My thighs are lapped. When I come out I will appear as naked before this great company: I suppress the thought. The Minister is wearing his water-proofed black robes and special waders. I will make you fishers of men. I want the mystery of the Essenes. Desert men, whose lips are smeared with honey and locusts' legs. On Jordan's bank, the Baptist's cry . . . There is more violence in this reversed birth than I imagined.

Beneath the surface, my head falls back, and water rushes up into my nostrils. I failed to get even a bronze medal for swimming at school because I refused the lowest dives to avoid this. Would it be so sacrilegious, or merely incongruous, if I put my fingers to work plugging my nose or my ears? As I stand upright, I am disappointed: I feel no difference. I know I have lied, but I do not want to admit this to myself.

I am spluttering.

Trailing up the smooth, wet steps, I feel only embarrassment at all those eyes watching, as my clothes cling closely to my body. Puddles of water, all the way, squelching at my feet, my trousers, tugging downwards. Sodden turn-ups. Memories of childhood incontinence, heavy, soaked clothes, drops tumbling into my eyes as my mother smoothed my feverish head. They are singing again.

> O Jesus, I have promised
> To serve Thee to the end:
> Be Thou for ever near me,
> My master and my friend:
> I shall not fear the battle
> If Thou art by my side,
> Nor wander from the pathway
> If Thou wilt be my guide.
>
> O let me feel Thee near me:
> The world is ever near;
> I see the sights that dazzle,
> The tempting sounds I hear;
> My foes are ever near me;
> Around me and within;
> But, Jesus, draw Thou nearer,
> And shield my soul from sin.

An old woman is waiting for me with a towel and a cup of tea. She treats me rather as if I have just given a pint of blood. Perhaps I have. Do this in remembrance of me. As I dry between my toes, I notice small

red sores, fringed with white, and wonder where the radiance is that should be burning in my soul. Is this what it means to be born anew?

But, of course, it had been more of a simulated crucifixion than a baptism, and this I would be foolish to forget.

1976 *Graham Road, London*

As I write, sitting in my study at Graham Road, black Dulcie comes tumbling into the room, laughing, talking, pointing, and falling over her mountainous self. They say that Dulcie is 'mad'. Colette gives her special tuition here, at home. Her enormously manic presence makes me immediately want to clamp myself down, like a limpet sensing an intrusive danger. On the small wooden cabinet beside the desk at which I am working is a cheap white soapstone replica of the bust of the Venus de Milo, which I bought in The Waste, the local market. Dulcie reaches across me and picks it up.

'Where did you get this?' she asks. 'It's so beautiful!'

I tell her I bought it for 75 pence in The Waste.

'I didn't know you could get things like that for 75 pence!' she says noisily. 'I've seen it on television. I thought it would have been a pound at least. If I had known, I would have bought it for myself.'

Dulcie knows quite well this is not what she has seen on television. In fact, she often seems to realise, rather better than most, that what goes on inside her head is not the same as what goes on in the world to which it appears to relate. Maybe that's the reason why she's 'mad'. She is sixteen, but not sweet. She washes so rarely that when she passes through a room she leaves behind a sour haze which hangs there even after she has gone. Downstairs, she will sit at Colette's feet and listen with gasps and giggles of enchantment to fairy stories about Snow White, frogs, princes, pumpkin coaches and girls in towers with cascades of golden hair.

1977 Graham Road, London

I am back, now, at my desk. Outside, down below, in the Hackney street, the bell of the Pink Paraffin man chimes a point in the seasonal eucharist. A few minutes ago, a rag-and-bone man went by, pushing his hand cart, hollering. Over by the railway bridge, a stone's throw from London Fields, is the totters' yard, where they keep their chickens, rags, pony and scrap metal: they are like survivors from Mayhew's London. Sometimes, up here, I feel myself to be part of a garret-in-Grub-Street way of literary life which is withering away too.

1978 Redding, Connecticut

Back in the barn, I spend a long time hammering out questions for Jasper Johns: it is as hard as preparing a chess game in advance. I have been warned about how difficult he is, about his use of aloof silences to try to humiliate his interviewer. The interviewee can always pose as the victim, the masochistic object of the encounter, but that rarely reflects the real situation. Who, after all, is the *subject* of the interview? I must manoeuvre to retain control from a position of over-preparedness. A real dialogue with Johns does not seem possible. I always start to prepare questions for interviews feeling there is not enough to ask about. And then it all boils up and spills over the edges. So much of the existing material about Johns seems to be the sort of awed sycophancy that bobs along in the wake of a spectacular market success. None of it really gets to grips with the cynical manufacture of the man as an artist, the overnight fabrication of his reputation, to meet the needs of a wilting abstract expressionism.

1975 Le Châtelet, France

I wonder what I would have felt if I had been able to read François Jacob's *The Logic of Living Systems* before I was baptised. Writing about the sixteenth century, he says, 'Knowledge based on a mixture of observation, hypotheses, reasoning, antique philosophy and principles

derived from scholasticism, magic and astrology, appears today to be very heterogeneous.' Nevertheless, he continues, it composed a perfectly coherent picture:

'Every observation based on sensory impressions fitted a whole where each thing and each being had its place as one part of a secret network woven by the supreme power. Knowledge could not be dissociated from faith. In its nature, the formation of a living being did not differ fundamentally from the process which sets a star revolving around the earth. Generation was only one of the recipes used daily by God to maintain the world which he had created.'

I try to imagine what might have happened if I had been able to recognise the 'perfectly coherent picture' which was continuously presented to me in childhood, as an illusion.

Let us suppose I found and unravelled inexplicable threads which could not be woven into a secret network of 'the supreme power'. Never mind this fraud about the Piltdown Man, sir! What about the fact that all living beings utilise the same optical isomers, or that the substance, deoxyribonucleic acid, in which genetic information is stored has now been identified. Into what corner of the Sunday School room would that teacher's God have crawled if I had been able to ask such questions then? But his answers are not that difficult to imagine. And, if he could not have thought of any, he would have separated the fact off, isolated it, and made sure it did not interrupt the serenity of the rest of the image. Edmund Gosse's father believed God had placed fossils in the earth to test man's faith. Our Sunday School teacher would have reminded us that there are many 'mysteries' in God's world! Almost anything could be worked or rubbed into the fabric somehow, or denied.

As Jacob writes, 'For an object to be accessible to investigation, it is not sufficient just to perceive it. A theory prepared to accommodate it must also exist. In the dialogue between theory and experience, theory always has the first word.' And when that theory is Faith, the last also. Of course, I had seen my eyeless Mexican fish. But, for a time, I was submerged in the subterranean cave of Faith.

1976 *Graham Road, London*

After Dulcie has left, I find myself thinking it was strange she picked on the soapstone head, and not the statuette of the whole figure of the Venus de Milo, *sans bras*, which stands just behind it. Colette gave this to me before we moved here to Hackney, when we were still living in Uxbridge Road. After I began my analysis, the Venus became one of my cluttered personal symbols, like the echinoderm test. I often bring her up in sessions with W. Everything about her intrigues and frustrates me. Two years ago, I began pulling out material from the bowels of the British Museum in a desperate attempt to recover her history.

I found out that the Venus de Milo had been rediscovered on April 8th, 1820, after a Greek peasant called Yorgos had fallen through the ground into a subterranean niche when working on his field. The statue immediately became embroiled in the conflict between the Greeks and the Turks; indeed, a pitched battle was fought over her on the shores of Melos, but she was carried off in dubious triumph by the French. Some say that she lost her arms in the struggle.

Throughout the nineteenth century, there were innumerable attempts to 'reconstruct' the Venus, and I began tracking these down. Some scholars had her holding a mirror, a shield, in a group with Mars or Hermes, clutching a spear or brandishing castanets. But in all probability, her left arm rested on a pillar and held an apple.

1977 *Graham Road, London*

When Anne and Michael came to visit us for lunch, I pushed aside the textual haze from Carlisle Street. But they made me feel a little dislocated. I read something in their looks and postures as if it was a criticism; I felt it all the more strongly because they so manifestly did not want it to be taken that way. Every time we have seen them over the last ten years, it has always been in their spaces. I think of them as living in elegant restored houses in Bath which Michael renders perfect. Hackney is inelegant: a shabby chaos. I can see the light streaming into

their spacious front room, and I feel ashamed of the brown filter of dirt on our window panes, and the distant gas works.

After lunch, we all went for a walk to London Fields. Michael made occasional comments about many of the buildings we passed. His words about a cornice here, some baroque flourish in a façade there, or a strange ornamental addition, highlighted details of houses just across the road which I, for all my endless gazing there, had barely noticed in all the years we have been living here. He saw my familiar territory quite differently and punctuated it with new points and commas of significance.

Anne is expecting a baby, next May. This makes me think back to last October: two months before Sylvia was born. Anne mothered me, ten years ago, before I made a lonely pilgrimage to that tumbled, sandstone Kouros in southern Sicily. My own brother was born in May, too. I remember how, feeling like an incestuous son, I went round the glass-blowers' island in the Venetian lagoon hand-in-hand with her. But I was no Don Giovanni! And when after that strange, searing summer, it became time to go and to leave my ghost stalking the bridges and canals, I became so distressed that I forgot to get off the shuddering water-bus, and I was carried on towards the lagoon.

Later, Anne came to work in Cambridge, and, more than once, I crossed that fake 'Bridge of Sighs' which joins the banks of the Cam thinking of her. I decided that she was a Venus, or a Beatrice, for me: unattainable, a living imago of an immaculate mother. Behind us, always, was the shroud of O.'s absence; O., my former master, who had taught me what I knew of poetry, and whom, after my own fashion, I loved, and who, in his, loved me; O., whom Anne at that time loved, and who, after his fashion, loved her. On that festival afternoon in Venice, she and I walked into a piazza and saw him seated at a café table with a boy, who became transfigured in my memory, as the years passed, into a golden-haired Venetian.

In that tightening knot, fraught with all the stifled ecstasy and tearful agony of late adolescence, I relived a past in the present. Anne and O. were the bearers of my projections. At lunchtime today, I reminded Anne of a letter she had sent to me in May 1967, announcing she had

met Michael. I ran upstairs and retrieved it from a green letters file in my study. I showed it to her. 'My life has changed radically. I am hoping to marry someone I met up here in January . . . Whatever you do, at the moment, please don't suddenly arrive – leave time for some sediment to form.' I have always prevented sediment from settling. Always stirring. It could only have been a month or two later that I found myself sitting in the back of Michael's car as the three of us fled from the wrath of his wife, through damp and mossy valleys and hills, scattered with bemused sheep.

Sediment: I used this image in analysis recently, but rather differently. I said that even if there was some volatile living matter at the bottom of the pond, I would still be able to establish a certain workable peace, just by not poking it around at the moment. I went on to say that W. underestimated the degree to which the writer is his own analyst; but in saying that I was myself forgetting that means a persistently continuous poking of whatever sediment remains.

Now they have gone. I still find it hard to work concentratedly today. The wine we drank at lunchtime distracts me. Colette comes into the study and we start talking about the landscape through my window. She tells me the gas works I have mentioned so often here in this journal are the same as those over by the canal at the far end of London Fields. She also makes me see that I was wrong in my belief that the tower block on the left of my 'screen' was the one in Eleanor Road. That scene, out there, which I have mentioned so many times, is itself but a displaced chimera of reality to me, an awkward painting, papered up behind a dirty window screen. Suddenly, as Colette talks, I realise how little work or thought I have done to connect my daily gazing from this desk with the knowledge I have gained of the terrain from, say, walking about it.

1978 *Redding, Connecticut*

It is just before midnight. There are no chimes here in the barn. That scuffling, outside, is a racoon, a rabbit, or perhaps just the wind. Here at this round table, for the last few hours I have been mortising the

Johns interview. The trap is sprung, I think. Perhaps I have stretched it too taut with Lilliputian trick questions. They won't get me far. The published profiles suggest a terse, pragmatic cleverness: when asked if he should pay his taxes, he immediately renders unto Caesar. As I glance over the quotes within quotes in my questions, the inquisitorial probing, the darting in with dated references to his critics, I wonder if, perhaps, I have not over-prepared again. These days, even on small tasks like researching and writing a series of questions, I feel myself to be setting out onto a surging ocean of impossibility, which I have no choice but to navigate. Like a foetus, head-trudging down that tight canal in the first tempest of becoming. Just when I feel everything is about to be shattered into flotsam and jetsam on the back of the breakers of despair, indeed, just when I feel I have nothing but unrelated fragments left, I discover the material has coalesced a moment before the twelfth hour . . . and far from having nothing at all, I have much too much.

Peter Townsend, editor of *Art Monthly*, told me that I dig my material too deeply. I get stuck with the monumental earth-works of the scholar, which I have neither the time nor the resources to complete. I should, he thought, turn over smaller sections of the surface more quickly with a journalist's trowel.

I push the typewriter and set of Johns questions away, and race on with these words in my notebook. Colette is asleep. Her breathing reminds me of a tableau of 'Sleeping Beauty' at Madame Tussauds, in which the wax girl's chest is gently heaved by an unseen electrical apparatus. Sylvia, too, is sleeping in her cot. I walk across the room and sit down on the blue eiderdown of the bed, still with my notebook and biro in hand. The clock on the windowsill ticks loudly, and fast. I remember what Bob said yesterday when he spoke about suffering: about not wanting to harp upon the withered cords of the skull which he saw every day in the mirror, pressing through the flesh of his face. There are similar obsessions in Johns' later work, too. One picture, *The Corpse and the Mirror*, shows, if nothing else, the falsity of his earlier claims to have dealt only with 'objective', alien, or neutral themes. *Ce n'est pas le temps* . . .

As I write, Sylvia begins to cough and to wake up. She sits up suddenly in her sleep, and starts trying to . . .

Here I broke off. I went round to her. By the time I reached her, she was asleep on her knees, but aware of being on her own. As soon as the least flash of wakefulness shoots through her, she starts to get up and to protest that she is not lying between us. But I was able to lay her down again, in the cot, and she fell back quickly into a deep sleep. The barn, filled with Bob's pictures, my words and their sleep, falls still.

I know I cannot join them yet. I begin to think again about the past.

1975 Le Châtelet, France

Colette has an allergy today. A red rash races over her cheeks. The family blames the oysters. The oysters and le changement. In England, le changement probably would not even be recognised. The French, however, are prepared to assume the organism has been ravaged by the sum of the changes brought about through moving from one place to another, the combined assaults of shifts in climate, food, water and temperature. In France, the way of being in the world is such that it would be acceptable to retire to your room blaming le changement: the English would simply assume foreign food or water had poisoned the blood.

As a critic, I am beginning to understand that perspective and narrative are similar sorts of lies. Now I can see it easily. In part, this comes through living surrounded by photographs. Renaissance perspective denies time, and situates what is depicted outside of it. The image presented is assumed to be 'timeless'. The painting is arranged so a static world converges upon the eye of the beholder. The viewer is posited as the radial centre of all he surveys: as much as anything, it was John Berger's writing which enabled me really to grasp that.

Similarly, narrative has a beginning, like the dot numbered 1 in those children's puzzles, and proceeds, remorselessly, to that dot numbered 38: then the reader arrives at the bear, or the biography,

which had always been there from the moment he set out. (For months, I have been troubled by my images of those puzzles.)

Consciousness itself is not very like any of these conventions. I am aware of myself as the bearer of my own time and particular history, but my trajectory through the world is determined by that limited yet decisive movement of *choice* between those possibilities existing for me within that which is given. The next stage of the journey is not inevitably the shortest route to the next telegraph pole. Yesterday's image of the miner's helmet in the shaft was better. I can thrash around, blindly, throwing light wherever I wish, assuming I am the creator of everything that falls into the brightness of the beam. Or I could settle for the study of a diminutive section of the coal face, and thereby become a specialist. But I like to believe I want to use the light to attempt to understand the cave I am in, in the hope that through analysis of it, I can act upon it and change it. This way, as the beam moves, I try to scrutinise everything it illuminates.

1976 *Graham Road, London*

I pick up the soapstone maquette of the head of the Venus in my hand. Last year, I heard a lecture by Hannah Segal, a Kleinian analyst, in which she related the need to make art to reparative drives, to the wish to restore lost internal objects which one feels have been destroyed by one's own destructive drives. I wrote to her at once telling her the story of the loss of the Venus, the fight which occurred on its rediscovery, and the subsequent reparative ingenuity of the scholars. But she never replied.

I continued to brood on the Venus, myself. Colette and I did finally visit her, last summer, when we went to Paris on our way back from inspecting Ferdinand Cheval's *Palais Idéal* in Hauterives. I bought a small jigsaw of the statue, no bigger than a postcard, at the Louvre shop. Last autumn, I finally published an article about her in *New Society*. I argued that any given object is seen differently, and therefore acquires different meanings, in successive historical moments. An image is re-created each time it is seen. But, I went on, in the case of the

Venus, there is not even a fixed object which has remained the same, or similar, through the passage of time. Almost certainly, I said, a characteristic of the original statue was its sense of wholeness, while the dominant feature of the surviving part was that of fragmentation.

I did not use any psychoanalytic ideas to interpret the statue, nor, of course, did I make mention of the urgent private meanings and associations it possessed for me. Rather I argued that, in the nineteenth century, the shattered statue – which would have seemed repugnant to the Greeks – had become an ideal because of a spreading sense of fragmentation and alienation. This, I argued, had been stimulated by loss of religious belief, and the spread of industrial capitalism. I sent the article in a letter to my father.

He wrote back and told me that he thought I was saying that every great work of art speaks its message to each generation, although it does not necessarily speak the same message to every age. 'I was interested to hear of the objective facts you narrate about the history of the Venus,' he wrote, 'much of which I was unaware of. But an age, an era, consists of so many people with such differing viewpoints that one cannot help wondering whether your assessment of the fragmentation of the age and of the seeking of an idealised whole does not arise out of political dogma, rather than out of objective fact. I fully admit that I do not know enough about the nineteenth-century French viewpoint to know.'

I was enraged by this letter. Not so much by the position it took, as by the old double-bind I felt it put me in. You, he seemed to be saying, are wrong; but of course, I am too modest and humble to tell you that. I wrote back, crossly, and at length, insisting that I had *not* intended to say that great works of art speak their message to every age. 'The real point,' I said, 'is this: the phrase "Venus de Milo" *does not relate to a given object at all*. That which survives is so different – physically – from the original that the idea that we have a single "great work of art", or "ideal", speaking its message (whether the same or different) in successive ages can be shown to be the product of ideology, rather than of serious scientific analysis.'

No wonder, last year, I did not confront the Venus as a material object, stripped of all meanings and associations: I did not believe that such an object was anywhere to be found. I should pick up those soapstone replicas and smash them into pieces. The 'whole' statuette is broken anyway: it snapped in half on the move here in 1974. There is an almost invisible crack right through it about an inch and a half above the base. If I just flicked it with my forefinger the top piece would crash to the ground and perhaps the marble woman would just disintegrate. I could throw the echinoderm test after it. But would I then be free?

1977 *Graham Road, London*

Looking over the entries I made here in 1976 and 1975, I remember how one day, last year, in a bookshop in Bath – Michael and Anne are on their way back there now – I picked up a book about the history of the Royal Academy which included in it a photograph of the chipped and broken plaster cast of that crucified man.

Many memories, of course, can be associated to, and interpreted just like dreams. The paths lead back to the same secret places. I think of this image of a man, impaled upon a cross, near where the healing waters flow. Bath is full of spiritual fathers and mothers for me. The street where that bookshop stands has something to do with O.; there is a restaurant there, I think, with the same name as his. The city is charged at every turn and corner with projected traces of my internal mythology.

Bath . . . I think of cousin George, with his velvety, vintage clarets and ports, which flush tongue, brain and body with an intimate and yet remote warmth, a suffusing glow which momentarily might be mistaken for a trace of that elixir of reciprocal love first tasted at the grape-nipple of the mother's long-forgotten breast. George is a *Chevalier du Tastevin*; sometimes he will give dinner parties at which each wine is one of the best from the years in which each of the several guests were born. Squeezed from the fruit of the vine in their natal years.

Colette and I once stayed with Michael and Anne in Bath and we shared the heat of a sauna. Like George's wines, the hot air melted the flesh. Each glimpse was lace-curtained with memories. Lying flat, swathed in towels, I thought about a pencil drawing by, I think, Forain which was reproduced in a book I used to love in the school library at Epsom. Everything felt like those Bonnard paintings of a woman dissolving in a bath tub, disappearing into the space which surrounds her.

I lost my glasses on the way to the sauna shower, and I called out in panic, 'I can't see! I can't see!' This memory reminds me of a pub at the Angel last year, where a stripper stole my spectacles, and slipped them behind the elastic against her thigh. Out, out, vile jelly! I see a whole company of angels, holding up a painted model of that other watery city: a vision of a Doge, huge and filling the whole sky, hovering high above the golden horses. There is an even finer horse, only a bus-ride away, outside the cool cathedral of St Anthony in Padua. Bath and Venice dissolve and submerge into each other. A spa of light and a lagoon of memories. The sun running and rippling over those warm, brown, Georgian stones, catching the glittering marble colours of San Marco. As a child, I drank a glass of tepid water in the Pump Room . . . a history reaching back and back. Long before I came, or saw, or conquered.

In Bath, too, I first saw Robert Natkin's paintings, including his great, shimmering, silvery Bath series, and I became sucked into his sensuous, breast-breath illusions. Back and back, into those infantile depths when I was possessed by a legion of desires, like a great feathered eagle, sucking and savaging with an imperious beak, as I lay pink and powdered on my mother's lap.

And so when last year I saw that picture in a Bath bookshop, the imagery of an academic crucifixion mingled with that of a rebirth, a Baptism, born-again in the warm waters of Bath flowing with milk and claret. Mingling, when they pierced his side. Two years ago, writing here, I linked my Whitsun event not with the descent of a dove, but with blood and nails. Tongues of fire. There is a card inside the dust-jacket of a copy of the New English Bible which my father gave

me, commemorating that day. All mixed up. Chaos. As pants the heart for cooling streams. But today, analysis seems like another kind of anti-Baptism for me: 'a New Beginning', a rebirth of myself . . . A conquest, perhaps, over a basic fault.

Damn! Damn! As I read back what I have written, I realise how living itself becomes all 'set up'; the episodes I have written about here are like a painter's still lives. Who looks at Cézanne to learn about apples? People, places and things become layered with these self-spun shrouds. We see Michael and Anne over and over again as year succeeds year. I feel the sort of love for them I only feel for my oldest friends. But sometimes I wonder if they are ever quite whole for me, or me for them. The worlds we live in seem so separate. Graham Road, Hackney . . . and the great circuses of Bath. We find a common ground, twice a year, for each other. But is it only for an image of the other? Perhaps, for me, that image is too precious to be filled with a contradictory concreteness.

I have a fantasy about Anne's world, which, I am sure, has nothing to do with the way it is for her. I dream of it as gentle, middle-class domesticity. I love their house, because it has a feeling which is secure, but not stifling. I associate it with patterned fabrics and stripped pine rather than over-polished silver or shining mahogany. I want those things . . . and yet I feel excluded from them. Michael has recently started carving in wood. When we were there, the wood shavings smelled good. Hackney becomes overhung with the stench of offal from the trucks leaving Smithfield market. In the working of the swollen grain, Michael comes closer, perhaps, to a real world than I ever could through these words.

All I produce is words, damn words. Endlessly, his raiment they could not divide, seamlessly, home-spun words. I live in another kind of plate-glassed space. Perhaps they have just broken through. But I feel a tenderness for them which renders them real and actual for me beyond all these shimmering distortions and idealisations of memory and fantasy.

I can't find the words I want for a friendship which is at once intimate and central, for me, and yet also strangely disconnected from the way

we are here in Hackney. What would Anne make of all these ruminations about Marxism and formalism? As I look for words in the space of this room, my eyes fall on Sylvia, asleep in her carry-cot, on the floor by my chair. Outside it is dusk. They will be back in Bath by now, perhaps.

Behind the just budding, leaf-shooting, great, green tree – my symbol in the world of the passing seasons – is a thin, watery haze of bloodish red, staining the fringe of the grey clouds. It looks like the sort of effect you get in a water-colour painting which you know cannot be true to nature. A membraneous skin lining the distant sky. It reminds me of Natkin. He always went on about the strange quality of the light in Bath. Then sometimes he likes to admit that he only called them 'Bath Paintings' to get some local interest in his work. But authenticity can sometimes be made manifest through artifice and contrivance. Natkin. Was I right or wrong about his work?

As I read back that entry about my baptism, I remember that, in the days that followed, I still believed something might happen. Eventually, I thought, I would come to feel differently. A new man! The eccentricity of what I had done never occurred to me.

As for black Dulcie, she came back many times, in her manic hugeness. They started to say she was suffering from epilepsy, too. She certainly had fits. She began to come to the house at all sorts of unscheduled times of the day and night. If I answered the door, she would roar past me like a tank, only stopping on the stairs to look back at me and ask, 'Is she in?' Sometimes, the phone would ring in the early hours of the morning, and it would be her. Poor Dulcie! Not even the special schools would take her. When she was not here, she would often ramble the streets of Dalston and Hackney. Her mother, a seemingly quiet and contained woman, just washed her hands of her. Sometimes, as Colette and I lay in bed at night, we would hear Dulcie in the street outside, as she stood by the bus stop, laughing with effervescent hysteria and a man. No one could really help her. She was for ever being picked up by police and ambulances and rushed to some closed institution or other. She viewed everything that happened to her with

magical indifference. Strangely, most of the time she seemed quite happy.

I am thinking like this because my mind is returning, all the time, to the end of analysis. I remember the very first session on November 6th 1972: the day after the old leaves had gone up in smoke. It was a Monday and we had just come back from spending a weekend with my parents. I began by talking about my father's obsessional traits, what I called his 'anality', and the way in which I felt he transferred all the problems arising from living in this world onto birds: he would read a book about *The Birds of Ireland*, but not, of course, about the troubles there. I spoke about what I experienced as his dissociation from his feelings, the sense of remoteness that sometimes enveloped him, and my mother's protective care.

I was surprised about how angry I was over a lot of what I was saying but, right from the beginning, a part of myself seemed to separate off and to view the material I produced about my own case disinterestedly, theoretically, analytically. So that even in that first session, when I told the story of his denunciation of me the previous Christmas when I brought home a copy of *7 Days*, with the cover story 'Was Christ a Collaborator?' – he called me a Communist who cared about the world but not about the family – even then, as I recounted all this, I was sitting somewhere above the flow of my own words, critically assessing what I was saying in the light of my own analytical theories. At one point, I even thought about writing a weekly column about the progress of my analysis!

When I told W. about my father's retentiveness over knowledge and books, I said, 'It all goes in and nothing comes out.' But for me, it was all coming out. In that first session, W. said very little. At the end, he commented, 'So this father you want to destroy is partly in yourself.' And I agreed: that seemed quite evident. But, on that first day, he asserted *his* authority, too. When I asked him if he would mind if I lit one of the small Manikin cigars I then smoked, he said he would prefer it if I did not. The next day, he implied this had been a significant exchange between us, but I swept it aside as futile, and carried on

talking about bull-fighting (which I was then researching in the British Museum), parricide and what happened between Anne, O. and myself in Venice, which I saw as a parallel of the situation within my family, or rather of my fantasised transformation of it. The day analysis began, I had, by chance, received a letter from O., who was making a trip to Venice, ' . . . it's the questions that count. And Venice is full of them, particularly on this Day of the Dead, flowers everywhere and even the bells in S. Maria Formosa have dared the masonry to ring.' He invited me to come and walk the length of the Zattere and part and meet to tell each other the after dinner dreams that didn't materialise. 'I long to see you – before I'm anatomised on your couch.'

The first two years on that couch were, in W.'s phrase, 'too easy'. I did 'all the work'. Later he was to tell me that during this phase he often felt I was trying to make him feel there was no need for him to be there at all. Perhaps he even said something about this at the time. Certainly, I always leaped in to explain the 'real' meaning of what I had been saying before he had a chance to comment on it himself. Then I neatly folded up another harrowing symptom, tucked it away, and went on . . . I did not find this surprising. I had imagined analysis would be like this before I went into it. After about a year, I began to think I was an exceptional patient. I had got through the work that took most analysands four or five years in just one! I thought there was only a little more left to do. I had no criticisms of W., nor analysis, to speak of: as I saw it, they had been necessary to my successful freeing of myself, from myself, by myself.

And it was exactly at that point, when the past mattered so much less in one sense and so much more in another, that the issue which had smouldered since the extinction of the Manikin cigar on that very first day moved to the centre of the analytic space, and the really productive difficulties of the analysis began. As I unravelled the threads of my narcissistic cocoon, I began to take more and more notice of him when he said I was ignoring aspects of my relationship to him; and as the locus of analysis shifted from my past as fossilised within my symptoms and my images, to that past as dynamically present within the transference relationship itself, I came to question furiously his disembodied

blankness, his conventional, emotionless, couch-side manner, his assumption of authority about how the game of my analysis should be played, his professionalism, and so forth. As I saw it, I was no longer prepared to remain a son within the transference relationship or a passive patient anaesthetised upon his couch: the father whom I now wanted to kill to set myself free I had projected firmly into him.

Thus began the era of violent struggles when the analysis came, again and again, to the very verge of disintegration. These culminated in an incident which, to any one who has no experience of analysis, must seem as trivial as the Manikin: namely, my literal refusal to take any more of it lying down. When I sat up, and faced him, things had already changed . . .

When he handed back the packet of my father's letters today – letters which he has kept for more than two years, despite my intermittent requests to have them back – it was almost as if he was returning the Dead Sea scrolls to me now the reconstruction and exegesis of them are completed. Behind the strange traditions of my symptomatic behaviour in the present, beyond the mystifying images of the contradictory accounts in the various gospels (some written later than others) preserved within me, and beyond those lost sources whose existence we have often surmised but whose contents we have never learned for certain, the other side of the darkening tunnel of metamorphosing infantile amnesia . . . But the metaphor is pressed too far. With his help, I hope I have found myself, as I saw him for the first time when I sat up and faced him, real, fleshly, concretely alive in a continuing present peopled by actual others.

1978 Redding, Connecticut

The past. There is one level, perhaps, on which I really have found a way through. Looking at Sylvia, sleeping here in the barn, I remember how as a child I feared my father's superior knowledge: his books, file cards and great slag heap of accreted, unconnected facts. Once, as he drove me to Oakwood Preparatory School – we were about to pass

140

Rookwood Maternity Home and turn into Boyatt Lane – I found myself wondering if he knew everything: if understanding was the possession of lists of names, dates and isolated details, then his was the longer by far. In the shit and prick of thought he was indubitably bigger than I.

This feeling that I was an intellectual midget never left me. And that, I suppose, is what the last confrontation we had, at the end of last year, was all about: by writing me a letter which challenged, and dismissed, my book on *The Champions*, he left me no choice but to demonstrate I had become a keener intellectual than he. This I did, to my satisfaction at least, in the long letter I sent him last December. Was this, I wonder, at the root of my long excursion into christology and theology which, prompted by *Socialist Challenge*'s invitation to review *The Myth of God Incarnate* for their Christmas issue, began at that time? In a sense, this was his one theoretical domain, the territory into which he could retreat from ideas, certain in his conviction not just of superior knowledge, but also of invincible concepts. Indeed, he often claimed I had only 'left the Faith' because I was aware only of its 'shallower', 'popular' writers.

The Michael Crichton book on Johns contained the improbable assertion that creativity – the capacity to make unlikely connections – is based on a particular hormone, serotonin, and that it is because Johns' 'serotonin-mediated inhibitory mechanisms' are more finely adjusted than those of others that he can make the work he does. Certainly my father kept and keeps everything apart in sealed boxes. Nothing must touch upon anything else, let alone connect with it, or symbolise it, at least at the level of consciousness. Everything is its inert self, for him, unrelated. That is how formalists think too. I think about that strange quotation from Michael Fried, about Anthony Caro's sculpture, which I have cited so many times in articles: 'All the relationships that count are to be found in the sculptures themselves and nowhere else ... It is as though the beholder bears no literal relation whatsoever to Caro's work; as though within the grip of a given sculpture, in the spell of its presentness, everything that has to do with the beholder's merely literal circumstances – his situation as

opposed to his nature, essence or condition – is abrogated, suspended as never before.' But, for me, the welter of connections and symbols mounts up around everything I see, cluttering the world, and strangling me: yet I can never stop exploring them.

But coming here to America gives me a kind of confidence. It makes me realise I have a more sharply developed intellectual formation than I admit to myself: this side of the Atlantic, people and ideas seem in a ceaseless flux, without any conceptual spine, or rooting in the accretions of historical deposits. Each new fad, fantasy or cult floats through, meeting no resistance.

1975 Le Châtelet, France

I am writing at the desk by the window. Colette's father comes into the room. He wants to talk with me, but communication is difficult. I find it harder to exchange 'small talk' and formal greetings than to say anything else. He sits down on the edge of the bed, tries to smile and to appear interested in what I am doing. Although this is his own house, he seems as uncomfortable in the presence of my books, papers and writing materials as my own father in a restaurant.

Our lives have intersected through the arbitrary relationship of father-in-law to son-in-law: neither blood, nor choice, binds us. And here, in this room, we have little to say to each other. I rationalise the silence by exaggerating my inability to speak French, but he knows that I can read *Le Monde*. In his turn he likes to profess that the matters with which I concern myself are beyond his comprehension. But I know he reads the weekly news magazines carefully, and he has developed views on everything that passes across his television screen.

Politically, he is what one might expect of a village *receveur des postes*. He once supported a purist, Gaullist nationalism, but, still hankering in his dreams for a man like the General, he deserted the party under fat Pompidou, when it became, in his view, an arm of big business, high finance and the Americans. Giscard d'Estaing embodied almost all those aspects of the New Gaullism he most disliked. Everything from his polo-necked sweater to his aristocratic antece-

dents, banking associations and Manhattan sympathies made M. le Receveur suspicious. He was not deceived by Giscard's disingenuous casualness, nor by his occasional visits to the homes of Mme Bourgeois and other 'ordinary' people for breakfast. That sort of thing makes him laugh with a cynicism he would never have directed at the General. Once, trying to carve out a conversational territory for mutual agreement between him and me, he hopefully threw out a comparison between De Gaulle and Mao, which he endeavoured to make more palatable by spicing it with observations about English 'self-discipline' in contrast to the indolent laxity of the French. (He is a great believer in national characteristics.) In the end, his love of 'order', his puritanism, and possibly his fantasy of all those little yellow people in blue boiler suits who had no extra-marital sex and whose trains ran on time pushed him over into the Communist–Socialist alliance at the last election.

The fact that I am a writer, and thus to him a layabout, is mitigated by the visible amount of typing and reading which I do. He often pops in to see what is going on, and because he can sense a structure he accepts these curious activities in lieu of work. Ordered amounts are what matter for him. Once, he beckoned me into his *bureau* with shining eyes: everything was neatly clipped, stacked, weighted and tidied away there. He opened the safe, and gestured to me to look inside. It was full of money, arranged in bundles of appropriate denominations, strapped round with elastic bands. Not a fluttering franc out of place. There was nothing else to be seen.

Although he distrusts intellectuals as much as I distrust the petit-bourgeois functionary, he likes to watch the pile of completed type-script mounting on my desk. The relationship between us, the meeting point of contingencies radiating out from our marriages, leaves us searching for a space within which we can coincide and sympathise with each other.

'What are you writing now?' he asks in French, pointing towards the sheets of paper. He saw my last book finished here: it was a taller heap of typescript than this one.

I do not know, myself, what it is that I am writing. I call this journal

my 'novel' . . . But it isn't a novel, of course. Nothing in this book is fictional. I try three or four French words that I think might do. None of them works. He has no ideas. I have no language. These are the rules of all our exchanges.

1976 Graham Road, London

A year ago, I saw so little. I did not realise the novel had been murdered; nor did I understand the absurdity of my belief that I might be able to grasp hold of a 'moment of becoming' for the historical future through mere writing. I was, and am, rigidly embedded within a monolithic 'I', an ornately fragmented pillar, shot through with the Corinthian sins of my past, which supports the empty dome of the echinoderm test: a five-pronged prison for an urchin such as myself, on whose anal apex sits 'I', excreting, upside down, words about the fact of being a writer, writing within the citadel of the internal space on the interior of the scooped-out skull, trapped inside the residue of frozen moments of accreted history which will not let me ride back into the world, into events.

1977 Graham Road, London

Seated here at my desk, its smooth black top cluttered with books and papers, I pick up the packet of my father's letters which W. returned to me this morning. On September 30th 1961, he sent me my first letter: I had just gone away to public school. 'By all means take communion with the Anglicans,' he wrote. 'We of the Baptist way of Faith do try to be tolerant and understanding of other denominations who do not think and act as we do and I think it will be an excellent opportunity for you to get an insight into the worship of the Church of England whilst you are at Epsom; you will find the prayer book a little strange at first but it contains some beautiful prayers and I think we all ought to be acquainted with it, even if we are not church people. Officially, I believe, the Church of England Chaplain is not supposed to give communion to any except those who have been confirmed, but actually

you will find that many of them adopt a broader attitude and when we were abroad we many times received communion from the hands of Anglican parsons and were happy to do so; it is part of the ecumenical life of the church.'

Later on, he writes, 'Mummy has to admit to one disappointment in the charges you left to her care. I do not know whether the angel fish missed you, or whether it did not like the look of mummy, but I am sorry to say it has died. All the rest of the livestock' – which included the axolotl – 'appear to be in fine fettle.' And so he ended in a tone that was to haunt our relationship: 'We all remember you in our prayers, praying that God may be near you in times of difficulty and problem, which arise in all spheres of life.'

As I read this letter again, sixteen years after it was sent, I am filled with a sadness which burns through my whole body. The end of analysis, too, is like going away for the beginning of term. But, today, the relative equilibrium and trust between W. and myself has been achieved *after* researching and resolving my conflict with him. At the time that my father wrote to me, our paths – 'we of the Baptist way of Faith' – were still apparently twined together. But, already, those seeds of rupture, sown so long before, were germinating, pushing out shoots through the deadening tarmac. The death of the angel fish in my bedroom aquarium, only days after I left home, was a kind of omen. Soon, he and I were to be locked in mortal combat.

I turn over the letters. For years, a weekly epistle, typed, single-spaced, on two sides of quarto sheets: each one replete with errors of spelling, grammar, punctuation and syntax. Yet they express so vividly the impossibility of all that passed between us. On the floor, beside me, as I read, is the carry-cot. Inside it, Sylvia sleeps, sucking at her dummy. I am the father now. Sometimes I forget how he fought to retain intellectual hegemony over me, how he tried to save me from the influence of 'pagan' and secular writers or thinkers; how he resisted my wish to become an artist, or a writer. And, all the time, over and over again, he emphasised that he did not wish to 'influence' me; that the choice was no one's but mine. As I showed signs of growing intellectual independence, the letters became more urgent, and turned into

packages: 'I would not dream of pushing books under your nose, but . . .'
And the 'buts' were brightly covered titles from the Religious Book
Club, or more weighty volumes from a second-hand religious book-
seller in Brighton, from whose mailing list he ordered for me. It was
doubly hard to oppose him, since he always reiterated that, of course, I
was free to read and believe what I wished. In those days, we were
locked in a frozen struggle, like the sculpted anguish of the Laocoön,
entwined by the static writhing of the sea-serpent of our shared past.

Sometimes, I start to think I exaggerated our conflicts. But these sad
letters bring back the bitterness of the front line along which I fought in
adolescence; here, I see so clearly what brought me to analysis. I
wanted to get to a position where I could say, in the words of the
popular song, and of the title of George Brown's autobiography, 'I did
it my way'. I chose to realise my life for myself. In his eyes, however, my
error was not that I challenged him: he felt there was nothing to
challenge because he had emancipated his children completely. But the
battle was *necessary* for me: there was no way I could begin to relate to
others without fighting and winning it. Analysis was the terrain in
which the unresolved parts of that struggle, lodged now within myself,
like live armaments left by a defeated enemy, could be dismantled or
exploded.

1978 Redding, Connecticut

Here, in the hushed Connecticut night, I keep thinking about the end of
analysis. The anniversary of a termination. About how that prolonged
ending filled two attenuated years. Is that another racoon, a rat or a
rabbit scratching on the wall of the barn? Out there is an impenetrable
American blackness.

I begin to think about how, before we set off for France in March
1975, I knew that W.'s wife had just given birth to a baby and that my
existing arrangements for treatment with him would certainly finish
that November. As a training analyst, W. was required to treat a
patient, under supervision; the patients selected for training analysts
were chosen, like myself, on basis of need, irrespective of ability to pay.

An appropriate fee was agreed, and paid to the Clinic, rather than the analyst himself: I was assessed at the minimum rate of 75p a session, but, for much of the time, I did not even have to pay that as my analyst was one of the few employed by the National Health. It was sometime early in 1975 that W. told me that these arrangements were limited to a period of three years, and would therefore, in my case, come to an end that November.

Colette is turning from her left to her right side, and groaning slightly in her sleep.

When W. told me about the child, I declared that he had 'put a foot through the screen of my transference'. At more or less the same time, I was also shocked to learn that I would either have to make a private financial arrangement with him, inevitably way below the market rate for psychoanalysis, or terminate the treatment. 'As I'm not going to accept your bloody charity,' I told him one morning in his consulting room not far from Freud's last house in Swiss Cottage, 'it will have to end.' The trip we made to France, and the beginning of my 'novel', this journal, were in some mysterious way intended to combine into a great leap towards 'HEALTH'.

John Berger had taken on the onerous role of the 'good father' for me, the idealisation of what I would like to become. (Or so I then thought.) Meanwhile, many of my feelings about 'the Mother' clustered around the fragmented Venus de Milo. I believed that, on this journey, I would confront John and the statue in their reality, as 'objects' in the world, stripped of their private meanings for me, and then I would be free. In Haute Savoie, I stared at the mountains and said, 'Once the whiteness of Omo made us think of snow; now, when we see snow, we think of the whiteness of Omo.' Reality was not so easily reachable. And, in the end, I did not see the Venus statue that spring, at all.

We drove back with John and Beverly, passing through the back passage of France – as John called it – heavy with ponderous clusters of Courbet rocks and snow, overhung, further north, with the white crosses of the ghosts of war. The hovercraft in which we crossed the Channel was briefly beached, and I already knew, somewhere in my

head, that all was not going to be perfectly well. The old fantasies were hammering again. And then, in the middle of the Blackwall Tunnel, the Deux Chevaux seized up: my back-seat dream became a living nightmare. We all got out of the car. One of the lanes in the tunnel had been closed for repair. The traffic thundered by, unnervingly close. I tried to signal to approaching vehicles to slow down, while John attempted to start the car. He got it going, and shot off, on his own, to the far end of the tunnel. Beverly, Colette and I crept out along the sidewalk, drenched in the roar of the traffic and an evil stench of petrol fumes. It was late when John dropped us off at Graham Road, but he and Beverly came in, briefly, to see our new house. When he entered my study, John gasped at the books and papers, crammed everywhere. 'It's like the inside of a head,' I said. And he assented in that intense way which leaves you uncertain whether in fact he agrees or not. And it was then I noticed his look of disapproval when he saw the goldfish in a tank on my table.

Nonetheless, in the days that followed, I still believed my analysis was finished. Soon after, I wrote in my 'novel', 'it seems pointless to say anything . . . What I can learn here, I have learned.' I talked a lot about the breaking of my focal symbols: the shattering of the echinoderm test; with its five-pronged holy star embedded in a calcareous globe it was a priceless symbol of my rigid, enclosed, five-person family . . . and indeed, of my own cranium, or brain-case, in which I had felt that family still to be embedded. (There was little I did not know about the biology and zoology of echinoids!) But I lectured W., too, on the true history of the goldfish, and the various proposed restorations of the Venus de Milo. I claimed, through successive sessions, that I was dispelling their private meanings for me so that I could finally reveal them as 'things in themselves', rather than symbols or signs. Redemption, I felt, would be achieved if only I could come to see the naked shingles of the world.

All this, I said, showed decisively that the analysis was over. But W. kept pointing out there was something much too neat about all this, that it was an 'intellectual' position. In fact, he argued, I was frantically trying to deny I needed analysis following the birth of his child – the

wretched, interpolating brother for me – and my feelings about the simultaneous 'rejection' involved in the ending of my Clinic vacancy. I remember how when one morning I announced that Rosie was no longer a focus for my mildly perverse fantasies, but rather someone about whom I felt sensuous desire, for herself and in herself as it were, he said, simply, 'I understand what you are saying. But I don't think life is as rosy as you are suggesting.'

Nor was it.

Sylvia is stirring now, muttering baby talk in her sleep. She is the true narcissist, unlapsed. The only word she has at the moment is *nez*, French for nose!

Soon, W. and I became locked into seemingly interminable sessions, wrangling, or so it seemed to me, about the question of the financial arrangements for analysis after the Clinic vacancy had ended. I argued it was the analyst's duty to complete the analysis we had entered into together, on the basis upon which we had set out. 'You have stretched me out on the operating table, cut me open, and are now refusing to carry on simply because I don't have enough money,' I said angrily. But he said my inability to perceive and try to meet his needs was an indication of how far I still had to go. And, suddenly, for the first time in the analytic process, my relationship with the analyst, the famous transference, became the core and focus of almost all the material I presented.

Although I now acknowledged he was right about the factors which had brought about the 'crisis in analysis' (i.e. the birth of his child and the ending of the Clinic vacancy), I kept on emphasising what I liked to call my 'stupendous' leap towards health. I not only wrote about this in this 'novel': I also issued him with letters and notes about what I was thinking and feeling, because, I said, I felt trapped if I had to make every communication to him from within the analytic space. I kept carbon copies of these, which, knowing I would be here for March 28th, I have brought out with me to Connecticut. 'My advances,' I wrote so pompously at this time, 'included the cessation of masturbation, the withering away of persistent, compulsive sexual imagery, the efflorescence of sensual sexuality in my relationship with Colette, and

the direct expression of unmediated affects (both positive and negative) in my relationship with her and others.' The tone – that of a clinical psychiatrist's report – belied the content.

This 'novel', or journal, also, of course became a contentious issue within the analysis. I said that although it was true that through the 'novel' I had set myself up as my own analyst, this was not just a sterile assertion of independence from analysis, but rather 'a creative advance on it'. 'My "novel",' I told him in May, just two months after I had started it, 'is about the search for "reality", a "reality" as existing separately from the mind that observes it; or about the distinction between what things *mean* to the observer, and what, in fact, they *are*. Specifically, it involves the unravelling of "self" from the environment, in the knowledge that this process is necessary before one can begin to discover the "other".' The echinoderm test was, I said, a metaphor for what the book – and analysis itself – was about, for me.

But, I went on to argue, the way I was thinking involved not just the uncovering of an independent reality, but the simultaneous critique of it. Here, I said, I was referring to *social* reality, more than physical reality. (Yes, I really did go on like this, through session after session.) Thus, I began to quote, and persisted in doing so, until the point of cloying tedium, from the early Marx. Again and again, I argued along the lines that the 'constitution of private property' summed up the whole inverted logic of modern society. Private property, I said, consecrated the right of individuals to pursue their own exclusive interests independently of, and sometimes against, society itself, and thereby warped the social relations between men and women.

I was possessed by all the self-righteous pomposity of the old New Left. 'I am in sufficient agreement with Marx's analysis,' I wrote in one of my letters to him, 'to believe that any formulation about "reality" (and hence any formulation about adaptation to it) *must* take into account this inversion within it, or else it will participate in the perpetuation of that inversion.'

And so, I would tell him, the supersession of private property 'is the complete emancipation of all human senses and attributes', and the point was (but of course) no longer to understand the world, but to

change it. And that meant my refusal to contemplate paying a 'reasonable' fee, in market terms, was not, as he suggested, indicative of my continuing omnipotence and self-insulation, but rather a sign of my determination to transcend those arid social relations determined by private property in which he and the majority of other unfortunate people lived their sorry lives. If he couldn't understand the point I was making, I suggested, he should spend the next three or four sessions reading the early Marx for himself . . . for which, of course, I would munificently continue to pay my nominal (by that time) £1.25p, or so, to the Clinic.

Out there, in the night, blanketed in blackness, all Bob Natkin's land; and each of these paintings around the walls here is worth how many thousands of dollars in the art market, today?

All this W. said (and rightly so) was an attempt to switch things to the level of 'real issues' to avoid my irrational conflicts. But, as always, I had a ready answer. I replied that the distinction he made between my 'irrationality' and reality lost its validity unless it contained a critique of the irrationality embedded within reality itself. 'As I take the view that the external environment is itself "upside down",' I kept on telling him, 'I am not going to have the same idea about what constitutes adult, adaptive behaviour as someone like yourself who resigns himself to the social environment and perceives it as normative reality.' I said I could only regard as adaptive behaviour behaviour which had as its goal the 'initiation of change *in reality*'.

And always, of course, the argument tracked back to what would happen to the fee in November. Thus, I told him, the idea that the achievement of an object relationship with another person was recognition of the primacy of the money relationship might be adaptive in his sense – but it was not in mine. I wrote to him, 'You are arguing that once the exceptional conditions created by the Clinic vacancy come to an end, then my need for analysis will be evaluated by my ability to pay for it. The amount of analysis which I can have will be determined solely by the amount of money I am able to find.' I was unrelenting, ever so. 'In your view, and in that of the "real" world, that is no doubt a reasonable position. Object relationships between people are usually

mediated by the money relationship, and all other needs become secondary to it. But that is precisely what I find unacceptable about existing social reality. *True* object relations, as Marx pointed out, involve the recognition of, and response to, human needs.' (I would even italicise after the fashion of my master.)

Sylvia is tangled up in her cot. I get up, and walk over to her, and make her comfortable. She protests in her sleep at the impingement.

And so, it seemed, by the end of that May, we were running into an ever-thickening ice-pack which threatened to destroy the work of analysis. From my point of view, the essence of the crisis was a difference concerning the nature of external reality. He was perfectly prepared to acknowledge this difference; nonetheless, he saw the real problem as my refusal even to consider the pathology of my own inner world. For my part, I began to think that, although I *did* need further analysis, it was hopeless to try and go on with W. I used to say it was like trying to discuss physics with a member of the Flat Earth Society.

'W. thinks my politics are something we can leave on one side for the purpose of analytic work,' I wrote. 'But the difference between us is one which precedes politics. It is about what is "real" and "rational", about, in fact, the nature of a healthy relationship to the self, others and the world they mutually inhabit. Since we see this issue from irreconcilably different positions, where,' I asked, 'is that common territory from which we can proceed?'

And yet, despite all this, I knew that I did not want to give up. I was there every morning, almost invariably before time. I wanted to fight on and find a way through. 'I lie there on that couch,' I wrote in my 'novel', 'and think we have travelled so far, that so much has been jettisoned that I wanted to jettison. But the crucial, the definitive leap, is denied by the very structure of the analytic relationship itself. I am not, however, content to abandon it at this point. That would be to accept an intolerable failure. But I am totally frustrated. I do not know how, or where, to go from here.'

I just kept on insisting that the stumbling-block was *his* lack of insight – not mine. 'Look,' he said to me one hot June day, 'I cannot be a good father to you.'

'I know that,' I replied, 'but you seem to have no difficulty in being a bad one.'

1975 *Le Châtelet, France*

'A novel,' I say to Colette's father, in despair. 'A novel, *un roman.*'

But I do not wish to discuss it with him. I cannot discuss it. He will ask me about the plot. He will want to know what it is about. I try hard to distract the beam of his eyes from the long lines of English type running across the white surfaces of my pages. I tell him that I am reading another book by a Frenchman, François Jacob. '*Le docteur?*' He has heard of Jacob. The prize-winner. He picks up the book, and flicks through the pages with his hand. He thinks it would interest him: a history of heredity. He reads *Historia*, a popular history monthly, and *L'Express*, a weekly news magazine. As long as I have known him, he has been threatening to cancel his subscription to the latter: he thinks it has become too pro-America and the multi-nationals, which his deeply rooted French nationalism makes him despise. But he will almost certainly carry on reading it.

'I always seem to be reading books by Frenchmen,' I say, hoping to lead him away from my English text. Yesterday it was Serge – well, at least he usually *wrote* in French; the day before that Roland Barthes. I mention Barthes' name. He repeats it twice. 'Barthes. Barthes. There were many families called Barthes in the first village where I was postmaster, Barthes *partout*. The postmen used to get all their letters muddled up.' I say that I often read French writers because there do not seem to be many good English writers at the moment. Out of formal courtesy, he denies this, although I know that he feels proud because I have said it. He thinks he must return the compliment, and I watch him trying to remember the name of an English writer. 'Agatha Christie,' he says with a grin.

That was a clever move! Now we can savour a moment of agreement, through simulated disdain for Agatha Christie. She's not in the league we are talking about, and he knows that perfectly well. But the truth is I've never read a novel by Agatha Christie, and I have seen a

translation of one of them among the encyclopedias and back issues of *Historia* on his shelves.

But he is not going to be deflected. He comes back again to what I am writing, earnestly tightening his face, and dropping his elbow into his knee. The Thinker. I try, inconspicuously, to cover the text with Jacob's book, which he has handed back to me. He can't read English, of course, but, in his job, he must be good at scanning words. If he sees too much he will start asking himself, 'What are Colette and Le Châtelet doing in *un roman*?'

I am not even sure about why I am being so secretive.

· Nothing about him is yet written.

'What is it about, this *roman*?' he asks.

I am used to evading this question in England with a wry smile, a screen of pretension. Ontology, or something like that. Evidently, that will not suffice here. It would be no use, either, making a joke of it and saying that I was writing a novel about writing a novel. He just would not understand. All novels, he knows *that much* about writing, have a plot, a story. Could I get away with saying it is about 'consciousness'? What is the French word for 'consciousness'? I don't know it. I say it in English, giving it a vaguely French sort of emphasis. A total failure. But now he is really interested. He desperately wants to unravel this clue. He picks up the manuscript.

1976 *Graham Road, London*

Chasing these mad March hares across French fields, I feel that cyclical madness rising: the terror of the turning globes; oh, the pain, *that* pain, again.

1977 *Graham Road, London*

The battle at analysis is all finished now. These last days have the feel of the end of term. Lord dismiss us with thy blessing. Does this mean the struggle with my father – inside and out – is over at last? As here in Graham Road I turn over these letters, sad mementoes of those

tortured years, streaming out over sheets of tired quarto, I remember the injurious traps which he sprung for me. 'We fully recognise that at your age you have a liberty of choice about many matters,' he writes in 1965, 'nor would we wish to impose our pattern of life upon you, even though we feel that it has played a very large part in bringing us both such richness and happiness of family life that you will appreciate that we have come to value it very highly. Whilst we recognise and accept your decision to follow the common, accepted social pattern nevertheless would you please be tolerant of us if we stick to our modest way of life and continue our habits of abstention from alcohol.'

How could I reply to such treble-binds! In my soul, I would scream, 'Stop! Stop! Stick to your "modest way of life", your "habits of abstention from alcohol", but at least accept I could not find *my* richness and happiness there!' But he could not let me leave quietly and shut the door behind me. Even when I managed to force my way out, I found I had to take his museum with me inside my head.

It all came out in his religious admonishments. He wanted to be humble but he could not resist twisting my heart and arm, or denouncing every error I made as I tried to leave his citadel behind me. In the mid-1960s, I began a short-lived flirtation with the Scarlet Woman of Rome. He tried to stop me talking to a Catholic priest; when he saw I was still involved with Catholicism, he wrote to me, 'Because you are moving out to a different field, may I beg that you will still be tolerant of the religious background from which you have stemmed. No one group or view has the monopoly of truth and every view is also compounded of error and distortion . . . Oecumenicity must begin with us in the home in mutual understanding and tolerance and genuine agreement to differ. As for me, I recognise the limited understanding I have of these matters and the limited aspect of the truth as I see it and afresh cast myself on the superabounding grace of God who welcomes us not because we think and do aright but because it is His very nature to do so. God be with you in all your earthly pilgrimage!' He wrote as if it was *I* who was seeking to convert him; all I wanted was to go off on my own.

Just a few months later, he revealed the limits of the tolerance he

demanded of others. 'May I be very frank with you and say that I cannot be tolerant of the all too obvious errors and self-deception of the church of Rome.' He went on to say he had to testify to the truth as he saw it, 'in the fellowship of the World Council of Churches'. 'I know of no injunction of the Church to put down heresy,' he explained. 'My master showed very little interest in putting down heresy.' My master, however, seemed intent upon it. Nonetheless he added, 'Having said all this somewhat violently, may I hasten to say that any criticism of any other Church on my part is made in great humility, as I know that I too only "see in part and understand in part".'

And so, it seemed to me, when he condemned the 'all too obvious errors and self-deception' of others, he did so in a spirit of tolerance and humility. When they pointed back at his own no less evident errors and self-deceptions they were only revealing their manifest intolerance and pride.

'Religion,' he said in that same letter, 'is not a suitable subject for argument, but when people tell us of what the Grace of God means to them and how through their various callings they have found Him, then we listen with real interest.' We both need one another's insight, he explained, but not one another's intellectual arguments. Even so, I could only have been tempted by the Papal Whore because I had not understood the intellectual arguments correctly. 'What sorrows me about you,' he wrote, 'is that you have not the background of biblical knowledge or church history to be able rightly to evaluate the argu-ments of Rome. Although you have been a freechurchman, you have never entered into the great treasury of scholarship, devotional works and the genuine fellowship which is our inheritance.'

Where, I wondered, did this leave those Polish peasants and Ameri-can Bible Belt Baptists who felt they had discovered the 'Grace of God' through means which contradicted this 'treasury of scholarship'? 'Much as I try to be tolerant to my separated brethren of Rome,' my father went on, 'I grieve to hear that in Roman circles they are talking of Mary as "co-redemptress with Christ". This is not a biblical insight.' Nonetheless, he could write, 'Arguments seem less significant as the years roll by and one learns increasingly to rest on God. It is easier for

me, than for you, because it is inherent in my faith that I should recognise the insights of others who differ from me.'

How could I react to all this? He condemned that faith which was then interesting me while claiming that the difference between us was that he recognised the insights of faiths other than his own, whereas I did not. He was inviolable, because he 'rested on God', and therefore knew, without recourse to argument, the truth of his words and ways. For all his declarations about the limits of his access to the truth, it seemed to me that my father believed he *was* God, omnipotent and omniscient. Indeed, I felt he was trying to seal down any escape hatch I might intuit from his truth. Although, at this time, I was seeking instruction from a Roman Catholic priest, I was also attending meetings of the Cambridge Humanist Society, exploring every possible route from the impasse of his beliefs. In that same letter, admonishing me for what he saw as my incipient Romanism, my father wrote, 'May I take one further little liberty? May I ask do you do wise to frequent with the humanist movement? When our faith is young it may be blasted easier by such harsh winds than when it grows settled. You are not very likely to convince them of the reality of God, but they may make it less easy for you to enjoy HIM.' Or him.

Clearly, there was to be no way out. 'It would be very nice to think,' he once wrote, 'that whatever branch of Christ's kingdom you end up in you could still join us in worship of a Sunday evening in our own church. It means very much to me that we, as a family, should all be able to gather in God's house together and realise His over-ruling might in our family affairs.' I read this, of course, as meaning that he was determined that I should continue to be ruled by *his* might.

My eventual encounter with Marxism was (for a time at least) my supersession of his confining 'Kingdom': I saw Marxism as representing the positing of human hopes back into human history, the recognition of our finite existence in a sensuously knowable material world, beyond which there was no divine transcendence. Above all, it meant, for me, the recognition that human feelings, like love, could only be fulfilling among human beings. I liked to think that the destruction of those conditions which had made a 'Holy Father' necessary for him

was part and parcel of my attempt to seize hold of the world, of my impossible escape from the cell of my past.

By the end of 1967, when, despite all his exhortations, I was losing faith altogether, and had fallen in love with Colette – 'hot, sweet, mammary love', I called it in a poem – he wrote to me about his own sometime 'uncertainties'. 'Two things, under the good hand of God, arrested me in my uncertainties. Firstly, the number of men, small but significant, of undoubted intellectual capacity and insight, who retained a faith in Christ. Ranging from Augustine to Barth, Brunner, Tillich and so forth; not that I could identify my beliefs with any of them fully, nevertheless I felt that if with all their great intellects they were able to continue in simple faith, then there could not be so great a cleavage between faith and the intellectual climate as I had suspected; this induced me to try to find out what for me was the essence of the faith.'

And what was that essence? For him, 'ultimately at the heart of Christianity is the strange figure of Christ Himself, His life and teachings, which represented for me all that I would want to be and alas all that I fail to become.' 'I know,' he confessed, 'I would have been far more effective in all my personal relationships if I had better brought His mind to bear on them, instead of what I have done. Moreover, when I am utterly dejected by the sense of failure in that I have let Him down, I feel assured that when I come before Him in confession, He neither condones my folly, or reproves my stupidity, but accepts me as I am (as He did in his earthly ministry to others), forgives me and sends me back again into the stream of life.'

It was, he explained, 'in our personal relationships that most of the stress of life comes. He and His teaching are highly relevant just there . . . How relevant need a religious faith be to the passing phase of any culture? Perhaps it is the modern culture that is increasingly irrelevant to any serious approach, let alone Christian approach, to life.'

And thus, staking all on the haloed mirror held up in the gospels of the Historical Jesus, he proclaimed Christianity as that redeeming power which had sent him back into the stream of life and healed his personal relationships. Why then are we both so alone?

Downstairs, I can hear Colette moving in the kitchen, stacking crockery, her long hair falling over her shoulders, the sadness I don't want to see in her heart.

These letters remind me vividly of why I decided that, for myself, I had to find another way; but the window between the study and the world is still there.

1978 Redding, Connecticut

So, for many months, W. continued as a bad father for me. Ah, these fathers! I look down at Sylvia, lost in the vulnerability of sleep. What will you come to think of yours? The paintings are all sunk in the shadows. I believe it was the steely clash of those word-headed male conflicts which held me back from the taste for such things. In the summer of 1975, W. kept on pointing out to me that what I said to him – my 'Marxism' – reeked of superiority, intellectual aloofness, a sense of Cause, and a fanatical messianism, expressed in my wish to establish the Kingdom of Heaven on Earth. My father, he implied, lived on within me, faithless but intact. And I resented and resisted what he said.

'I think you have a very clear idea of what you would like to become,' W. once said, 'but not of what you still are.' Several influences began to change the way I felt about myself and led me slowly and suspiciously to recognise my leap into health was not all I wished it to be. Sometimes, quite new ideas would penetrate the complex patina of rationalisations so skilfully meccanoed around my character, and spontaneously release unseen pools of feelings which had lain, constrained, beneath.

For example, towards the end of July 1975, I was invited at the last minute to 'cover' the Congress of the International Psychoanalytic Association, held that year at the Dorchester Hotel. *New Society* commissioned me so late that I did not even know in time to tell W. before the summer break. There, with their headphones and conference papers, were the ghosts of my past and present: Zeitling, whom I first consulted at Cambridge, and of course W. himself, hurrying through foyers and seminars. We met in a milling crowd of analysts: I

wanted him to know I hadn't intended to shock or surprise him by my presence, that I had not known when I last saw him that I, too, would be there. We exchanged a few polite words, awkwardly. Later, his comment on this meeting – our first outside the consulting room – was, 'I was surprised how like a woman you were.' 'It says something about you,' I answered, 'that it took you so long to notice.'

What fascinated me, at the Congress, however, was the dispute between the 'new', European analysts and the Americans. André Green, from France, gave the inaugural paper in which he spoke of a malaise at the very heart of psychoanalysis. 'I think,' he said, 'that one of the main contradictions which the analyst faces today is the necessity (and the difficulty) of making a body of interpretations (which derive from the work of Freud and of classical analysis) co-exist and harmonise with the clinical experience and the theory of the last twenty years.'

Green argued that it was no longer possible to think in terms of welding new pieces to an existing theoretical core. He emphasised that 'the perception of the change that is beginning today is that of *a change within the analyst*'. He explained that he had been working with 'borderline' states, conditions which could be classified neither as neurotic, nor as psychotic, yet which retain aspects of both.

This work had led Green to a new view both of 'psychic reality' and of the psychoanalytic situation itself. He suggested the existence of a psychotic core, or 'blank psychosis', within everyone. Whereas Freud argued that the neuroses were the 'negative of the perversions', Green held that 'the implied model of neurosis *and* of perversion is nowadays based on psychosis'. Indeed he saw the defence mechanisms, the ways in which the ego attempts to ward off anxiety, as being mobilised against the fear of madness and of self-negation.

None of these ideas went down very well with Leo Rangell, a past president of the International Psychoanalytic Association, and a die-hard paleo-Freudian, who dismissed Green's work as an 'eclectic *mélange*' of Freud, Melanie Klein, French existentialism and oriental philosophy. Rangell claimed that though the world was changing rapidly, the 'trunk' of psychoanalytic theory did not need to subject itself to such change, whatever the 'poetic and mystical' activities might

be at its periphery. Rangell maintained that 'the oedipal-phallic-castration phase is a hub, a bull's eye of psychoanalytical penetration'. He seemed upset that some of the most archaic Freudian concepts were no longer in widespread use. 'Where,' he asked, 'are the libidinal phases? Where is all that we learned about the anal phase?' And then, producing a gasp of astonishment from a group of British analysts sitting close to me, he added, 'So much has been lost in the zealous quest for the first year or months of life. I have a patient for whom, to understand her anal phase, is to understand her life.'

Of course, I was on Green's side: his stress on this 'blank psychosis' at the root of consciousness, and on the fear of madness, touched something deeply within me. At the press conference after these inaugural papers, I behaved in a strange fashion. There were only a handful of journalists there, most of whom had not attended the sessions. The questions were banal: about the number of Institutes in the world, or Freud's smoking habits. Suddenly, I began to push. I asked how two men holding such different views as André Green and Leo Rangell about what psychoanalysis was could remain in the same society. This produced agitated flannel about the umbrella of Freudian theory. 'But,' I insisted, 'that is exactly what André Green seemed to be arguing needed to be dismantled.' Green replied he had only just met Rangell, and emphasised the need for discussion. Then I asked him if he could ever conceivably say of one of his patients, 'to understand her anal phase is to understand her life'. Green said something about not knowing a case about which he would use such a formulation.

But P. Giovacchini, the President of the Society, who was seated between his disputing stars to face the press, was clearly uneasy about the direction the questioning was taking. The press conference was brought to an abrupt end. The man from *New Behaviour*, sitting next to me, said, 'It was just getting interesting. I thought you were onto something.'

On the way out, André Green came up to me and stressed, again, he had only just met Leo Rangell. 'But you can't remain in the same society as someone who believes that to understand a patient's anal phase can be to understand her life,' I said with vehement conviction.

Understandably, he looked astonished that a journalist should address him in this manner, but said nothing. Rangell's wife, however, gave me her husband's card, and recommended his new book to me.

The following day, another American analyst approached me. 'Are you getting any answers to your many questions?' he said. He offered to 'brief' me, the journalist from *New Behaviour* and another woman writer who was covering the conference. He started to explain the difference between French 'existentialism' and truly 'scientific' psychoanalytic theory. 'Sartre believes we all feel a sort of existential angst,' he said. 'And that's what is behind these new ideas. But the only trouble is that ordinary people just don't feel that way.' The journalist from *New Behaviour* and the woman smiled: I did not. Existential angst was exactly what I had always felt.

Indeed, I knew that Green was talking about an aspect of myself that I had been denying. I was so intrigued by his ideas that I even entertained the fantasy of going to work with him (doing what I was not sure) in France. After one session, I got him to re-state his theory of 'blank psychosis' as we stood in the empty conference hall, so that I could get the summary of it right for my article. This I wrote as soon as the conference was finished.

And then, awash with these disturbing ideas, I went to join Colette in a village near Latour de Carol, in France. Something Green had said made me feel that I should re-read Ronald Laing. Of course, we had all read him in the late 1960s, along with Jorge Luis Borges and Henry Miller, but I, at least, had done so without much understanding. Now I re-read him in the light of my own history and my growing dissatisfaction with the limitations of Freudian methodology. It wasn't so much that I thought Ronald Laing was 'right', but that, like André Green, he triggered all sorts of half-formed intuitions and insights into myself. He made me change what I *felt* about myself.

Today, nearly three years later, I can vividly remember how, one Sunday, I sat in a hayloft next to the cottage where we were staying. That afternoon, the storms were particularly heavy. Water seemed to fall from the sky in sheets and slabs; the thunder groaned and growled at the back of the hills. All was wetness, moisture and dripping things.

Arlette and Christian had taken Colette out in their minibus to gather raspberries and wild strawberries, but I stayed among the bundles and bales of hay, from where I had a grandstand view when the elements opened up. Of course, the others came back very quickly; Colette called up from the ground, through the pouring rain, to say that the storm was exciting. It had drenched her. But it seemed to shatter the placid inevitability of life, to open up new potentialities.

And there, I finished my re-reading of Ronald Laing. As I did so, I could hear Arlette and Christian's baby crying out in the house nearby. The storm seemed to fill her with terror. Laing argued that in what he called the 'schizoid' personality, a fundamental splitting of the self occurs, so that what is presented to the world is a false self, a kind of protective shell behind which the inner self is sheltered to preserve its autonomy. This state Laing described as one of 'primary ontological insecurity' ('existential angst'?) characterised by the establishment of a polarity between 'complete isolation or complete merging of identity rather than separateness and relatedness'.

The truth was, of course, that until not so very long beforehand I had always thought of myself as an obsessional – like father, like son – whose life could be fully (or more or less fully) explained by reference to the anal phase. On my way out of my father's religion, I had taken to gambling, immersing myself in the overwhelming sense of loss to be derived from submission to the arbitrary decisions of the roulette wheel. Characteristically, I had then jointly edited a collection of Freudian papers on gambling which I introduced with a long essay, 'Gambling: A Secular "Religion" for the Obsessional Neurotic', a paper which emphasised 'the strategic role of anality in the gambling neurosis'. I sent a copy of this to Charles Rycroft. He wrote back that, although he was sure I was right in insisting that gambling was a variety of obsessional neurosis, he was less sure that I was right in accepting Freud's interpretation of the nature and origin of obsessionality. He said my book was vitiated by the fact that both Freud and I were obsessionals. 'As a result, we have an obsessional author, using an obsessional's theories, to elucidate an obsessional phenomenon.'

This letter from Rycroft, perhaps more than anything else, first led

me to question my intellectual allegiance to Freud. And, in that hayloft, Laing's 'schizoid' personality, fringed with 'ontological insecurity', seemed infinitely more relevant to myself than anality. Certainly, my sense of separateness could hardly be denied. And was it a coincidence that, only the previous day, on the banks of a stream nearby, I had experienced one of those rare, intense and almost indescribable moments of blissful fusion with nature and the world, when the boundaries of self seem to ripple and vanish, and I felt subsumed into the whole of nature? And as for relatedness, and reciprocity: though I longed for them, they had hardly been my forte.

Characteristically, Laing said, this inner self is regarded as being separate from the body, or as occupying an autonomous space within the body, with whose functions and processes it does not experience itself as being integrated. He wrote,

'The unembodied self, as onlooker at all the body does, engages in nothing directly. Its functions come to be observation, control, and criticism *vis-à-vis* what the body is experiencing and doing, and those operations which are usually spoken of as purely "mental". The unembodied self becomes hyperconscious.'

Laing related the establishment of this false-self system to what is commonly called 'self-consciousness': the schizoid individual, he said, is assuring himself that he exists by always being aware of himself. 'Yet,' he went on, 'he is persecuted by his own insight and lucidity.' How could I fail to recognise myself there? Because of its disembodied nature, Laing went on, the schizoid's inner self is, on the one hand, 'omnipotent', capable of anything, and of all grandiosity; and on the other is pursued by barrenness and ineffectual powerlessness: preoccupied with its own imagos, it forgoes the possibility of effective action in the external world. (I remembered that feeling of exclusion from a history in the name of which Serge professed to act.) 'The sense of being able to do anything and the feeling of possessing everything then exist side by side with a feeling of impotence and emptiness.'

Laing pointed out that the disembodied self can of course be isolated at any time, whether other people are present or not. Because he fears engulfment, or merging, the schizoid individual is also afraid of what

Laing called 'a real live dialectical relationship with real live people'. He can relate himself only to depersonalised persons, 'to phantoms of his own phantasies (imagos), perhaps to things, perhaps to animals'. Oh, those idealised Johns, statues, tests, axolotls and goldfish! 'If the whole of the individual's being cannot be defended,' Laing said, 'the individual retracts his lines of defence until he withdraws within a central citadel.' The Rock and Fortress of Seclusion.

The thunder continued to grumble and roar behind the hills. The baby cried again. Water dripped. I could hear Colette, Christian and Arlette laughing and talking inside the house. This detachment of the inner self, Laing explained, meant that it need never be revealed in the individual's expressions and actions. Nothing is experienced spontaneously or immediately, but the other is always at one remove. The world is often experienced as threatening. The inner self often ascribes to itself a transcendent, religious or mystical quality, through which it aims to leap above the world, and be safe. 'The self,' he continued, 'is precluded from having a direct relationship with real things, and real people.' It can only relate with immediacy to objects which are objects of its own imagination, or memory, not to real people.

I ran my finger down from my forehead to the centre of my chest: all this, I *knew*. What, after all, was my 'novel', this journal, but a manifestation of that? Or, as Laing put it, the abundance which is felt to be 'out there' is longed for (my 'sensuous reality') in contrast to the emptiness of the inner self, yet any participation in it is felt to be impossible and also insufficient. 'So,' he wrote, 'the individual must cling to his isolation – his separateness without spontaneous, direct relatedness – because in doing so he is clinging to his identity. His longing is for complete union. But of this very longing, he is terrified, because it will be the end of his self. He does not wish for a relationship of mutual enrichment and exchange of give-and-take between two beings "congenial" to each other.'

Even when I write about Colette here, she is so often over there: asleep, beyond the pane of glass.

But, Laing concluded, all this is bound around by the pervasive

self-consciousness which has as its roots the fear that one will be seen through. The schizoid individual, Laing said, characteristically seeks to make his awareness of himself as intensive and extensive as possible, yet he often exists 'under the black sun, the evil eye, of his own scrutiny'. Laing claimed, 'The glare of his awareness kills his spontaneity, his freshness; it destroys all joy.' And that false self will also certainly be harassed by what Laing called 'compulsive behavioural fragments'.

So, in that hayloft, with its smell of wet grass, soaked dust, rumblings of a disgruntled Zeus and whimperings of a tiny child, I recognised not only my father, but, more importantly, that part of myself which perpetuated a living death of the father within me. I *knew* this 'ontological insecurity', this 'existential angst', this split of mind and body, this freezing of spontaneity, this longing for fusion with imagined external plenitude, this sense of isolation within the citadel and fortress of despair, this use of objects in the world – from whores to spiny-skinned echinoderm tests, from axolotls to soapstone statuettes – as symbols or imagos . . . above all, I knew this sense that words alone could redeem and make living once more, and the repeated discovery that they could not. 'My self-consciousness,' I had told my analyst not long before I left, 'is the last symptom I wish to destroy.' My black sun; my evil eye. And there, in that French hayloft, I saw clearly for the first time the relationship between my divided self and my pursuit of both psychoanalysis and Marxism.

Ironically, my piece on the Congress in *New Society* had ended with a reference to Charles Rycroft, as one prominent analyst who is sceptical about the validity of applying causal-deterministic principles derived from the physical sciences to the study of living beings who are capable of consciousness and creative activity. 'Rycroft,' I wrote, 'remains a member of the British Society, but he was conspicuous by his absence from last week's Congress. If Green's ideas are anything to go by, this formal presence and actual absence within the Congress space might well be read as an indicator of the potential significance of his views. For the sake of psychoanalysis itself,' I concluded, 'one can only hope that this is the case.'

When I got back to London, there was a letter from Dr Rycroft saying, 'I must confess that although I was flattered by your last paragraph, it also induced acute existential anxiety in me, as I have a suspicion that your assessment of my role or non-role in British psychoanalysis may be correct, in which case I shall have to decide in the next few months whether to accept the mantle being offered me or not . . . We must meet again in September. I am back in London on the 1st.'

But when I went back into my own analysis that September, I continued to mix flashes of insight into the confusions of my own inner world with relentless intellectual denial, and remorseless pursuit of every chink and contradiction I could perceive in W.'s attitude to myself. Trapped, still, by the revolving globes of our two realities, I would argue that this isolation could only be resolved by the establishment of what I called 'a dialectical relationship between analyst and patient'. As my impingements rained down upon him incessantly he was forced to entrench, more and more, on those 'professional' conventions which so angered me.

In the first week of September, in characteristic style, I delivered a paper to him (as if he was Congress!) entitled, 'The Countertransference: Some Notes on the Analyst's Use of Messianic Projections in Defence of his "Unconscious" Ideology'. In those arrogant, self-justifying tones, I wrote, 'Let us look more closely at what happens when the patient's view of the external world comes into conflict with that of the analyst, and the analyst refuses to resolve these differences dialectically.' Now, I wonder how he tolerated this stuff. 'All that the analyst can do is to assert that the patient is resisting. Evidently, no *arguments* to the contrary produced by the patient can convince him otherwise. But, from behind his curtain of privilege, the analyst can express his view to the patient as a purely "professional" interpretation; that is, he can explain the difference in terms of resistance and neurosis on the part of the patient. But if, in fact, a *real* difference exists between them, in which the patient has achieved a superior' – ah yes! now there's the give-away: 'a superior' – 'insight into the nature of the external world, and has adapted his behaviour accordingly, the

conclusion of the analyst will be expressed in exactly the same way as if the patient was in fact resisting.'

I went on to argue that since the analyst set himself up as the ultimate arbiter of what reality was, and took his own perception of it as being synonymous with reality itself, and simultaneously refused to enter into any dialectical discussion of the matter with the patient, there was no possibility of what I chose to call 'a genuine resolution of differences, and a mutual advance towards a better conception of reality'.

Thus, I ended my portentous paper, 'The situation which the analyst creates for the patient has all the characteristics of a double-bind within the family.' And, for a time, it seemed the analysis was certain to falter upon those rocky shores. W. continued to accuse me of being a zealot, a sectarian, religiose, messianic and idealist: I would counter by saying that this was a projection of a part of himself onto me.

'In the analytic situation,' I wrote, 'the unquestioned and unquestionable ideology, the "real" version of reality, against which mine must always secretly be tested, the dogmatic, ultimate truth is that of the analyst's own ideology. Of course, I threaten this, while he keeps it carefully hidden behind his "professional" attitudes.' I argued that because the analyst refused to question this absolute truth, he was compelled to attempt to convert me to it through compelling me to admit my 'resistance'. 'Thus,' I wrote, 'he attributes to me precisely those attitudes which belong to himself.' Refusing to acknowledge a 'Cause' in my own life, I assumed that, when he spoke about my affiliation to a 'Cause', he was probably referring to his conception of himself within the psychoanalytic movement.

I ended by acknowledging that, like all projections, there was a kernel of truth in specific aspects of the counter-transference. After all, I reasoned, the analyst knew a great deal about my childhood, and the religious influences that had been brought to bear on me. 'He can dismiss my present views, ideas and achievements in the real world and assert that "really" I am still that little boy who believed in his father's messianic, sectarian religion. My father indeed sought constantly to "convert" me to his world view, insisted upon faith, and spoke bitterly

about my "unscientific" attitudes to the world. He also refused to confront his own ideology, and assumed that he was relating to me without such an ideology. The letters he wrote to me demonstrate all this. These put me in the same double-bind as my analyst puts me in now.'

I was free, I argued, to believe whatever I liked; but my father simultaneously insisted I should accept his untenable positions, while denying he held any such positions. If I did not do so, my father would produce reasons for demonstrating why I was resisting the truth about myself and the world. 'For many months,' I wrote, 'my analyst has had these letters in his possession. He has confessed that he "does not know" why he cannot return them to me – despite my requests. Perhaps his identification with my father (in terms of his relationship to me) is greater than he realises. It is easier for him to see my father within me than within himself. He "knows a zealot when he sees one", but what he sees is a part of himself in me. As he keeps telling me, he is not going to be a "good father" to me.'

But all these words rattled out with a feeling of deadness, evasion, denial and self-justification: none of it rang true. Dimly, through the dead patina of verbalisations, I began to glimpse that my analysis was moving towards its psychotic core: that all this talk was my defence against madness and disintegration. As through a glass darkly, I saw glimmerings of my 'underlying psychosis'. That month, brought to the brink by the theories and ideas to which I had naturally been so receptive, I began to feel and explore a sense of nothingness within myself. I sketched out the story of 'Robinson's Triune Sin' – about an encounter with a triangle of absolute emptiness within the self – with a feverish excitement. It began, 'There was a boy at my school – I shall call him Robinson – who believed he had committed the sin against the Holy Ghost.' I sent a copy to Charles Rycroft, and one day, on the way to analysis, I met him in the street. 'I am sorry I haven't written to you about your story yet,' he said. 'But I liked it very much. If I were you, I would publish and be damned.' I did. And I realised that W. and I had, in effect, penetrated a territory in which what was at stake was sanity itself. Towards the end of the month, I gave him a poem. Even though

the rockiest parts of analysis still lay ahead, in many ways, I still look back on it as the turning point.

Look, look, we have reached the threshold:
Standing together on the very borderline.
Lear stares at the blind bowl of the howling sky, and cries:
'This way madness lies!' He knows.
Wise Regan – oh so sane – replies:
O sir, you are old,
Nature in you stands on the very verge
Of her confine: you should be rul'd, and led
By some discretion, that discerns your state
Better than you yourself.
But Lear was not his Fool – or hers;
He knew that pit.
Do you think it is the first time that I peer down it, now, with you?
Here, the mad mother grins and grimaces with her dragon's maskade
Her schizophrenic face, your text book says.
But can that be the mirror where I saw myself in ten thousand splinters,
 hopelessly?
There was a chaos beyond chaos: all is scattered fragments.
A self, a world, without a whole globe turning.
('Cut them off! Pluck them out!' he cried.)
A jigsaw of a spherical test whose bits and pieces build –
 – build nothing
 nothing but
 the curving void.

Some favourite images:
A Venus in ten thousand fragments: and I as its beholder too.
Nothing, nothing, nothing, nothing, nothing.
A fine line! Leading nowhere to that blankness far beyond beyond
Swimming down a stream, inside a whole test, led by Dante.
Meeting myself in a million microbes: each one an autonomous part;
Nothing adding up.

Ah yes! And Regan knows.
Here, upon the trembling edge, she begs for trust,
Holds out her knowing hand to cure the basic fault,
And calls, come fly with me, like angels, to a new beginning.
Only believe, and thou shalt see . . .
But what I see, I see.
For Regan – wizened like Lot's wife into an immovable pillar –
Is smirking through a dragon's mask.
And Regan asks for trust!
Offering as surety, her holy saints,
Erikson, Balint, and Winnicott.

But in that flight from my first madness, I did not pluck my eyes:
In the cellar of the mind,
The emptiness is palpable.
There hums and seethes an infinity of nothingness,
A pit unfathomable; bottomless.
Because there are no pathways, there can be no guides.

Look, look that baby sleeps:
This one's mother has strong arms, at least.
Blood, breath and heat flow through their embrace.
She's no stiff and battered statue: no cold and rattling test.
The baby feels the round, whole oneness of its loving world:
Self, undivided, grows and gently separates and all is smiling peace.

But we, the leering ones, who never sucked at warm Utopia's loving
 pap
Perhaps have much less learning to undo.
A battered and fragmented self,
 within a splintering world,
 peopled by shattered others
Was all we ever knew.
The real divided world reveals itself to us without a rosy veil
Sadly, brave and murderous Regan, after the sweet cradle

Basic trust is basically at fault.
In a world where property is King, only a mother gives without
 interest:
She can have the whole child in her hands,
And if not always her, who else?

Or, if all's well with the world,
Then, I *am* mad.

You think I do not know.
But, in fact, it is that I will not pluck my eyes out which worries you.

Sylvia, at least, seems sound asleep: here, in this barn, watching them both, in the stillness of the night, that agony of existential pain seems far away.

1975 *Le Châtelet, France*

I think of snatching the manuscript of the 'novel', this journal, back from him. That would be foolish. He would not realise why I was doing it. Fortunately, he seems to be most interested in counting the number of pages written since the date at the top. He glances hurriedly through the first few sheets, still trying to repeat the word 'consciousness'. He is excited now, and still holding the manuscript in his hand, he crosses over to the door and calls out to Colette. I follow him, still hoping to retrieve the pages. He starts to ask her for the French for this word he cannot pronounce, tapping significantly on the sheets of paper as he does so. To get things over quickly, I intervene. 'What is the French for consciousness?' I ask Colette in English. But I am now beginning to remember that, in French, there is no such word, at least not as distinct from conscience: for the French, ego and superego are fused, and I know that, given a choice, the assumption he will make will be that of conscience. As soon as Colette has given him a word, he repeats it, nodding sagely. 'Eh! *Conscience*.' I imagine he is feeling relieved, perhaps thinking to himself, 'So these intellectuals have a conscience after all.'

At last, I manage to recover the manuscript. But not before he has run his eyes over most of its pages. He is in my position now: he is holding all the ideas in his hand, but the language is lacking. They are no use to him in relation to another. This morning, he went to church for confession. Not to have done so at Easter would have been a sin. Unlike my consciousness, his conscience has been absolved this day.

'All this is too philosophical,' he says without malice. 'You want to write books which no one will read!' He is laughing now, looking at me closely in the face, tapping on the desk with his forefinger. I feel more relaxed. Perhaps he is even wondering if I am about to regain enough conscience to go to confession one day.

In fact, of course, he does very well. Perhaps only the curé and the school-master would even have tried to have a conversation with an English writer. And, as for the curé, he is not cursed with a son-in-law.

He walks across to the other side of the room, repeating something about there not being much money in philosophical books. Colette has been reading Guillaume Apollinaire's *Les Onze Milles Verges*, the first text he published anonymously when he was 27. It is a piece of poor pornography, a pot-pourri of *culs*, cunts, amputations and ejaculations. He sits down on the bed with it and reads it for about four minutes, silently. His back is towards me. I wonder if I should say something. It seems hopeless. I can say nothing. I fill my pipe. He leaves the room without saying a word, without looking back at me. I want to call after him, 'Well! You say you don't understand ideas. And we both accept that. I say I don't understand French. Don't you realise that that is all French to me.'

1976 Graham Road, London

Shuffling through these past passages: pot-pourris of *culs* and cunts. Amputated cellophane gluteal muscles. Flickering, flickering. The spilling of the seed; it is the time of year. Out, out, vile jelly. White and teeming. The body trembling, while the past, reconstructed into a longed-for future, flickers over the skull screen. Only the present absent. What turning and swivelling of the huge split globes. What

struggling to shatter the empty dome of the test. Nothing changes. Words, words, words. We are still in prison. The fortress of the past. Out there, Graham Road greys and pales: the other side of the dirty glass of my window pane. Ah, the pain! Like Crashaw's crucified Christ. Criss-crossed with exquisite, rose-lipped weals and wounds. Bleeding; heartless; across old, cold, thorny pages. The iconography of a sweet conceit.

1977 *Graham Road, London*

But these letters are evidence: the sacred text, the book of the dead, the record of Jacob's struggle . . . Now, as I leave analysis behind, their fading words hammered through faint ribbons, leading like dream-ladders to that past, fill me with tears. Here, on the further shore beyond anger, I find myself mourning for a father I never knew, the man who insulated himself in a cloud of unknowability: he gazed into the pages of ancient scripture as if they were a mirror bearing nothing but a halo painted upon it, wherein he saw his own reflection transformed into that of the beatified Historical Jesus and, having seen his own inner self, glowing, loved it and idealised it, as an imago by which he could live his life. Unreachable, untouchable, unknowable. And he struggled, again and again, to hoist me up onto a cross beside his own. This evening, with analysis ending, I feel only compassion for him, a kind of tenderness for what might have been . . .

I keep thinking about Serge's phrase: 'an impossible escape'. Where all this marching business began. That is all which counts. Finding that unfindable *way through*. It was so typical of me that when the impasse in psychoanalysis really seemed to be choking us towards the end, and even W. was for giving up, I was for hacking on. And there, if nowhere else on that long journey, I had got things more right than he.

Downstairs, now, I can hear Sylvia crying. I look up from my desk and push the pile of letters away from me. I gaze, as always, through my study window. It is night now, but there is still enough light in the sky for me to see as far back as the gas cylinders. I switch off the lamp so all the books and letters are swamped in darkness. Out there, I can

survey the hum and glow of this fragment of a sleeping city. A single figure walks by on the far side of the street, hurrying home through the darkness. Alone. Watching him pass, I have the feeling that this is more like a beginning than an ending. Sylvia is crying again. I can hear Colette saying something to her. I will go down to them.

1978 Redding, Connecticut

Even after I had given W. the Regan poem, the analysis was bitterly hard going. Again and again it seemed poised on the threshold of collapse. Certainly, I acknowledged my revealed madness; but, I argued, this did not negate my insights into the true nature of 'reality'. Rather, *because of* that madness, I suggested, I could see things he never could. Again and again I referred to the fact that Newton's physics had a formal relationship to his underlying psychosis; I argued that the levels had to be kept separate. The physics could not be judged by its informing madness. There had to be some space in analysis in which 'reality' could be discussed as something other than a symbol of my inner world.

The fee, I said, was a *real* conflict between us, whatever psychological associations it might carry; precisely insofar as it was real, it could not be contained by the transference, but rather contained the transference. 'The conflict between us,' I wrote in January, 'is a particular manifestation of a contradiction which is at the heart of psychoanalysis, and its practice within a capitalist society.'

Endlessly, I reiterated the argument that there was an irreconcilable opposition between the therapeutic aim of psychoanalysis and the privileged position it had been forced to adopt under existing social relations. My analysis had tumbled into that general contradiction. Analytic work, in and of itself, could not resolve this; he, at least, had to acknowledge the importance of those external forces in creating the 'crisis' in our relationship. But he still said that if this crisis had not arisen around the fee, it would have sprung up over something else: he felt my insatiable infantile needs lay behind this patina of rationalisations and he had to defend himself against my 'exploitative' actions.

Above all, he insisted, he was not there to do what I wanted. Always, I homed in relentlessly on his compromises and contradictions, the unease he so evidently felt about many aspects of the analytic relationship, like a boxer worrying his opponent's bruised eye. Always, everything seemed to be teetering on the brink of disintegration.

But that March, Colette became pregnant, and everything changed. Somehow, the baby's anticipated birth-date heralded a 'natural' ending for analysis, but the swelling globe of Colette's extending belly affected me deeply and daily. At the time, I felt she was vanishing somewhere into the apex of her huge womb: for much of her pregnancy, she was peculiarly cold, remote and distant. I went through all kinds of strange bodily manifestations of sympathetic magic and couvade. All this made the tired abstractions of analysis seem curiously empty. But I pursued them nonetheless.

Two months before the baby was due, I lay back on the couch and looked at the plaster frieze running round the top of his consulting-room walls: it was based on the egg and cross motif. I had read somewhere these were the symbols of life and death. But the cross had been reduced to an anonymous mark. The wall to the right of the couch was plated with sound-proofing tiles. Polystyrene, fibre glass, or something other vile to the touch. Like hardened human tissues. I tapped it with my fingers and thought about the baby, down there, beneath the skin of Colette's stomach, kicking. By now, easily big enough to be viable, according to the text books.

'It's all right,' I said to W., 'I'm just tapping against the inside of the womb trying to get out. But no one can hear me.'

He tells me I am worried about those elements of my father-within-me which persist as I become a father myself. He says I am wondering whether I will be able to cope when I leave the womb of analysis . . . when the baby is born. His interpretations seem true, but empty. Like my words, they fall short. They count for nothing, unlike Colette's fecund womb. No germinal mystery. Loose necklaces of known analogies. As I walked down Harley Street after this session on the way to catch my bus, I felt intensely irritated. I had a fantasy about shattering

the façades of all the lying, pompous houses, to expose the false professional intimacies going on behind them.

From December onwards, I began to insist more and more that I wanted the analytic relationship to become reciprocal, dialectical and democratic. W. replied that my demands for change in him were symptoms of perverse manipulativeness, my need to arrange and model the world in my own image, and he stood his ground. But I said the only way he felt he could relate to me – for professional reasons, of course – was as my father had related to me when I was a child. He presented himself to me as aloof, untouchable, unchallengeable, possessed of 'The Truth' over and above the situation we were both in . . . Meanwhile, he accused me of presenting a 'one-dimensional' self to him. I said this could only change when the situation itself was changed; he countered by saying the analyst did not have to explain his techniques to his patients.

So, I felt, 'Daddy' knew best again, and I wasn't going to have any of it. Nor was I going to give up, or give in. The analysis, I said, could only end when, within the analysis itself, I could achieve a more 'equal' relationship with him. I came to feel he was allowing me no choice except to try and implement changes in the analytic situation by force, without his consent. 'Violence,' I wrote, comparing my situation with that of the blacks in Rhodesia, 'is the only way through which I can work towards that reciprocity I wish to achieve.'

And this was the point we had reached by the end of the first week in December, as Colette and I prepared for a birth. The whole world, it seemed, was doing the same. Haloed infants everywhere. 'And what rough beast, its hour come round at last, Slouches towards Bartholomew's to be born?' We had been to Natural Child Birth classes together. We had been briefed; Colette had mastered her breathing exercises. We were ready. In those final days she began, at last, to glow and radiate. They wheeled her from the ambulance to the Maternity Wards at Barts, and as I hurried beside her, I felt so proud of her. She looked more quietly confident, more determined, than I could ever remember having seen her before. I remember thinking she had the bearing of a queen! When we arrived in the labour ward, the houseman

said that things should not be long as Colette was well advanced. But the birth quickly turned into a nightmare. After a few hours, they may have suspected something was wrong, but they didn't tell Colette or me about this. All we knew was that our careful preparations were being swept away without explanation or apology. Colette's waters were broken artificially, the houseman said 'accidentally', and she was then ushered on to a kind of inevitable, mechanical conveyor belt, from induction to epidural and forceps delivery. Through all this I tried, hopelessly, to hold open the space in which she could have the kind of birth she wanted. At the very least, I wanted them to tell her what was being done to her, and why. But I think that for them I was just an impinging nuisance.

The labour was long. Colette was courageous: she kept on going with a grim determination. I admired her, and felt humbled by all she was going through. Towards the end, however, she was exhausted. A midwife leaned over her and said, 'We are going to give you a little help to get the baby out.' I could see Colette had barely heard what she said, let alone registered what she meant.

'Do you mean you are going to use forceps?' I asked.

'Yes,' the midwife said.

'Well, could you explain to Colette what you are going to do and ask her what she thinks about it?' I said.

At this moment the registrar who had been called in for the delivery arrived. Neither of us had seen him before. The midwife turned to him at once and said, 'The husband objects to the use of forceps.' This was not true. After all she had been through, and been subjected to, I could see there was no chance of Colette pushing the baby out herself. But the registrar immediately said he would carry out an examination to see whether forceps were necessary, and asked me to leave the room while he did so.

When I was called back, everything had been covered in green drapes. The medical staff stood in masks and gowns like members of the Ku Klux Klan. The great lights were blazing, as if a football match was about to begin. In the middle of it all was Colette, lying flat on her back, with her feet raised up in harnesses. I could not escape the feeling

that somehow I had let her down. The registrar informed me that he was going to carry out a forceps delivery and he did not want me to be present. I replied that I had been with my wife for more than twenty hours of her labour, that we had always agreed I should be present at the birth, and I wanted to be with her then, however difficult it might prove to be.

He looked irritated. 'I am in charge here,' he said. 'And I don't want you standing over me.'

I remember saying something about not even wanting to see what he was doing, but just wanting to be near Colette. He was shaking his head. Everyone else in the room stood silent and still like inquisitorial sentinels. I was close to tears. I turned to Colette. She said something like, 'Peter, we can't do anything else. We have to do what they want.' As a concession, he said, 'You can come back in when the baby is about to appear. I'll let you know.'

I stood in the corridor, listening to Colette's screams. It must have hurt her a lot. Again, I had this feeling that I had let her down, that, in this moment of terrible suffering, I wasn't there. I started to sob. The houseman came up and said, 'What's the matter with you? You don't look much like a happy father!'

I was upset and angry. I said I did not like the way Colette had been treated.

'I don't think you know much about babies,' she said.

'Well, I know more than you,' I retorted.

'More than me?' she said disdainfully.

'Oh, not technically, no. But you don't understand anything about the feelings of the mother, the father or the child,' I replied. I was going to say something about Barts being run like the pig-farm we visited at Stowlangtoft, but I checked myself, because, to my surprise, I saw she was almost in tears. At that moment, I was called back into the delivery room.

I went straight to the far end of the bed and took hold of Colette's hand, and told her I was back again. I felt ashamed because I had not been with her. She was still in wracking pain. I comforted her for a few moments, and then the registrar said, 'Well, carry on then, Dr Y.' His

tone implied, 'You see, after all that, the husband does not really want to be here at all.' He was irritated that I was not giving my full attention to him, and the bottom half of Colette. He seemed to think I ought to wish to observe 'objectively' like his medical students.

On the cabinet, by Colette's bed, I noticed her circular mirror: she had brought it from home so that she could watch the baby coming out, just as they had told us to do at the Natural Child Birth class. It served as a pathetic reminder of what we had intended things to be like. It made me feel that I had to try and preserve a memory of the birth for the sake of all three of us, and so I tried to watch, and to comfort and encourage Colette too.

But the registrar insisted on delivering a technical running commentary with the baby. He meant well enough, I think. Perhaps it was even his way of proffering a reconciliation, of showing there were 'no hard feelings'. But the idea of talking continuously and detachedly to a man while he worked on a woman came naturally to him. And he kept it up right through the birth. For him, it was a matter of emptying a muscular sack as efficiently as possible.

Colette looks so peaceful, sleeping there, in her bed beside Sylvia's cot now: it seems strange to remember all the blood, pain and delirious joy of that hospital room, here in the silence of a Connecticut night. Her womb is empty now. Then, I placed myself next to Colette's right thigh. There, I could see what was happening and keep in touch with her. He motioned me to stand behind him; he would have been standing between me and her, and I would have been reduced to a mere voyeur. I stayed where I was. And despite all that had happened, the experience was the most intense and exhilarating of my life.

The crown of the baby's head was pressing against the mother's opening, forming a purple and crimson oval: a blinded Cyclops eye. The registrar pulled the steel blades of the forceps away, like a circus juggler manipulating a ball between two sticks. His movements were swift and confident. Sometimes, he made me think of those Formula One racing car engineers who can switch punctured tyres at break-neck speed in the pits. I kept saying to Colette, 'It's coming!' or 'The head's almost out!' The registrar did not like this. I was ignoring his dry

lecture, and he probably hated the trace of emotion in the way I spoke.

Suddenly, the head was free! It stuck out into the world, while the baby's body lingered on within the birth canal. I wanted to communicate something of that marvellous moment, that sense of exultation that I felt, to Colette. In that stifling room, I felt I was the last remaining link between all the suffering she had been through, and that moment of creative becoming which was taking place between her legs. The medical staff only spoke to her about the avoidance of pain. I looked into her face, and stared back at this lividly purple grapefruit: our child, coming into independent being! I found myself filled, at once, with an unexpected surge of exhilarated emotions, a welling up, from the depths of my body and soul, of unbounded sensual joy, passion and pride. I wanted to push through all the medical staff, instruments, mucus and covering sheets and hug Colette. I already knew what she would know instants later: that all her pain and humiliation was being swept away. I heard the registrar say, 'It's a lovely little girl, Mrs Fuller.'

'Colette,' I said. 'You've done it! It's over! She's born! Our baby is here!'

I had not realised how moved, changed and happy our baby's birth would make me: in the days that followed, I was swept along by a sense of proud protectiveness towards Colette and Sylvia, a feeling of triumphant joy. Nothing, I felt, was ever going to be the same for me again. This was real: not a watery, wordy or painted birth. But a baby springing from the living flesh. And yet, neither Colette nor I could simply forget the anger we felt about the circumstances under which she had come into this world.

Of course, the birth changed what was happening in my analysis. When I told W. about what had happened, and what I felt, he readily agreed there was a lot wrong with current obstetric practice. But I felt he was refusing to accept the *reality* of what I was saying, because he accused me of 'sniffing out' objectification and even of 'looking for a fight' with the registrar. I resented this interpretation, and refused to accept that my resentment had anything to do with resistance. We had gone to Barts expecting to carry out the Natural Child Birth procedures we had learned together. Only slowly, as the labour unravelled, did I

realise they had no intention of letting us do this. Even then, I felt I had never sought confrontation: I had just tried to stand out for Colette's right to know what was being done to her.

I told W. bitterly that, *in fact*, the doctors at Barts regard the unit as a sort of birth machine, and saw themselves as intensive managers of labour. We found out that on Colette's ward, eleven out of twelve women had had epidurals; a hundred per cent had been forceps deliveries. Everyone had been given an episiotomy, i.e. cut and sewn. The model of birth, I said, which the hospital sought to impose *was* inhuman and mechanical. Colette and I had agreed that I should try to hold open the space, as far as possible, for what I described to W. as 'a "fully human" birth'. When I realised this was impossible, I had more or less accepted the situation. But W., I felt, was arguing that I should simply tolerate the intolerance of others, their exertion of concrete physical power to prevent Colette from realising the kind of birth she wanted. I said that a similar situation prevailed in analysis: he was always arguing I should tolerate and accept techniques I perceived as socially determined, oppressive, and obstacles to those fully human relations I was struggling to realise. W. himself was like the registrar, who sincerely believed he was acting in the patient's best interests while he applied unnecessary and dehumanising techniques.

I resented the way in which he kept interpreting Sylvia's birth as if it was only a 'symbol' of what was happening in analysis for me. 'The way you talk about it reminds me of that question attributed to Jung,' I told him. ' "What is the penis but a phallic symbol?" ' But Sylvia's birth was more *real* to me than anything I had experienced. I insisted that I wanted the last phase of my analysis transformed to a situation in which he became the midwife, or assistant, to my new birth, not the authoritarian manager of it. Again and again, I asked him at least to consider talking about changes in the form of the analysis. 'I think David Cooper was probably right,' I told him. ' "A major part of analytic work is finding a non-neutral analyst who is on the same side as oneself." ' But, I added, I had left that rather late in the day.

Still he did not move. I played the familiar grooves, endlessly, sterilely, repetitively. Eventually, he suggested that the analysis should

be terminated at this point because we had become stuck. I am nothing if not tenacious, and I insisted that I wanted to go on. And, on January 7th 1977, I decided to make my move. I refused to take any more of it lying down, trussed, as it were, like Colette in that lithotomy position. I knew from the books that obstetricians preferred their patients to deliver from this position, flat on their backs, with their legs strapped, but that it was, in fact, the most inefficient of all for actually 'giving birth'. I said I would not go on the couch any more, but sat down in a chair, stiffly, parallel to him. This small change altered everything: I experienced it as a new situation, a new position, a new potential. Now, I said, we are like two passengers on a tube train: there is at least a possibility we can journey in the same direction. For myself, I felt like Gulliver, the man mountain, when he sat up and tore away the Lilliputian threads that bound him.

Soon after, following a peculiarly bad session, I sent W. a note in which I said that I regretted the fact that, within the analytic space, it was impossible for me to find a position from which I could say to *him*, rather than to The Analyst as the object of My Transference, how grateful I was to him for having survived my onslaughts. I asked him, please, to try and hang on, as, despite appearances, I felt we might be getting somewhere. And even as I wrote this, I felt enormous relief, a sense that I was not inextricably committed to my strident, manipulative, empty hectoring. Immediately after this, I was able to produce what I called an 'eleventh hour formulation', in which I could admit that, behind the overt content of all our struggles, I could glimpse what had been going on. I took this in to the next session, and, pompously, I read it out to him, word by word.

I said that we seemed to have uncovered a primitive but highly organised psychotic technique, or position, in myself which presumably belonged to a very early stage of my development. I had never managed to supersede it. 'This whole organisation,' I told him, 'in its earliest and most primitive form has now become the focus of analysis.' I went on to say that as a defence, it had a very long history for me, and had therefore acquired an intractable character. 'I surprise myself with the subtlety I am prepared to put into rationalising it,' I went on. 'I

know full well I am reluctant to relinquish it, indeed that I cling to it tenaciously like a man on a desert island, hugging his pathetic raft even when a boat appears which might be able to take him off the island altogether. I overemphasise the need for change in the analyst in order that I can avoid this change within myself.'

Things had reached such a pitch, I said, that I no longer saw the analyst as analyst, nor even as a person at all – and certainly not as a more or less good, or relatively benign one. Rather, I oscillated between relating to him as if he was a thoroughly bad part of myself, or, alternatively, some sort of out-and-out enemy, a malignant persecutor, in fact. Somehow, I admitted, the whole of the psychoanalytic relationship had been drawn into this quasi-psychotic organisation. I felt that the transference had become identificatory and persecutory in character. Part of the trouble was that W., understandably, could not always hold his ground: he was forced into colluding with what was happening, into relating back to me with an intractably rigid system of denial, splitting and projection. And so mistrust, which amounted to paranoid suspicion, reigned. If he tried to talk about my psychotic organisation, I shooed him away by trying to talk about his . . . And he reacted in a persecutory way, *in fact*.

'A result of this,' I went on, 'is that I spend much of my time in analysis at the centre of a solipsistic and narcissistic world, which I defend tenaciously. I am subtle at dressing it up on the surface as genuine autonomy and "realising my own choice", but,' I said, 'it isn't that. It is a kind of raging, primitive omnipotence which the analyst sees through as easily as I do. Still, within the analysis, I won't let go of the hermetic shell because the analyst seems to be as deeply into his role as persecutor, as I into mine of persecuted: behind the façade, I nurse in terror my own deepest confusions about identity, fragmentation, disintegration, futility and nothingness. I.e. all that we ought to be analysing.'

A battered and fragmented self,
within a splintering world,
peopled by shattered others
Was all we ever knew.

But, I said, I felt that despite all this there was in me a drive, perhaps originally born of desperation, towards good, whole, full object relations with others, towards a nuanced, tentative and feelingful relationship with people in the world. Perhaps W. found it hard to get in touch with that part of me because I had become such a bad object, *for him*. I said that he could not deal with 'my projective moment', the devious cunningness with which I carefully isolated all those aspects of him onto which I could make my projections stick, like glue . . .

Upright, I could admit all this. And to admit it, not through words, but through the feelings informing those words, was in a way to have resolved it. And, for the next few weeks, all I could feel was gratitude towards the analyst for having just managed to stand his ground. 'You had to offer a wall. I had to beat against it. There was no other way. I can't see that it could have been done any differently. You had to hold your ground as best you could. I had to bear down upon it.' But I was already talking about it as something that *had happened*. It was all over. Towards the end, I would sit in the chair, without a sense of tension, but with, at last, nothing more to *say*. The silences were still. It was finished Over. Like a book which could have been written in another way, but had been drawn to its conclusion this way. Over. Born again.

1975 *Le Châtelet, France*

In the living room, I can hear him haranguing Colette. 'You bought that book?' he says. 'You are reading books like that! He must have been mad. Obsessed. You don't *enjoy* that sort of thing, do you?' And always the tip-tap-tip-tap of the intellectual's portable typewriter, knocking off the words of his novel about conscience in the other room.

At supper, the television is on. There is a charged silence around the table. An interview with an extreme right organisation demanding justice for *les pieds-noirs* emanates from the box. They are threatening terrorism. Colette's mother says, 'They should not put that sort of thing on television. At least not at Easter.' She feels certain we will agree. But we stay silent.

'You can't blame them,' Colette's father says, angrily. 'Intellectuals put those ideas into their empty heads. Whenever something like that goes on, there are always intellectuals behind it.'

I smile at Colette.

He catches the smile from the corner of my lips.

He does not return it.

1976 Graham Road, London

The glass will not break. Rebirths are violent things. One can drown, or choke, or be cut into ribbons of flesh before one glimpses the new world, beyond. I cannot breathe. All the fossils turning, mind-forg'd manacles, fathers, prefects, whores: switching. I remember, I remember . . . a day when Campbell, Head of House, called for a fag. And I, who had been reading Shelley beneath the trees, was last to answer. He had just returned from a rugger match, muddy and covered with sweat. He lay back sprawled on a chair in the prefects' room.

'Take off my boots,' he said.

For a moment I stood there, staring. I stepped forward and began to kneel towards those slimy laces. Then, suddenly, I straightened.

'No!' I shouted, 'No! Take off your own bloody boots.'

And I walked out and slammed the door.

That evening, during Prep, I was summoned to the box-room where the worst offences were dealt with. Prefects lined the space like leering sentinels. Campbell made a speech about how he was not going to enjoy this either, but as Head of House, he could not stand for that sort of guts.

I remember . . . oh, how ashamed I am of what I remember now. That strange yielding collusion, which later I was to experience when being subsumed by loss at the roulette wheel. Where, oh where, was all my burning fire, indignant rage? Cowed. Uddered. Milk-sopped. *I* apologised to *him*.

I had to kneel on a stool placed in the middle of the room, and hold onto its legs, near the floor. It was more horrible than rape: ritual and tradition roped me there. No screaming, and no fighting back. He took

off his jacket, and ran at me from the other side of the room, brandishing a cane. The pain shot through my body. Six times. And all the old sores of the past, inflicted in the nursery, and those searing paternal exchanges, all the Kiki stuff yet to come, the twisting obsessions, hinted at, began to bleed, and bleed, mingling there, in that sweaty box-room smelling of socks, dubbin, mud, remembered talc and imagined tart perfume. All those tyrannies, and submissions. I brought all that to the analytic couch. And I'm still not yet free of it. The past is weightier than the present. The future does not yet exist.

1977 Graham Road, London

We are in bed. I look over the edge. Sylvia is asleep in her carry-cot, beside us. Her dummy wobbles within her mouth. Each day, she seems to grow visibly bigger . . . becoming her own future. Sometimes I imagine she is looking at me quizzically, as if confident of her own sanity, criticising my amiable madness towards her. I am the father now. And the range of her expressions amazes me. She has no need of words to communicate what she feels.

1978 Redding, Connecticut

It is very late. I look at them both, asleep. My two little girls. Colette is snoring. I walk over to her, and run my hand gently down the side of her face. Through all this it was her love, in the end, that let me find myself, through finding her. A love we confirmed in Sylvia. Hot and sweet, palpable and mammary . . . and yet here among all these images and words, I am still yearning for complete intimacy. Sometimes, she seems so cold: so far away. Yet always so much warmer than fonts, imagos, paper theories and consulting-room 'births'. I lift my fingers and leave them for a moment in the aura of the heat coming off her head, without actually touching. Then I kneel down, and put my arms over her shoulders.

All around us, here, in this American barn, are our things: two pairs of baby shoes, 'sneakers', we bought today. A packet of Johnson's

disposable diapers. A camera. A medley of Sylvia's clothes. The clock is ticking loudly. *Ce n'est pas le temps qui passe* . . . The pillars holding up the roof of the barn cast shadows all over the floor. I glance across at the *Reveries of a Lapsed Narcissist*, over there in the shadows, for the last time: there is no mystery about why I love it so much. And I climb into bed beside Colette, and switch off the light.

EPILOGUE

The story told here has a sad ending. Just as I was beginning to break out of the citadel of the past and myself, and beginning to be able to enjoy my relationship with Colette . . . she left. Anyone who reads this journal will probably feel they understand why she had to do so. Reading it back myself, today, so do I. I think. But I did not, could not, understand at the time; and even if I had, I suspect it would have made little difference. It is another of the sub-themes of this book that insight can do little to alleviate pain.

Graham Road, London
June 29th 1983

ACKNOWLEDGEMENTS

I would like to thank all of those who read the whole or parts of the manuscript of *Marches Past*, and gave me permission to name them, and to publish what I had written about them – especially Clive Barker, John Berger, Colette Fuller, Ronnie Fraser, Derek Hirst, Robert Natkin, Christopher Oliver, Rosie van der Beek, and Dr Kenneth Wright. I also owe a special debt of gratitude to my father who, upon being told about this book, most generously recommended that I should go ahead and publish it.

I am grateful to Carmen Callil, my publisher, who made numerous helpful suggestions about both the language and structure of the book, and has sustained me with her constant enthusiasm and encouragement through all the difficulties involved in bringing it to the press. I would also like to thank Jan Dalley for the painstaking work she has put into the editing of the text and for her unfailing support.

Finally, there are many whose appearance in this book is incidental: in most cases, their names have been changed. They, too, deserve my thanks.

Peter Fuller, Stowlangtoft, December 1985